GW01458716

Ancient Pagan and Modern Christian Symbolism

With an Essay on Baal Worship, on the Assyrian Sacred Grove and Other Allied Symbols by John Newton

By Thomas Inman

With 200 Illustrations

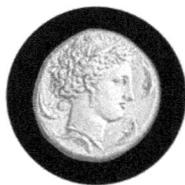

PANTIANOS
CLASSICS

Published by Pantianos Classics

ISBN-13: 978-1-78987-271-2

First published in 1875

This reprint is based upon the Fourth Edition of 1884

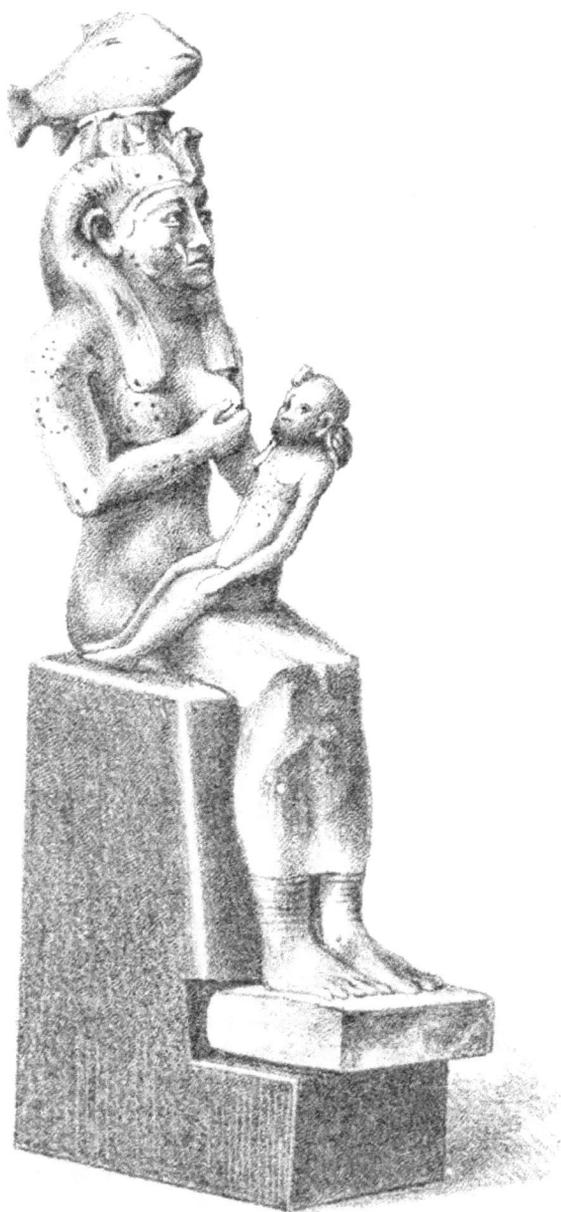

PLATE I.

Contents

Preface

The woodcuts in the present volume originally appeared in a large work, in two thick volumes, entitled *Ancient Faiths embodied in Ancient Names.* It has been suggested to me by many, that a collection of these Figures, and their explanation, are more likely to be generally examined than a very voluminous book. The one is, as it were, an alphabet; the other, an essay. The one opens the eyes; the other gives them opportunities to use their vision. The one teaches to read; the other affords means for practice. As the larger work endeavours to demonstrate the existence of a state of things almost unknown to the British public, so it is necessary to furnish overwhelming proof that the allegations and accusations made against certain nations of antiquity, and some doctrines of Christianity, are substantially true. Consequently, the number of witnesses is greater than is absolutely necessary to prove the point.

12, Rodney Street, Liverpool,
 July, 1869.

Preface to Second Edition

The demand which has sprung up for this work has induced the Author to make it more complete than it was originally. But it could not be made perfect without being expanded into a volume whose size would be incompatible with cheapness. When every Figure would supply a text for a long discourse, a close attention is required lest a description should be developed into a dissertation.

In this work, the Author is obliged to confine himself to the explanation of symbols, and cannot launch out into ancient and modern faiths, except in so far as they are typified by the use of certain conventional signs.

A great many who peruse a book like this for the first time, and find how strange were the ideas which for some thousands of years permeated the religious opinions of the civilised world, might naturally consider that the Author is a mere visionary—one who is possessed of a hobby that he rides to death. Such a notion is strengthened by finding that there is scarcely any subject treated of except the one which associates religion, a matter of the highest aim to man, with ideas of the most intensely earthly kind. But a thoughtful reader will readily discern that an essay on Symbolism must be confined to visible emblems. By no fair means can an author who makes the crucifix his text introduce the subject of the Confessional, the Eucharist, or Extreme Unction. Nor can one, who knows that Buddha and Jesus alike inaugurated a faith which was unmarked by visible symbolism, bring into an interpretation of emblems a comparison between the preaching of two such distinguished men. In like manner, the Author is obliged to pass over the difference between Judaism, Christianity as propounded by the son of Mary, and that which passes current for Christianity in Rome and most countries of Europe.

All these points, and many more, have been somewhat fully discussed in the Author's larger work, so often referred to in this, and to that he must refer the curious. The following pages are simply a chapter taken from a book, complete perhaps in itself, but only as a brick may be perfect, without giving to an individual any idea of the size, style, or architecture of the house from which it has been taken. If readers will regard these pages as a beam in a building, the Author will be content.

8, Vyvyan Terrace,
Clifton, Bristol,
August, 1874.

Introduction

IT may, we think, be taken for granted, that nothing is, or has ever been, adopted into the service of Religion, without a definite purpose. If it be supposed that a religion is built upon the foundation of a distinct revelation from the Almighty, as the Hebrew is said to be, there is a full belief that every emblem, rite, ceremony, dress, symbol, etc., has a special signification. Many earnest Christians, indeed, see in Judaic ordinances a reference to Jesus of Nazareth. I have, for example, heard a pious man assert that "leprosy" was only another word for "sin"; but he was greatly staggered in this belief when I pointed out to him that if a person's whole body was affected he was no longer unclean (Lev. xiii. 13), which seemed on the proposed hypothesis to demonstrate that when a sinner was as black as hell he was the equal of a saint. According to such an interpreter, the paschal lamb is a type of Jesus, and consequently all whom his blood sprinkles are blocks of wood, lintels, and side-posts (Exod. xii. 22, 28). By the same style of metaphorical reasoning, Jesus was typified by the "scape-goat," and the proof is clear, for one was driven away into the wilderness, and the other voluntarily went there—one to be destroyed, the other to be tempted by the devil! Hence we infer that there is nothing repugnant to the minds of the pious in an examination respecting the use of symbols, and into that which is shadowed forth by them. What has been done for Judaism may be attempted for other forms of religion.

As the Hebrews and Christians believe their religion to be God-given, so other nations, having a different theology, regard their own peculiar tenets. Though we may, with that unreasoning prejudice and blind bigotry which are common to the Briton and the Spaniard, and pre-eminently so to the mass of Irish and Scotchmen amongst ourselves, and to the Carlists in the peninsula, disbelieve a heathen pretension to a divine revelation, we cannot doubt that the symbols, etc., of Paganism have a meaning, and that it is as lawful to scrutinise the mysteries which they enfold as it is to speculate upon the Urim and Thummim of the Jews. Yet, even this freedom has, by some, been denied; for there are a few amongst us who adhere rigidly to the precept addressed to the followers of Moses, viz., "Take heed that thou enquire not after their gods, saying, How did these nations serve their gods?" (Deut. xii. 30.) The intention of the prohibition thus enunciated is well marked in the following words, [1] which indicate that the writer believed that the adoption of heathen gods would follow inquiry respecting them. It is not now-a-days feared that we may become Mahometans if we read the Koran, or Buddhists if we study the Dhammapada; but there are priests who fear that an inquiry into ecclesiastical matters may make their followers Papists,

Protestants, Wesleyans, Baptists, Unitarians, or some other religion which the Presbytery object to. The dislike of inquiry ever attends those who profess a religion which is believed or known to be weak.

The philosopher of the present day, being freed from the shackles once riveted around him by a dominant hierarchy, may regard the precept in Deuteronomy in another light. Seeing that the same symbolism is common to many forms of religion, professed in countries widely apart both as regards time and space, he thinks that the danger of inquiry into faiths is not the adoption of foreign, but the relinquishment of present methods of religious belief. When we see the same ideas promulgated as divine truth, on the ancient banks of the Ganges, and the modern shores of the Mediterranean, we are constrained to admit that they have something common in their source. They may be the result of celestial revelation, or they may all alike emanate from human ingenuity. As men invent new forms of religion now, there is a presumption that others may have done so formerly. As all men are essentially human, so we may believe that their inventions will be characterised by the virtues and the failings of humanity. Again, experience tells us that similarity in thought involves similarity in action. Two sportsmen, seeing a hare run off from between them, will fire at it so simultaneously that each is unaware that the other shot. So a resemblance in religious belief will eventuate in the selection of analogous symbolism.

We search into emblems with an intention different from that with which we inquire into ordinary language. The last tells us of the relationship of nations upon Earth, the first of the probable connections of mankind with Heaven. The devout Christian believes that all who venerate the Cross may hope for a happy eternity, without ever dreaming that the sign of his faith is as ancient as Homeric Troy, and was used by the Phoenicians probably before the Jews had any existence as a people; whilst an equally pious Mahometan regards the Crescent as the passport to the realms of bliss, without a thought that the symbol was in use long before the Prophet of Allah was born, and amongst those nations which it was the Prophet's mission to convert or to destroy. Letters and words mark the ordinary current of man's thought, whilst religious symbols show the nature of his aspirations. But all have this in common, viz., that they may be misunderstood. Many a Brahmin has uttered prayers in a language to him unintelligible; and many a Christian uses words in his devotions of which he never seeks to know the meaning. *"Om manee pani" "Om manee padme houm," "Amen" and "Ave Maria purissima"* may fairly be placed in the same category. In like manner, the signification of an emblem may be unknown. The antiquary finds in Lycian coins, and in Aztec ruins, figures for which he can frame no meaning; whilst the ordinary church-goer also sees, in his place of worship, designs of which none can give him a rational explanation. Again, we find that a language may find professed interpreters, whose system of exposition is wholly wrong; and the same may be said of symbols. I have seen, for example, three distinctly different interpretations given to one Assyrian inscription, and have heard as

many opposite explanations of a particular figure, all of which have been incorrect.

In the interpretation of unknown languages and symbols, the observer gladly allows that much may be wrong; but this does not prevent him believing that some may be right. In giving his judgment, he will examine as closely as he can into the system adopted by each inquirer, the amount of materials at his disposal, and, generally, the acumen which has been brought to the task. Perhaps, in an investigation such as we describe, the most important ingredient is care in collation and comparison. But a scholar can only collate satisfactorily when he has sufficient means, and these demand much time and research. The labour requires more time than ordinary working folk can command, and more patience than those who have leisure are generally disposed to give. Unquestionably, we have as yet had few attempts in England to classify and explain ancient and modern symbols. It is perhaps not strictly true that there has been so much a laxity in the research, of which we here speak, as a dread of making public the results of inquiry. Investigators, as a rule, have a respect for their own prejudices, and dislike to make known to others a knowledge which has brought pain to their own minds. Like the Brahmin of the story, they will destroy a fine microscope rather than permit their co-religionists to know that they drink living creatures in their water, or eat mites in their fruit. The motto of such people is, "If truth is disagreeable, cling to error."

The following attempts to explain much of ancient and modern symbolism can only be regarded as tentative. The various devices contained herein seem to me to support the views which I have been led to form from other sources, by a careful inquiry into the signification of ancient names, and the examination of ancient faiths. The figures were originally intended as corroborative of evidence drawn from numerous ancient and modern writings; and the idea of collecting them, and, as it were, making them speak for themselves, has been an after-thought. In the following pages I have simply reprinted the figures, etc., which appear in *Ancient Faiths embodied in Ancient Names* (second edition). I make no attempt to exhaust the subject. There are hundreds of emblems which find herein no place; and there are explanations of symbols current to which I make no reference, for they are simply *exoteric*.

For the benefit of many of my readers, I must explain the meaning of the last word italicised. In most, if not in all, forms of religion, there are tenets not generally imparted to the vulgar, and only given to a select few under the seal of secrecy. A similar reticence exists in common life. There are secrets kept from children, for example, that are commonly known to all parents; there are *arcana*, familiar to doctors, of which patients have no idea. For example, when a lad innocently asks the family surgeon, or his parent, where the last new baby came from, he is put off with a reply, wide of the mark, yet sufficient for him. When I put such a question to the maids in the kitchen, to which place for a time I was relegated, the first answer was that the baby came from the parsley bed. On hearing this, I went into the garden, and, find-

ing the bed had been unmoved, came back and reproached my informant for falsehood. Another then took up the word, and said it was the carrot bed which the baby came from. As a roar of laughter followed this remark, I felt that I was being cheated, and asked no more questions. Then I could not, now I can, understand the *esoteric* sense of the sayings. They had to the servants two distinct significations. The only one which I could then comprehend was *exoteric*; that which was known to my elders was the *esoteric* meaning. In what is called "religion" there has been a similar distinction. We see this, not only in the "mysteries" of Greece and Rome, but amongst the Jews; Esdras stating the following as a command from God, "Some things shalt thou publish, and some things shalt thou show secretly to the wise" (2 Esdras xv. 26).

When there exist two distinct explanations, or statements, about the signification of an emblem, the one "esoteric," true, and known only to the few, the other "exoteric," incorrect, and known to the many, it is clear that a time may come when the first may be lost, and the last alone remain. As an illustration, we can point to the original and correct pronunciation of the word [—Hebrew—], commonly pronounced Jehovah. Known only to a select few, it became lost when these died without imparting it; yet what is considered to be the incorrect method of pronouncing the word survives until to-day. [2]

We may fairly assume that, when two such meanings exist, they are not identical, and that the one most commonly received is not the correct one. But when one alone is known to exist, it becomes a question whether another should be sought. If, it may be asked, the common people are contented with a fable, believing it true, why seek to enlighten them upon its hidden meaning? To show the bearing of this subject, let us notice what has always struck me as remarkable. The second commandment declares to the Jews, "Thou shalt not make unto thee any graven image, or any likeness of anything that is in heaven above, or that is in the earth beneath, or that is in the water under the earth; thou shalt not bow down thyself to them," etc. (Exod. xx. 4). Yet we find, in Numbers xxi., that Jehovah ordered Moses to frame a brazen serpent, whose power was so miraculous that those who only looked at it were cured of the evils inflicted by thanatoid snakes.

Then again, in the temple of the God who is reported to have thus spoken, and who is also said to have declared that He would dwell in the house that Solomon made for Him, an ark, or box, was worshipped, and over it Cherubim were seen. These were likenesses of something, and the first was worshipped. We find it described as being so sacred that death once followed a profane touching of it (2 Sam. vi. 6, 7), and no fewer than 50,070 people were done to death at Bethshemesh because somebody had ventured to look inside the box, and had tried to search into the mystery contained therein (1 Sam. vi. 19). It is curious that the Philistines, who must have touched the box to put their strange offerings beside it (see 1 Sam. vi. 8), were not particularly bothered. They were "profane"; and priests only invent stories, which are applicable to the arcana which they use in worship, to blind the eyes of and

give a holy horror to the people whom they govern. How David worshipped the ark as being the representative of God we see in 2 Sam. vi. 14, 16, 17, 21.

The ark of the covenant was indeed regarded by the Jews much as a saint's toe-nail, a crucifix, an image of the Virgin, a bit of wood, or a rusty old nail is by the Roman Catholics. So flagrant an apparent breach of the second commandment was covered for the common Hebrews by the assertion that the mysterious box was a token of God's covenant with His people; but that this statement was "exoteric," we feel sure, when we find a similar ark existing and used in "the mysteries" of Egypt and Greece, amongst people who probably never heard of Jews, and could by no chance know what passed in the Hebrew temple.

When become dissatisfied with a statement, which is evidently intended to be a blind, some individuals naturally endeavour to ascertain what is behind the curtain. In this they resemble the brave boy, who rushes upon a sheet and turnip lantern, which has imposed upon his companions and passed for a ghost. What is a bugbear to the many is often a contemptible reptile to the few. Yet there are a great number who would rather run from a phantom night after night than grapple with it once, and would dissuade others from being bold enough to encounter it. Nevertheless, even the former rejoice when the cheat is exposed.

As when, by some courageous hand, that which has been mistaken by hundreds for a spectre has been demonstrated to be a crafty man, no one would endeavour to demonstrate the reality of ghosts by referring to the many scores of men of all ranks who had been duped by the apparition thus detected; so, in like manner, when the falsehood of an exoteric story is exhibited, it is no argument in its favour that the vulgar in thousands and many a wise man have believed it. Speaking metaphorically, we have many such ghosts amongst ourselves; phantoms, which pass for powerful giants, but are in reality perfect shams. Such we may describe by comparing them to the apocryphal vampires. It is to me a melancholy thing to contemplate the manner in which mankind have, in every age and nation, made for themselves bugbears, and then have felt fear at them. We deride the African, who manufactures a Fetish, and then trembles at its power, but the learned know perfectly well that men made the devil, whom the pious fear, just as a negro dreads Mumbo Jumbo.

In the fictitious narratives which passed for truth in the dark ages of Christianity, there were accounts of individuals who died and were buried, and who, after a brief repose in the tomb, rose again. Some imagined that the resuscitated being was the identical one who had been interred. Others believed that some evil spirit had appropriated the body, and restored to it apparent vitality. Whatever the fiction was, the statement remained unchallenged, that some dead folk returned to earth, having the same guise as when they quitted it. We believe that a similar occurrence has taken place in religion. Heathendom died, and was buried; yet, after a brief interval, it rose again from its tomb. But, unlike the vampire, its garb was changed, and it was

not recognised. It moved through Christendom in a seductive dress. If it were a devil, yet its clothing was that of a sheep; if a wolf, it wore broadcloth. If it ravened, the victims were not pitied. Heathenism, by which I mean the manners, morals and rites prevalent in pagan times or countries, like a resuscitated vampire, once bore rule throughout Christendom, in which term is included all those parts where Christian baptism is used by all the people, or the vast majority. In most parts it still reigns supreme.

When vampires were discovered by the acumen of any observer, they were, we are told, ignominiously killed, by a stake being driven through the body; but experience showed them to have such tenacity of life that they rose again, and again, notwithstanding renewed impalement, and were not ultimately laid to rest till wholly burnt. In like manner, the regenerated Heathendom, which dominates over the followers of Jesus of Nazareth, has risen again and again, after being transfixed. Still cherished by the many, it is denounced by the few. Amongst other accusers, I raise my voice against the Paganism which exists so extensively in ecclesiastical Christianity, and will do my utmost to expose the imposture.

In a vampire story, told in *Thalaba*, by Southey, the resuscitated being takes the form of a dearly beloved maiden, and the hero is obliged to kill her with his own hand. He does so; but, whilst he strikes the form of the loved one, he feels sure that he slays only a demon. In like manner, when I endeavour to destroy the current Heathenism, which has assumed the garb of Christianity, I do not attack real religion. Few would accuse a workman of malignancy who cleanses from filth the surface of a noble statue. There may be some who are too nice to touch a nasty subject; yet even they will rejoice when some one else removes the dirt. Such a scavenger is much wanted.

If I were to assert, as a general proposition, that religion does not require any symbolism, I should probably win assent from every true Scotch Presbyterian, every Wesleyan, and every Independent. Yet I should be opposed by every Papist, and by most Anglican Churchmen. But why? Is it not because their ecclesiastics have adopted symbolism into their churches and into their ritual? They have broken the second commandment of Jehovah, and refuse to see anything wrong in their practice or gross in their imagery. But they adopt Jehovah rather than Elohim, and break the commandments, said to be given upon Sinai, in good company.

The reader of the following pages will probably feel more interest therein if he has some clue whereby he may guide himself through their labyrinth.

From the earliest known times there seems to have been in every civilised nation the idea of an unseen power. In the speculations of thoughtful minds a necessity is recognised for the existence of a Being who made all things—who is at times beneficent, sending rain and warmth, and who at others sends storm, plague, famine, and war. After the crude idea has taken possession of the thoughts, there has been a desire to know something more of this Creator, and an examination into the works of Nature has been made with

the view to ascertain the will and designs of the Supreme. In every country this great One has been supposed to inhabit the heaven above us, and consequently all celestial phenomena have been noticed carefully. But the mind soon got weary of contemplating about an essence, and, contenting itself with the belief that there was a Power, began to investigate the nature of His ministers. These, amongst the Aryans, were the sun, fire, storm, wind, the sky, the day, night, etc. An intoxicating drink, too, was regarded as an emanation from the Supreme. With this form of belief men lived as they had done ere it existed, and in their relations with each other may be compared to such high class animals as elephants. Men can live peaceably together without religion, just as do the bisons, buffaloes, antelopes, and even wolves. The assumption that some form of faith is absolutely a necessity for man is only founded on the fancies of some religious fanatics who know little of the world. [3]

But as there is variety in the workings of the human mind, so there were differences in the way wherein the religious idea was carried out. Some regarded the sun and moon, the constellations and the planets, as ministers of the unseen One, and, reasoning from what was known to what was unknown, argued thus: "Throughout nature there seems to be a dualism. In the sky there are a sun and moon; there are also sun and earth, earth and sea. In every set of animals there are males and females." An inquiry into the influence of the sun brought out the facts that by themselves its beams were destructive; they were only beneficent when the earth was moist with rain. As the rain from heaven, then, caused things on earth to grow, it was natural that the main source of light and heat should be regarded as a male, and the earth as a female. As a male, the sun was supposed to have the emblems of virility, and a spouse whom he impregnated, and who thereby became fertile.

In examining ancient Jewish, Phoenician, and other Shemitic cognomens, I found that they consisted of a divine name and some attribute of the deity, and that the last was generally referable equally to the Supreme, to the Sun, as a god, and to the masculine emblem. If the deity was a female, the name of her votary contained a reference to the moon and the beauties or functions of women. The higher ideas of the Creator were held only by a few, the many adopted a lower and more debased view. In this manner the sun became a chief god and the moon his partner, and the former being supposed to be male and the latter female, both became associated with the ideas which all have of terrestrial animals. Consequently the solar deity was associated in symbolism with masculine and the moon with feminine emblems.

An inquiry into antiquity, as represented by Babylonians, Assyrians, Egyptians, Phoenicians, Hebrews, Greeks, Etruscans, Romans, and others, and into modern faiths still current, as represented in the peninsula of India, in the Lebanon, and elsewhere, shows that ideas of sex have been very generally associated with that of creation. God has been described as a king, or as a queen, or as both united. As monarch, he is supposed to be man, or woman, or both. As man differs from woman in certain peculiarities, these very

means of distinction have been incorporated into the worship of god and goddess. Rival sects have been ranged in ancient times under the symbol of the **T** and the **O** as in later times they are under the cross and the crescent. The worship of God the Father has repeatedly clashed with that of God the Mother, and the votaries of each respectively have worn badges characteristic of the sex of their deity. An illustration of this is to be seen amongst ourselves; one sect of Christians adoring chiefly the Trinity, another reverencing the Virgin. There is a well-known picture, indeed, of Mary worshipping her infant; and to the former is given the title *Mater Creatoris*, "the mother of the Creator." Our sexual sections are as well marked as those in ancient Jerusalem, which swore by Jehovah and Ashtoreth respectively.

The idea of sexuality in religion is quite compatible with a ritual and practice of an elaborate character, and a depth of piety which prefers starvation to impurity, or, as the Bible has it, to uncleanness. To eat "with the blood" was amongst the Hebrews a crime worthy of death; to eat with unwashed hands was a dreadful offence in the eyes of the Pharisees of Jerusalem; and in the recent famine in Bengal, we have seen that individuals would rather die of absolute hunger, and allow their children to perish too, than eat bread or rice which may have been touched by profane hands, or drink milk that had been expressed by British milkmaids from cows' udders. Yet these same Hindoos, the very particular sect of the Brahmins, have amongst themselves a form of worship which to our ideas is incompatible with real religion. The folks referred to adore the Creator, and respect their ceremonial law even more deeply, than did the Hebrews after the time of the Babylonish captivity; but they have a secret cult in which—and in the most, matter-of-fact way— they pay a very practical homage to one or other of the parts which is thought by the worshipper to be a mundane emblem of the Creator.

The curious will find in *Essays on the Religion of the Hindus*, by H. H. Wilson, in the *Dabistan*, translated by Shea and Troyer (Allen and Co., London), 3 vols., 8vo., and in *Memoirs of the Anthropological Society of London* (Trübner and Co.), vols. 1 and 2, much information on the method of conducting the worship referred to. The first named author thinks it advisable to leave the Brahminic "rubric" for the "Sakti Sodhana," for the most part under the veil of the original Sanscrit, and I am not disposed wholly to withdraw it.

But Christians are not pure; some of my readers may have seen a work written by an Italian lady of high birth, who was in early life forced into a nunnery, and who left it as soon as she had a chance. In her account she tells us how the women in the monastery were seduced by reverend Fathers, who were at one time the instruments of vice, at another the guides to penitence. Their practice was to instruct their victims that whatever was said or done must be accompanied by a pious sentence. Thus, "I love you dearly" was a profane expression; but "I desire your company in the name of Jesus," and "I embrace in you the Holy Virgin," were orthodox. In like manner, the Hindus have prayers prescribed for their use, when the parts are to be purified prior to proceeding to extremities, when they are introduced to each other, in the

agitation which follows, and when the ceremony is completed. Everything is done, as Ritualists would say, decently and in order; and a pious orgie, sanctified by prayers, cannot be worse than the penance ordained by some "confessors" to those faithful damsels whose minds are plastic enough to believe that a priest is an embodiment of the Holy Ghost, and that they become assimilated to the Blessed Virgin when they are overshadowed by the power of the Highest (Luke i. 85).

There being, then, in "religion" a strong sensual element, ingenuity has been exercised to a wonderful extent in the contrivance of designs, nearly or remotely significant of this idea, or rather union of the conceptions to which we have referred. Jupiter is a Proteus in form; now a man, now a bull, now a swan, now an androgyne. Juno, or her equivalent, is sometimes a woman, occasionally a lioness, and at times a cow. All conceivable attributes of man and woman were symbolised; and gods were called by the names of power, love, anger, desire, revenge, fortune, etc. Everything in creation that resembled in any way the presumed Creator, whether in name, in character, or in shape, was supposed to represent the deity. Hence a palm tree was a religious emblem, because it is long, erect, and round; an oak, for it is hard and firm; a fig-tree, because its leaves resemble the male triad. The ivy was sacred from a similar cause. A myrtle was also a type, but of the female, because its leaf is a close representation of the *vesica piscis*. Everything, indeed, which in any way resembles the characteristic organs of man and woman, became symbolic of the one or the other deity, Jupiter or Juno, Jehovah or Astarte, the Father or the Virgin. Sometimes, but very rarely, the parts in question were depicted *au naturel*, and the means by which creation is effected became the mundane emblem of the Almighty; and two huge phalli were seen before a temple, as we now see towers or spires before our churches, and minarets before mosques. (Lucian, *Dea Syria*.)

Generally, however, it was considered the most correct plan to represent the organs by some conventional form, understood by the initiated, but not by the unlearned. Whatever was upright, and longer than broad, became symbolic of the father; whilst that which was hollow, cavernous, oval, or circular, symbolised the mother. A sword, spear, arrow, dart, battering ram, spade, ship's prow, anything indeed intended to pierce into something else was emblematic of the male; whilst the female was symbolised as a door, a hole, a sheath, a target, a shield, a field, anything indeed which was to be entered. The Hebrew names sufficiently indicate the plan upon which the sexes were distinguished; the one is a זכר *zachar*, a perforator or digger, and the other נקבה *nekebah*, a hole or trench, *i.e.* male and female.

These symbols were not necessarily those of religious belief. They might indicate war, heroism, prowess, royalty, command, etc., or be nothing more than they really were. They only symbolised the Creator when they were adopted into religion. Again, there was a still farther refinement; and advantage was taken of the fact, that one symbol was tripliform, the other single; one of one shape, and the other different. Consequently, a triangle, or

three things, arranged so that one should stand above the two, became emblematic of the Father, whilst an unit symbolised the Mother.

These last three sentences deserve close attention, for some individuals have, in somewhat of a senseless fashion, objected, that a person who can see in a tortoise an emblem of the male, and in a horse-shoe an effigy of the female organ, must be quite too fantastical to deserve notice. But to me, as to other inquirers, these things are simply what they appear to be when they are seen in common life. Yet when the former creature occupies a large space in mythology; when the Hindoo places it as the being upon which the world stands, and the Greeks represent one Venus as resting upon a tortoise and another on a goat; and when one knows that in days gone by, in which people were less refined, the [—Greek—] was displayed where the horse-shoe is now, and that some curiously mysterious attributes were assigned to the part in question; we cannot refuse to see the thing signified in the sign.

Again, inasmuch as what we may call the most prominent part of the tripliform organ was naturally changeable in character, being at one time soft, small, and pendent, and at another hard, large, and upright, those animals that resembled it in these respects became symbolical. Two serpents, therefore, one Indian, and the other Egyptian, both of which are able to distend their heads and necks, and to raise them up erect, were emblematic, and each in its respective country typified the father, the great Creator. In like manner, another portion of the triad was regarded as similar in shape and size to the common hen's egg. As the celebrated physiologist, Haller, remarked, "*Omne vivum ex ovo*" every living thing comes from an egg; so more ancient biologists recognised that the dual part of the tripliform organ was as essential to the creation of a new being as the central pillar. Hence an egg and a serpent became a characteristic of "the Father," El, Ab, Ach, Baal, Asher, Melech, Adonai, Jahu, etc. When to this was added a half moon, as in certain Tyrian coins, the trinity and unity were symbolised, and a faith expressed like the one held in modern Rome, that the mother of creation is co-equal with the father; the one seduces by her charms, and the other makes them fructify.

To the Englishman, who, as a rule, avoids talking upon the subject which forms the basis of many an ancient religion, it may seem incredible that any individual, or set of writers, could have exercised their ingenuity in finding circumlocutory euphemisms for things which, though natural, are rarely named. Yet the wonder ceases when we find, in the writings of our lively neighbours, the French, a host of words intended to describe the parts referred to, which correspond wholly with the pictorial emblems adopted by the Greeks and others.

As English writers have, as a rule, systematically avoided making any distinct reference to the sexual ideas embodied in ancient Paganism, so they have, by their silence, encouraged the formation of a school of theology which has no solid foundation, except a very animal one. As each individual finds out this for himself, it becomes a question with him how far the information shall be imparted to others. So rarely has the determination to accuse

the vampire been taken, that we can point to very few English books to which to refer our readers. We do not know one such that is easily accessible; K. Payne Knight's work, and the addition thereto, having been privately printed, is not often to be found in the market. To give a list of the foreign works which the author has consulted, prior to and during the composition of his book on Ancient Faiths, would be almost equivalent to giving a catalogue of part of his library. He may, however, indicate the name of one work which is unusually valuable for reference, viz., *Histoire abrégée des Differens Cultes*, par J. A. Dulaure, 2 vols., small 8vo., Paris, 1825. Though out of print, copies can generally be procured through second-hand booksellers. Another work, *'Récherches sur les Mystères de Paganisme*, by St. Croix, is equally valuable, but it is very difficult to procure a copy.

The ancient Jews formed no exception to the general law of reverence for the male emblem of the Creator; and though we would, from their pretensions to be the chosen people of God, gladly find them exempt from what we consider to be impurities, we are constrained to believe that, even in the worship of Jehovah, more respect was given to the symbol than we, living in modern times, think that it deserves. In their Scriptures we read of Noah, whose infirm temper seems to have been on a par with his weakness for wine, cursing one of his three sons because, whilst drunk, he had negligently exposed his person, and the young man had thought the sight an amusing one. Ham had no reverence for the symbol of the Creator, but Shem and Japhet had, and covered it with a veil as respectfully as if it had been the ineffable framer of the world (Gen. ix. 21-27). As our feelings of propriety induce us to think that the father was a far greater sinner than the son, we rejoice to know that the causeless curse never fell, and that Ham, in the lands of Canaan, Assyria, and Babylonia, and subsequently in Carthaginian Spain, were the masters of those Hebrews, whose main force, in old times, lay in impotent scoldings, such, as Shakespeare puts into the mouth of Caliban.

One of the best proofs of the strong sexual element which existed in the religion of the Jews is the fact that Elohim, one of the names of the Creator amongst the Hebrews, is represented, Gen. xvii. 10-14, as making circumcision a sign of his covenant with the seed of Abraham; and in order to ascertain whether a man was to be regarded as being in the covenant, God is supposed to have looked at the state of the virile organ, or—as the Scripture has it—of the hill of the foreskin. We find, indeed, that Jehovah was quite as particular, and examined a male quite as closely as Elohim: for when Moses and Zipporah were on their way from Midian to Egypt, Exod. iv. 24, Jehovah having looked at the "trinity" of Moses' son, and having found it as perfect as when the lad was born, sought to slay him, and would have done so unless the mother had mutilated the organ according to the sacred pattern. Again, we find in Josh. v. 2, and in the following verses, that Jehovah insisted upon all the Hebrew males having their virile member in the covenant condition ere they went to attack the Canaanites. We cannot suppose that any scribe could dwell so much as almost every scriptural writer does upon the subject

of circumcision, had not the masculine emblem been held in religious veneration amongst the Jewish nation.

But the David who leaped and danced, obscenely as we should say, before the ark—an emblem of the female creator—who purchased his wife from her royal father by mutilating a hundred Philistines, and presenting the foreskins which he had cut off therefrom "in full tale" to the king (1 Sam. xviii. 27, 2 Sam. iii. 14), who was once the captain of a monarch who thought it a shame beyond endurance to be abused, tortured, or slain by men whose persons were in a natural condition (1 Sam. xxxi. 4), and who imagined that he, although a stripling, could conquer a giant, because the one had a sanctified and the other a natural member—is the man whom we know as the author of Psalms with which Christians still refresh their minds and comfort their souls. The king who, even in his old age, was supposed to think so much of women that his courtiers sought a lovely damsel as a comfort for his dying bed, is believed to have been the author of the noble nineteenth Psalm, and a number of others full of holy aspirations. It is clear, then, that sexual ideas on religion are not incompatible with a desire to be holy. The two were co-existent in Palestine; they are equally so in Bengal.

We next find that Abraham, the cherished man of God, the honoured patriarch of the Jews, makes his servant lay his hand upon the master's member, whilst he takes an oath to do his bidding, precisely like a more modern Palestinian might do; and Jacob does the same with Joseph. See Gen. xxiv. 8, and xlvii. 29.

As it is not generally known that the expression, "under my thigh," is a euphemism for the words, "upon the symbol of the Creator," I may point to two or three other passages in which the *thigh* (translated in the authorised version *loins*) is used periphrastically: Genesis xxxv. 2, xlvi. 26; Exod. i. 5. See Ginsburg, in Kitto's *Biblical Cyclopedia*, vol. 3, p. 348, *s. v.* Oath.

I have on two occasions read, although I failed to make a note of it, that an Arab, during the Franco-Egyptian war, when accused by General Kleber of treachery, not only vehemently denied it, but when he saw himself still distrusted, he uncovered himself before the whole military staff, and swore upon his trinity that he was guiltless. In the Lebanon, once in each year, every female considers it her duty to salute with her lips the reverenced organ of the Old Sheik.

Again we learn, from Deut. xxiii. 1, that any unsanctified mutilation of this part positively entailed expulsion from the congregation of the Lord. Even a priest of the house of Aaron could not minister, as such, if his masculinity had been in any way impaired (Lev. xxi. 20); and report says that, in our Christian times, Popes have to be privately perfect; see also Deut. xxv. 11, 12. Moreover, the inquirer finds that the Jewish Scriptures teem with promises of abundant offspring to those who were the favourites of Jehovah; and Solomon, the most glorious of their monarchs, is described as if he were a Hercules amongst the daughters of Thespius. Nothing can indicate the licentiousness of the inhabitants of Jerusalem more clearly than the writings of Ezekiel.

[4] If, then, in Hebrew law and practice, we find such a strong infusion of the sexual element, we cannot be surprised if it should be found elsewhere, and gradually influence Christianity.

We must next notice the fact, that what we call impurity in religious tenets does not necessarily involve indecency in practice. The ancient Romans, in the time of the early kings, seem to have been as proper as early Christian maidens. It is true that, in the declining days of the empire, exhibitions that called forth the fierce denunciations of the fathers of the Church took place; but we find very similar occurrences in modern Christian capitals. In Spartan days, chastity and honesty were not virtues, but drunkenness was a vice. In Christian England, drunkenness is general, and we cannot pride ourselves upon universal honesty and chastity. It is not the national belief, but the national practice, which evidences a people's worth. Spain and Ireland, called respectively "Catholic" and "the land of saints," cannot boast of equality with "infidel" France and "free-thinking" Prussia. England will be as earnest, as upright, and as civilised, when she has abandoned the heathen elements in her religion, as when she hugs them as if necessary to her spiritual welfare. Attachment to the good parts of religion is wholly distinct from a close embrace of the bad ones; and we believe he deserves best of his country who endeavours to remove every possible source of discord. None can doubt the value of the order, "Do to others as you would wish others to do to you." If all unite to carry this out, small differences of opinion may at once be sunk. How worthless are many of the dogmas that people now fight about, the following pages will show.

In our larger work we have endeavoured to show that there may be a deep sense of religion, a feeling of personal responsibility, so keen as to influence every act of life, without there being a single symbol used. The earnest Sakya Muni, or Buddha, never used anything as a sacred emblem; nor did Jesus, who followed him, and perhaps unconsciously propagated the Indian's doctrine. When the Apostles were sent out to teach and preach, they were not told to carry out any form of ark or crucifix. To them the doctrine of the Trinity was unknown, and not one of them had any particular reverence for her whom we call the Virgin Mary, who, if she was '*virgo intacta*' when Jesus was born, was certainly different when she bore his brothers. Paul and Peter, though said to be the fathers of the Roman Church, never used or recommended the faithful to procure for themselves "a cross" as an aid to memory. The early Christians recognised each other by their deeds, and never had, like the Jews, to prove that they were in covenant with God, by putting a mutilated part of their body into full view. We, with the Society of Friends, prefer primitive to modern Christianity.

In the following pages the author has felt himself obliged to make use of words which are probably only known to those who are more or less "scholars." He has to treat of parts of the human body, and acts which occur habit-

ually in the world, which in modern times are never referred to in polite society, but which, in the period when the Old Testament was written, were spoken of as freely as we now talk of our hands and feet. In those days, everything which was common was spoken of without shame, and that which occurred throughout creation, and was seen by every one, was as much the subject of conversation as eating and drinking is now. The Hebrew-writers were extremely coarse in their diction, and although this has been softened down by subsequent redactors, much which is in our modern judgment improper still remains. For example, where we simply indicate the sex, the Jewish historians used the word which was given to the symbol by which male and female are known; for example, in Gen. i. 27, and v. 2, and in a host of other places, the masculine and feminine are spoken of as *zachar* and *nekebah*, which is best translated as "borers" and "bored." Another equally vulgar way of describing men is to be found in 1 Kings xiv. 10. But these observations would not serve us much in symbolism did we not know that they were associated with certain euphemisms by which when one thing is said another is intended; for an illustration let us take Isaiah vii. 20, and ask what is meant by the phrase, "the hair of the feet"? It is certain that the feet are never hairy, and consequently can never be shaved. Again, when we find in Gen. xlix. 10, "the sceptre shall not depart from Judah, nor a lawgiver from between his feet," and compare this with Deut. xxviii. 57, and 2 Kings xviii. 27, where the words are, in the original, "the water of their feet," it is clear that symbolic language is used to express something which, if put into the vernacular, would be objectionable to ears polite. Again, in Genesis xxiv. 2 and xlvii. 29, and in Heb. xi. 21, it is well known to scholars that the word "thigh" and "staff" are euphemisms to express that part which represents the male. In Deut. xxiii. 1, we have evidence, as in the last three verses quoted, of the sanctity of the part referred to, but the language is less refined. Now-a-days our ears are not attuned to the rough music which pleased our ancestors, and we have to use veiled language to express certain matters. In the following pages, the words which I select are drawn from the Latin, Greek, Sanscrit, Shemitic, or Egyptian. Hea, Ann, and Asher replace the parts referred to in Deut. xxiii. 1; Osiris, Asher, Linga, Mahadeva, Siva, Priapus, Phallus, etc., represent the Hebrew *zachar* ; whilst Isis, Parvati, Yoni, Sacti, Astarte, Ishtar, etc., replace the Jewish *nekebah*. The junction of these parts is spoken of as Ashtoreth, Baalim, Elohim, the trinity and unity, the androgyne deity, the arba, or mystic four, and the like.

I will only add, that what I refer to has long been known to almost every scholar except English ones. Of these a few are learned; but for a long period they have systematically refrained from speaking plainly, and have written in such a manner as to be guilty not only of *suppressio veri* but of *suggestio falsi*.

After reading thus far, I can imagine many a person saying with astonishment, "Are these things so?" and following up his thoughts by wondering what style of persons they were, or are, who could introduce into religion such matters as those of which we have treated.

In reply, I can only say that I have nothing extenuated, and set down nought in malice. But the first clause of the assertion requires modification, for in this volume there are many things omitted which I have referred to at length in my larger work. In that I have shown, not only that religious fornication existed in ancient Babylon, but that there is reason to believe that it existed also in Palestine. The word קדש, *Kadesh*, which signifies "pure, bright, young, to be holy, or to be consecrated," is also the root from which are formed the words *Kadeshah* and *Kadeshim*, which are used in the Hebrew writings, and are translated in our authorised version "whore" and "sodomite." See Bent, xxiii. 17.

Athanasius tells us something of this as regards the Phoenicians, for he says, (*Oratio Contr. Gent.*, part i., p. 24.) "Formerly, it is certain that Phoenician women prostituted themselves before their idols, offering their bodies to their gods in the place of first fruits, being persuaded that they pleased the goddess by that means, and made her propitious to them."

Strabo mentions a similar occurrence at Comana, in Pontus, book xiii., c. iii. p. 86—and notices that an enormous number of women were consecrated to the use of worshippers in the temple of Venus at Corinth.

Such women exist in India, and the priests of certain temples do everything in their power to select the loveliest of the sex, and to educate them so highly as to be attractive.

The customs which existed in other places seem to have been known in Jerusalem, as we find in 1 Kings xiv. 24., XV. 12, that *Kadeshim* were common in Judea, and in 2 Kings xxiii. 7, we discover that these "consecrated ones" were located "by the temple," and were associated with women whose business was "to make hangings for the grove." What these tissues were and what use was made of them will be seen in Ezekiel xvi. 16.

Even David, when dancing before the ark, shamelessly exposed himself. Solomon erected two pillars in the porch of his temple, and called them Jachin and Boaz, and added pomegranate ornaments. We have seen how Abraham and Jacob ordered their inferiors to swear by putting the hand upon "the thigh"; and we have read of the atrocities which occurred in Jerusalem in the time of Ezekiel. Yet the Jews are still spoken of as God's chosen people, and the Psalmist as a man after God's own heart.

But without going so far back, let us inquire into the conduct of the sensual Turks, and of the general run of the inhabitants of Hindostan. From everything that I can learn—and I have repeatedly conversed with those who have known the Turks and Hindoos familiarly—these are in every position in life as morally good as common Christians are.

My readers must not now assert that I am either a partisan or a special pleader when I say this; they must consider that I am making the comparison as man by man. I do not, as missionaries do, compare the most vicious Mahomedan and Brahmin with the most exemplary Christian; nor do I, on the other hand, compare the best Ottoman and Indian with Christian criminals; but I take the whole in a mass, and assert that there is as large a percentage

of good folks in India and Turkey as there is in Spain and France, England or America.

The grossest form of worship is compatible with general purity of morals. The story of Lucretia is told of a Pagan woman, whilst those of Er and Onan, Tamar and Judah relate to Hebrews. David, who seduced Bathsheba, and killed her husband, was not execrated by "God's people," nor was he consequently driven from his throne as Tarquin was by the Romans.

In prowess and learning, the Babylonians, with their religious prostitution, were superior to the "chosen people." Of the wealth and enterprise of the Phoenicians, Ancient History tells us abundance.

There are probably no three cities in ancient or modern times which contain so many vicious individuals as London, Paris, and New York. Yet there are none which history tells us of that were more powerful. No Babylonian army equalled in might or numbers the army of the Northern United States. Nineveh never wielded armies equal to those of the French Napoleon and the German William, and Rome never had an empire equal to that which is headed by London.

The existence of personal vice does not ruin a nation in its collective capacity. Nor does the most sensual form of religion stunt the prosperity of a people, so long as the latter do not bow their necks to a priesthood.

The greatest curse to a nation is not a bad religion, but a form of faith which prevents manly inquiry. I know of no nation of old that was priest-ridden which did not fall under the swords of those who did not care for hierarchs.

The greatest danger is to be feared from those ecclesiastics who wink at vice, and encourage it as a means whereby they can gain power over their votaries. So long as every man does to other men as he would that they should do to him, and allows no one to interfere between him and his Maker, all will go well with the world.

Whilst the following sheets were going through the press, my friend Mr. Newton, who has not only assisted me in a variety of ways, but who has taken a great deal of interest in the subject of symbolism, gave me to understand that there were some matters in which he differed very strongly from me in opinion. One of these was as to the correct interpretation of the so-called Assyrian grove; another was the signification of one of Lajard's gems, Plate iv., Fig. 3; and the most conspicuous of our divergences was respecting the fundamental, or basic idea, which prompted the use in religion of those organs of reproduction which have, from time immemorial, been venerated in Hindostan, and, as far as we can learn, in Ancient Egypt, Babylonia, Assyria, Tyre, Sidon, Carthage, Jerusalem, Etruria, Greece, and Rome, as well as in countries called uncivilised. I feel quite disposed to acquiesce in the opinions which my old friend has formed respecting the Assyrian grove, but I am not equally ready to assent to his other opinions.

Where two individuals are working earnestly for the elucidation of truth, there ought, in my opinion, to be not only a tolerance of disagreement, but an honest effort to submit the subject to a jury of thoughtful readers.

As I should not feel satisfied to allow any other person to express my opinions in his words, it seemed to me only fair to Mr. Newton to give him the facility of enunciating his views in his own language. It was intended, originally, that my friend's observations upon the "grove" should be followed by a dissertation upon other relics of antiquity—notably upon that known as Stonehenge—but circumstances have prevented this design being carried into execution.

When two individuals who have much in common go over the same ground, it is natural, indeed almost necessary, that they should dwell upon identical topics. Hence it will be found that there are points which are referred to by us both, although possibly in differing relationship.

As my own part of the following remarks were printed long before I saw Mr. Newton's manuscript, I hope to be pardoned for allowing them to stand. The bulk of the volume will not be increased to the extent of a full page.

If I were to be asked the reason why I differ from Mr. Newton in his exalted idea about the adoption of certain bodily organs as types, tokens, or emblems of an unseen and an inscrutable Creator, my answer would be drawn from the observations made upon every known order of priesthood, from the most remote antiquity to the present time. No matter what the creed, whether Ancient or Modern, the main object of its exponents and supporters is to gain over the minds of the populace. This has never yet been done, and probably never will be attempted, by educating the mind of the multitude to think.

In Great Britain we find three sets of hierarchs opposed to each other, and all equally, by every means in their power, prohibit independent inquiry.

A young Romanist convert, as we have recently seen, is discouraged from persevering in the study of history and logic; a Presbyterian is persecuted, as far as the law of the land permits, if he should engage in an honest study of the Bible, of the God which it presents for our worship, and of the laws that it enforces. A bishop of the Church of England is visited by the puny and spiteful efforts of some of his nominal equals if he ventures to treat Jewish writings as other critics study the tomes of Livy or of Herodotus.

One set of men have banded together to elect a god on earth, and endeavour to coerce their fellow-mortals to believe that a selection by a few old cardinals can make the one whom they choose to honour "infallible."

Another set of men, who profess to eschew the idea of infallibility in a Pope, assume that they possess the quality themselves, and endeavour to blot out from the communion of the faithful those who differ from them "on points which God hath left at large."

Surely, when with all our modern learning, thought, and scientific enquiry, hierarchs still set their faces against an advance in knowledge, and quell, if possible, every endeavour to search after truth, we are not far wrong when

we assert, that the first priests of barbarism had no exalted views of such an abstract subject as life, in the higher and highest senses, if indeed in any sense of the word.

Another small point of difference between my friend and me is, whether there has been at any time a figured representation of a *kakodoemon*—except since the beginning of Christianity—and if, by way of stretching a point, we call Typhon—Satan or the Devil—by this name, as being opposed to the *Agathodoemon*, whether we are justified in providing this evil genius with wings. As far as I can judge from Chaldean and Assyrian sculptures, wings were given to the lesser deities as our artists assign them to modern angels. The Babylonian Apollyon, by whatever name he went, was winged—but so were all the good gods. The Egyptians seem to have assigned wings only to the favourable divinities. The Jews had in their mythology a set of fiery flying serpents, but we must notice that their cherubim and seraphim were all winged, some with no less than three pairs—much as Hindoo gods have four heads and six, or any other number of arms.

Mr. Newton assumes that the dragon mentioned in Rev. xii. was a winged creature, but it is clear from the context, especially from verses 14 and 15, that he had no pinions, for he was unable to follow the woman to whom two aerial oars had been given.

The dragon, as we know it, is, I believe, a mediæval creation; such a creature is only spoken of in the Bible in the book of Revelation, and the author of that strange production drew his inspiration on this point from the Iliad, where a dragon is described as of huge size, coiled like a snake, of blood-red colour, shot with changeful hues, and having three heads. Homer, Liddell, and Scott add—used δράχων and ὄφις indifferently for a serpent. So does the author of Rev. in ch. xx. 2. I have been unable to discover any gnostic gem with anything like a modern dragon on it.

Holding these views, I cannot entertain the proposition that the winged creatures in the very remarkable gem already referred to are evil genii.

In a question of this kind the mind is perhaps unconsciously biased by comparing one antiquarian idea with another. A searcher amongst Etruscan vases will see not only that the angel of death is winged, but that Cupid, Eros, or by whatever other name "desire" or love goes, frequently hovers over the bridal or otherwise voluptuous couch, and attends beauty at her toilet. The Greeks also gave to Eros a pair of wings, intended, it is fancied, to represent the flutterings of the heart, produced when lovers meet or even think of each other. Such a subordinate deity would be in place amongst so many sexual emblems as Plate iv. Fig. 3 contains, whilst a *koakdoemon* would be a "spoil sport," and would make the erected serpents drop rather than remain in their glory.

These matters are apparently of small importance, but when one is studying the signification of symbolical language, he has to pay as close an attention, and extend the net of observation over as wide a sea as a scholar does when endeavouring to decipher some language written in long-forgotten

characters, and some divergence of opinion between independent observers sharpens the intellect more than it tries the temper.

[1] "even so will I do likewise."
[2] It is supposed by some that *Jahveh* is the proper pronunciation of this word, but as the first letter may represent, *ja, ya,* or *e,* and the third *u, v,* or *o,* whilst the second and fourth are the soft *h,* one may read the word *Jhuh,* analogous to the *Ju* in Jupiter; *Jehu,* the name of a king of Israel; *Yahu* as it is read on Assyrian inscriptions; Jeho, as in Jehoshaphat; *Ehoh,* analogous to the *Evoe* or *Euoe* associated with Bacchus; and *Jaho,* analogous to the J. A. O. of the Gnostics. The Greek "Fathers" give the word as if equivalent to *yave, yaoh, yeho,* and *iao.*

But the question is not how the word may be pronounced, but how it was expressed in sound when used in religion by the Hebrew and other Semitic nations, amongst whom it was a sacred secret, or ineffable name, not lightly to be "taken in vain."
[3] Whilst these sheets were passing through the press, there appeared a work, published anonymously, but reported to be by one of the most esteemed theologians who ever sat upon an episcopal bench. It is entitled *Supernatural Religion.* London: Longmans, 1874. From it we quote the following, vol. ii., p. 489:—
"We gain infinitely more than we lose in abandoning belief in the reality of Divine Revelation. Whilst we retain pure and unimpaired the treasure of Christian Morality, we relinquish nothing but the debasing elements added to it by human superstition. We are no longer bound to believe a theology which outrages reason and moral sense. We are freed from base anthropomorphic views of God and His government of the universe; and from Jewish Mythology we rise to higher conceptions of an infinitely wise and beneficent Being, hidden from our finite minds, it is true, in the impenetrable glory of Divinity, but whose Laws of wondrous comprehensiveness and perfection we ever perceive in operation around us. We are no longer disturbed by visions of fitful interference with the order of Nature, but we recognise that the Being who regulates the universe is without variableness or shadow of turning. It is singular how little there is in the supposed Revelation of alleged information, however incredible, regarding that which is beyond the limits of human thought, but that little is of a character which reason declares to be the wildest delusion. Let no man whose belief in the reality of a Divine Revelation may be destroyed by such an inquiry complain that he has lost a precious possession, and that nothing is left but a blank. The Revelation not being a reality, that which he has lost was but an illusion, and that which is left is the Truth. If he be content with illusions, he will speedily be consoled; if he be a lover only of truth, instead of a blank, he will recognise that the reality before him is full of great peace.

"If we know less than we have supposed of man's destiny, we may at least rejoice that we are no longer compelled to believe that which is unworthy.

The limits of thought once attained, we may well be unmoved in the assurance that all that we do know of the regulation of the universe being so perfect and wise, all that we do not know must be equally so. Here enters the true and noble Faith—which is the child of reason. If we have believed a system, the details of which must at one time or another have shocked the mind of every intelligent man, and believed it simply because it was supposed to be revealed, we may equally believe in the wisdom and goodness of what is not revealed. The mere act of communication to us is nothing: Faith in the perfect ordering of all things is independent of Revelation.

"The argument so often employed by Theologians that Divine Revelation is necessary for man, and that certain views contained in that Revelation are required by our moral consciousness, is purely imaginary, and derived from the Revelation which it seeks to maintain. The only thing absolutely necessary for man is Truth and to that, and that alone, must our moral consciousness adapt itself."

[4] See Ezekiel xxii. 1-30, and compare Jerem. v. 7, 8.

Pagan and Christian Symbolism

Plate I.

This is taken from a photograph of a small bronze image in the Mayer collection of the Free Museum, in Liverpool. The figure stands about nine inches high, and represents Isis, Horus, and the fish. It is an apt illustration of an ancient custom, still prevalent amongst certain Christians, of reverencing a woman, said to be a virgin, giving suck to her child, and of the association of Isis, Venus, and Mary with the fish. Friday, for example, is, with the Romanists, both "fish day," and "dies Veneris." Fish are known to be extraordinarily prolific. There was a belief that animals, noted for any peculiarity, imparted their virtues to those who ate them; consequently, tigers' flesh was supposed to give courage, and snails to give sexual power. The use of fish in connubial feasts is still common. Those who consider it pious or proper to eat fish on Venus' day, or Friday, proclaim themselves, unconsciously, adherents to those heathen ideas which deified parts about which no one now likes to talk. The fish has in one respect affinity with the mandrake.

Since the first publication of this work, a friend has suggested to me another reason, besides its fertility, for the fish being emblematic of woman. From his extensive experience as a surgeon, and especially among the lower order of courtesans, he has repeatedly noticed during the hot months of the year that the parts which he had to examine have a very strong odour of fish. My own observations in the same department lead me to endorse his assertion. Consequently, I think that in warm climates, where the utmost cleanliness can scarcely keep a female free from odour, scent, as well as other attributes, has had to do with the selection of the fish as an emblem of woman.

Still further, I have been informed by another friend that in Yorkshire, and I understand in other counties of England, the *double entente* connected with the fish is so marked that it is somewhat difficult to render it into decent phraseology. It will suffice to say that in the county mentioned, Lais or Phryne would be spoken of as "a choice bit of fish," and that a man who bore on his features the stamp which is imprinted by excessive indulgence, would be said to have indulged too much in "a fish diet." I do not suppose that in the Yorkshire Ridings the folks are unusually well acquainted with mythology, yet it is curious to find amongst their inhabitants a connection between Venus and the Fish, precisely similar to that which has obtained in the most remote ages and in far distant climes.

It is clear from all these facts that the fish is a symbol not only of woman, but of the yoni.

PLATE II.

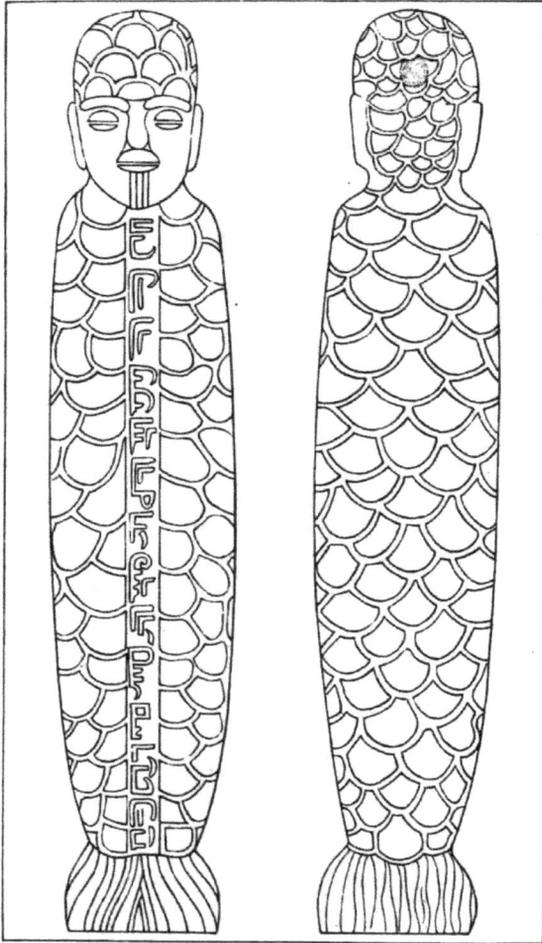

Plate II.

Is supposed to represent Oannes, Dagon, or some other fish god. It is cop-ied from Lajard, *Sur le Culte de Venus*, pl. xxii., 1, la, and is thus described, "Statuette inédite, de grès houiller ou micacé, d'un brun verdâtre. Elle porte par devant, sur une bande perpendiculaire, un légende en caractères Syri-aques très anciens (*Cabinet de M. Lambert, à Lyon*)." I can find no clue to the signification of the inscription. It would seem paradoxical to say that there is something in common between the bull-headed deity and Oannes. It is so, nevertheless. One indicates, *par excellence*, physical, and the other sexual, power. That Oannes may, for the Assyrians, represent a man who played a part with them similar to that of Penn among the Indians of Pennsylvania, I do not deny; but, when we find a similar fish-god in Philistia and Hindostan,

and know that Crishna once appeared as a fish, the explanation does not suffice. It is curious that Jesus of Nazareth should be called "a fish"; but this only proves that the religion of Christ has been adulterated by Paganism.

PLATE III.

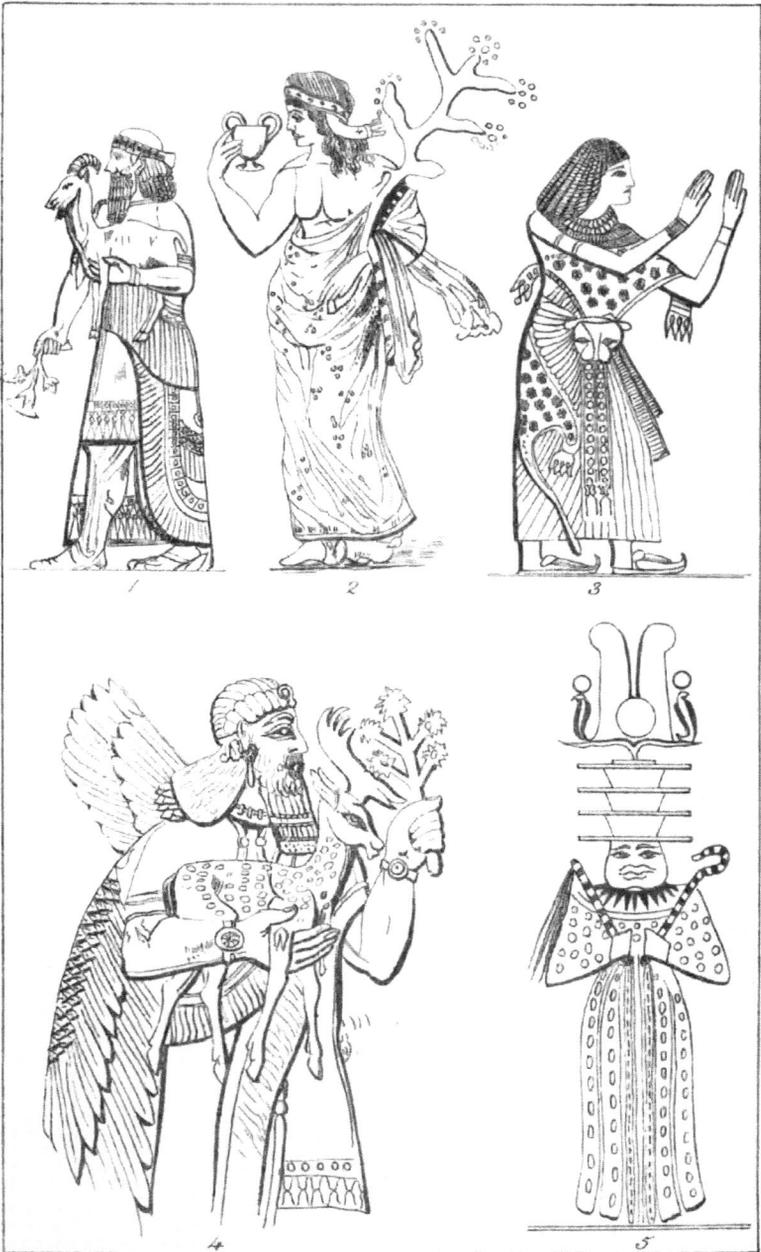

Plate III.

Figs. 1 and 4 are illustrations of the antelope as a religious emblem amongst the Assyrians. The first is from Layard's *Nineveh*, and in it we see carried in one hand a triply branched lotus; the second, showing the regard for the spotted antelope, and for "the branch," is from Bonomi's *Nineveh and its Palaces*.

Fig. 2 illustrates Bacchus, with a mystic branch in one hand, and a cup in the other; his robe is covered with spots arranged in threes. The branch is emblematic of the *arbor vitæ*, or tree of life, and its powers of sprouting. Such a symbol is, by outsiders, figured on the houses of newly married couples amongst the Jews of Morocco, and seems to indicate the desire of friends that the man will show that he is vigorous, and able to have many sprouts from the tree of life. It will be noticed that on the fillet round the god's head are arranged many crosses. From Hislop's *Two Babylons*, and Smith's *Dictionary*, p. 208.

Figs. 3 and 5 are intended to show the prevalence of the use of spots on priestly dresses; they are copied from Hislop's *Two Babylons*, and Wilkinson, vol. vi., pi. 88, and vol. iv., pp. 841, 858. For an explanation of the signification of spots, see Plate iv., Fig. 6, *infra*.

Plate IV.

Fig. 1 represents an Assyrian priest worshipping by presentation of the thumb, which had a peculiar signification. Sometimes the forefinger is pointed instead, and in both cases the male is symbolised. It is taken from a plate illustrating a paper by E. C. Ravenshaw, Esq., in *Journal of Royal Asiatic Society*, vol. xvi., p. 114. Amongst the Hebrews, and probably all the Shemitic tribes, *bohen*, the thumb, and *ezba*, the finger, were euphemisms. They are so in some parts of Europe to the present day. [1] The hand thus presented to the grove resembles a part of the Buddhist cross, and the shank of a key, whose signification is described in a subsequent page.

Fig. 2 is a Buddhist emblem; the two fishes forming the circle represent the mystic yoni, the sacti of Mahadeva, while the triad above them represents the mystic trinity, the triune father, Siva, Bel, or Asher, united with Anu and Hea. From *Journal of Royal Asiatic Society*, vol. xviii., p. 892, plate ii.

Fig. 3 is a very remarkable production. It originally belonged to Mons. Lajard, and is described by him in his second *Memoire*, entitled *Recherches sur le Culte, les Symboles, les Attributs, et les Monumens Figurés de Vénus* (Paris, 1837), in pages 32, *et seq.*, and figured in plate I., fig. 1. The real age of the gem and its origin are not known, but the subject leads that author to believe it to be of late Babylonian workmanship. The stone is a white agate, shaped like a cone, and the cutting is on its lower face. The shape of this gem indicates its dedication to Venus. The central figures represent the androgyne deity, Baalim, Astaroth, Elohim, Jupiter genetrix, or the bearded Venus Mylit-

ta. On the left side of the cutting we notice an erect serpent, whose rayed head makes us recognise the solar emblem, and its mundane representative, *mentula arrecta*; on a spot opposite to the centre of the male's body we find a lozenge, symbolic of the yoni, whilst opposite to his feet is the amphora, whose mystic signification may readily be recognised; it is meant for Ouranos, or the Sun fructifying Terra, or the earth, by pouring from himself into her.

PLATE IV.

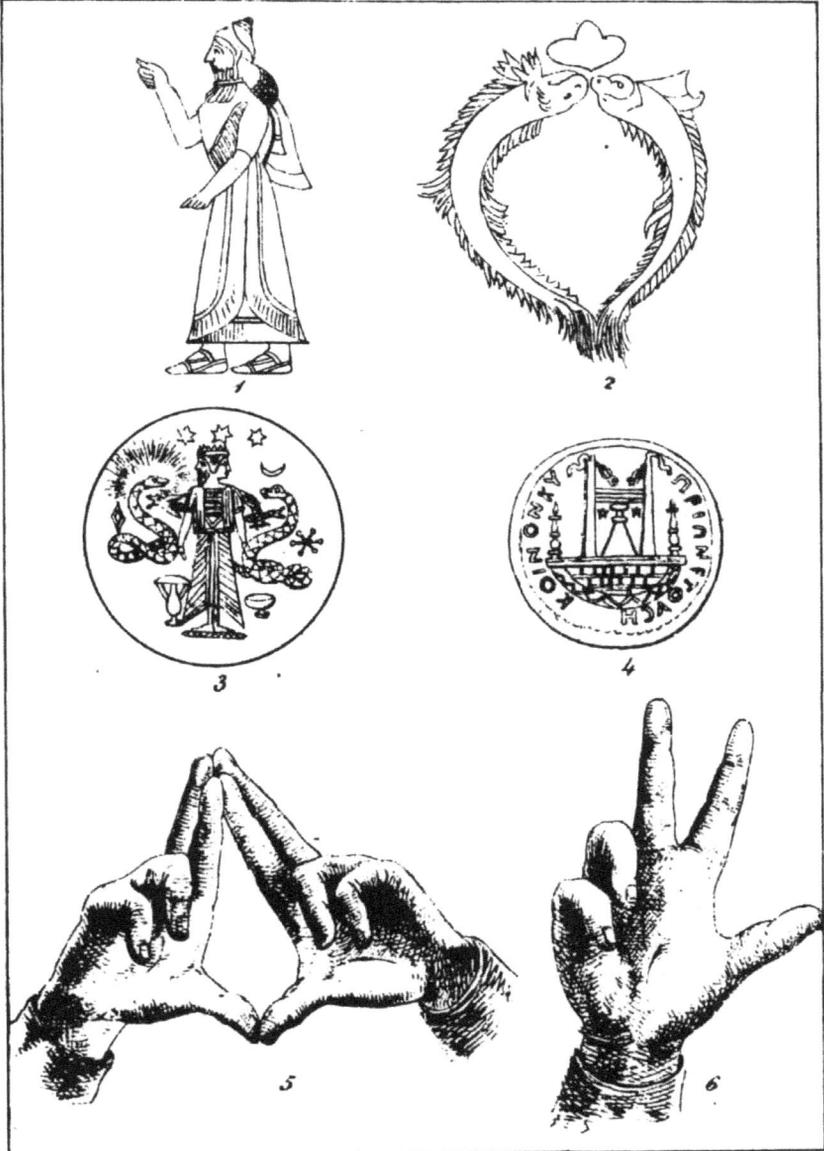

The three stars over the head of the figure, and the inverted triangle on its head, are representations of the mythological four, equivalent to the Egyptian symbol of life (figs. 31, 82). Opposite to the female are the moon, and another serpent, which may be recognised by physiologists as symbolic of *tensio clitoridis*. In a part corresponding to the diamond, on the left side, is a six-rayed wheel, emblematic, apparently, of the sun. At the female's feet is placed a cup, which is intended to represent the passive element in creation. As such it is analogous to the crescent moon, and is associated in the Roman church with the round wafer, the symbol of the sun; the wafer and cup thus being synonymous with the sun and moon in conjunction. It will be observed that each serpent in the plate is apparently attacked by what we suppose is a dragon. There is some difficulty in understanding the exact idea intended to be conveyed by these; my own opinion is that they symbolise Satan, the old serpent that tempted Eve, viz., fierce lust, Eros, Cupid, or desire, which, both in the male and female, brings about the arrectation which the serpents figure. It is not to be passed by without notice, that the snake which represents the male has the tail so curved as to suggest the idea of the second and third elements of the trinity. Monsieur Lajard takes the dragons to indicate the bad principle in nature, i. e., darkness, night, Ahriman, etc. On the pyramidal portion of the gem the four sides are ornamented by figures—three represent animals remarkable for their salacity, and the fourth represents Bel and Ishtar in conjunction, in a fashion which can be more easily imagined than described in the mother tongue. The learned will find the position assumed in Lucretius, *Dê Rerum Naturâ*, book iv., lines 1256, seq.

Fig. 4 is also copied from Lajard, plate i., fig. 10. It is the reverse of a bronze coin of Vespasian, struck in the island of Cyprus, and represents the conical stone, under whose form Venus was worshipped at Paphos, of which Tacitus remarks, Hist., ii., c. 8, "the statue bears no resemblance to the human form, but is round, broad at one end and gradually tapering at the other, like a goal. The reason of this is not ascertained." It is remarkable that a male emblem should be said to represent Venus, but the stone was an aerolite, like that which fell at Ephesus, and was said to represent Diana. It is clear that when a meteoric stone falls, the chief priests of the district can say that it is to be taken as a representative of their divinity.

My very ingenious friend, Mr. Newton, suggests that the Venus in question was androgyne; that the cone is a male emblem, within a door, gateway, or delta, thus resembling the Assyrian grove. It is certain that the serpents, the two stars, and the two candelabra, or altars with flame, favour his idea.

Fig. 5 represents the position of the hands assumed by Jewish priests when they give the benediction to their flock. It will be recognised that each hand separately indicates the trinity, whilst the junction of the two indicates the unit. The whole is symbolic of the mystic Arba—the four, i, e., the trinity and unity. One of my informants told me that, being a "cohen" or priest, he had often administered the blessing, and, whilst showing to me this method of benediction, placed his joined hands so that his nose entered the central ap-

erture. On his doing so, I remarked "*bene nasatus*," and the expression did more to convince him of the probability of my views than anything else.

PLATE V.

33

Fig. 6, modified in one form or another, is the position assumed by the hand and fingers, when Homan and Anglican bishops or other hierarchs give benediction to their people. A similar disposition is to be met with in Indian mythology, when the Creator doubles himself into male and female, so as to be in a position to originate new beings. Whilst the right hand in Plate VII. symbolises the male, the left hand represents the mystic feminine circle. In another plate, which is to be found in Moor's *Hindu Pantheon*, there is a similar figure, but draped fully, and in that the dress worn by the celestial spouse is covered with groups of spots arranged in triads and groups of four. With regard to the signification of spots, we may notice that they indicated, either by their shape or by their name, the emblem of womankind. A story of Indra, the Hindoo god of the sky, confirms this. He is usually represented as bearing a robe covered with eyes; but the legend runs that, like David, he became enamoured of the wife of another man, who was very beautiful and seen by chance, but her spouse was one whose austere piety made him almost equal to Brahma. The evil design of Indra was both frustrated and punished. The woman escaped, but the god became covered with marks that recalled his offence to mind, for they were pictures of the yoni. These, by the strong intercession of Brahma with the Rishi, were changed by the latter into eyes. This story enables us to recognise clearly the hidden symbolism of the Hindoo and Egyptian eye, the oval representing the female, and the circle the male lodged therein—i.e., the androgyne creator.

Plate V.

Is a copy of a mediæval Virgin and Child, as painted in Della Robbia ware in the South Kensington Museum, a copy of which, was given to me by my friend, Mr. Newton, to whose kindness I am indebted for many illustrations of ancient Christian art. It represents the Virgin and Child precisely as she used to be represented in Egypt, in India, in Assyria, Babylonia, Phoenicia, and Etruria; the accident of dress being of no mythological consequence. In the framework around the group, we recognise the triformed leaf, emblematic of Asher; the grapes, typical of Dionysus; the wheat ears, symbolic of Ceres, *l'abricot fendu*, the mark of womankind, and the pomegranate *rimmon*, which characterises the teeming mother. The living group, moreover, are placed in an archway, *delta*, or door, which is symbolic of the female, like the *vesica piscis*, the oval or the circle. This door is, moreover, surmounted by what appear to be snails, whose supposed virtue we have spoken of under Plate i. This identification of Mary with the Sacti is strong; by-and-by we shall see that it is as complete as it is possible to be made.

PLATE VI

Plate VI.

Is a copy of figures given in Bryant's *Ancient Mythology*, plates xiii., xxviii., third edition, 1807. The first two illustrate the story of Palemon and Getus, introducing the dolphin. That fish is symbolic of the female, in consequence of the assonance in Greek between its name and that of the womb, *delphis*

and *delphus*. The tree symbolises the *arbor vitæ*, the life-giving sprout; and the ark is a symbol of the womb. The third figure, where a man rests upon a rock and dolphin, and toys with a mother and child, is equally suggestive. The male is repeatedly characterised as a rock, hermes, menhir, tolmen, or upright stone, the female by the dolphin, or fish. The result of the junction of these elements appears in the child, whom both parents welcome. The fourth figure represents two emblems of the male creator, a man and trident, and two of the female, a dolphin and ship. The two last figures represent a coin of Apamea, representing Noah and the ark, called *Cibotus*. Bryant labours to prove that the group commemorates the story told in the Bible respecting the flood, but there is strong doubt whether the story was not of Babylonian origin. The city referred to was in Phrygia, and the coin appears to have been struck by Philip of Macedon. The inscription round the head is [—Greek inscription—]See *Ancient Faiths*, second edition, Vol. ii.., pp. 128, and 885-892.

The Supreme Spirit in the act of creation became two-fold; the RIGHT SIDE WAS MALE, THE LEFT WAS PRAKRITI, SHE IS OF ONE FORM WITH BRAMAH.

She is Maya, eternal and imperishable, such as the Spirit, such is the inherent energy. (The Sacti) as the Faculty burning is inherent in pure.

(Bramah Vaivartta Puranu, Professor Wilson.)

Plate VII.

Is a copy of an original drawing made by a learned Hindoo pundit for Wm. Simpson, Esq., of London, whilst he was in India studying its mythology. It represents Brahma supreme, who in the act of creation made himself double, i.e. male and female. In the original the central part of the figure is occupied by the triad and the unit, but far too grossly shown for reproduction here. They are replaced by the *crux ansata*. The reader will notice the triad and the serpent in the male hand, whilst in the female is to be seen a germinating seed, indicative of the relative duties of father and mother. The whole stands upon a lotus, the symbol of androgyneity. The technical word for this incarnation is "Arddha Nari."

Plate VIII.

Is Devi, the same as Parvati, or Bhavani. It is copied from Moor's *Pantheon*, plate xxx. The goddess represents the feminine element in the universe. Her forehead is marked by one of the symbols of the four creators, the triad, and the unit. Her dress is covered with symbolic spots, and one foot peculiarly placed is marked by a circle having a dot in the interior. The two bear the same signification as the Egyptian eye. I am not able to define the symbolic import of the articles held in the lower hands. Moor considers that they represent scrolls of paper, but this I doubt. The raised hands bear the unopened lotus flower, and the goddess sits upon another.

PLATE VII.

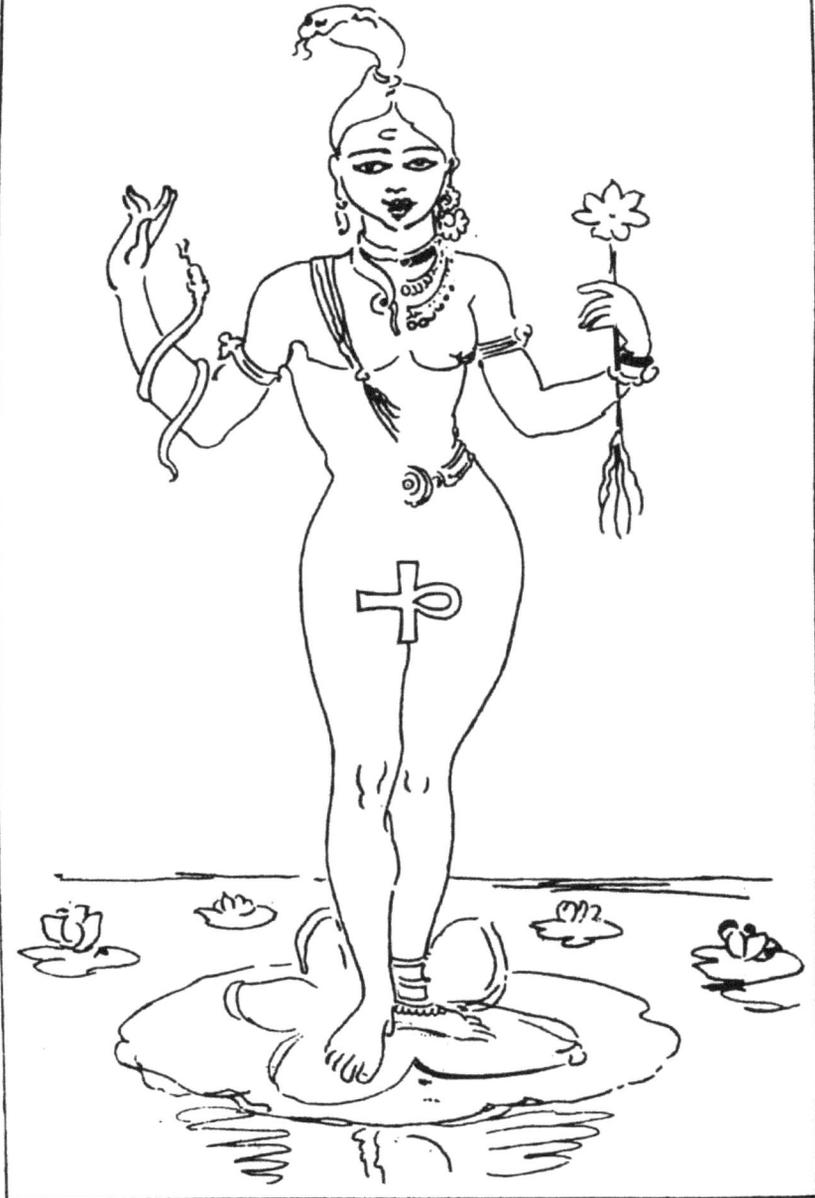

"THE SUPREME SPIRIT IN THE ACT OF CREATION BECAME, BY YOGA, TWO-FOLD, THE RIGHT SIDE WAS MALE, THE LEFT WAS PRAKRITI. SHE IS OF ONE FORM WITH BRAMAH. SHE IS MAYA, ETERNAL AND IMPERISHABLE, SUCH AS THE SPIRIT, SUCH IS THE INHERENT ENERGY, (THE SACTI) AS THE FACULTY OF BURNING IS INHERENT IN FIRE."

(BRAMAH VAIVARTTA PURANU, PROFESSOR WILSON.)

ARDANARI-ISWARA.

FROM AN ORIGINAL DRAWING BY CHRISHA SWAMI, PUNDIT.

PLATE VIII.

PLATE IX.

1

2

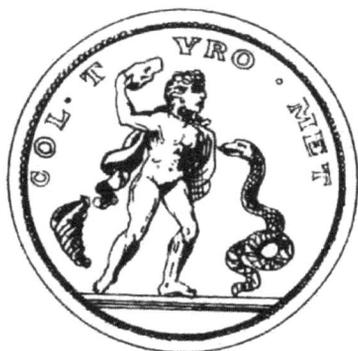

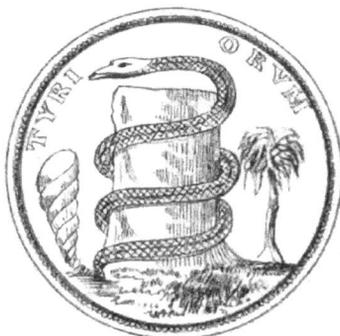

3

4

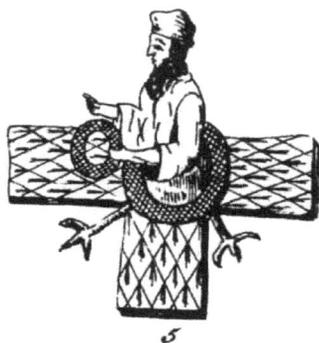

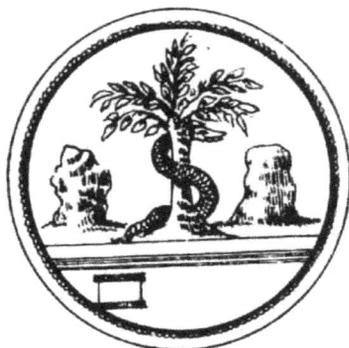

5

6

PLATE X.

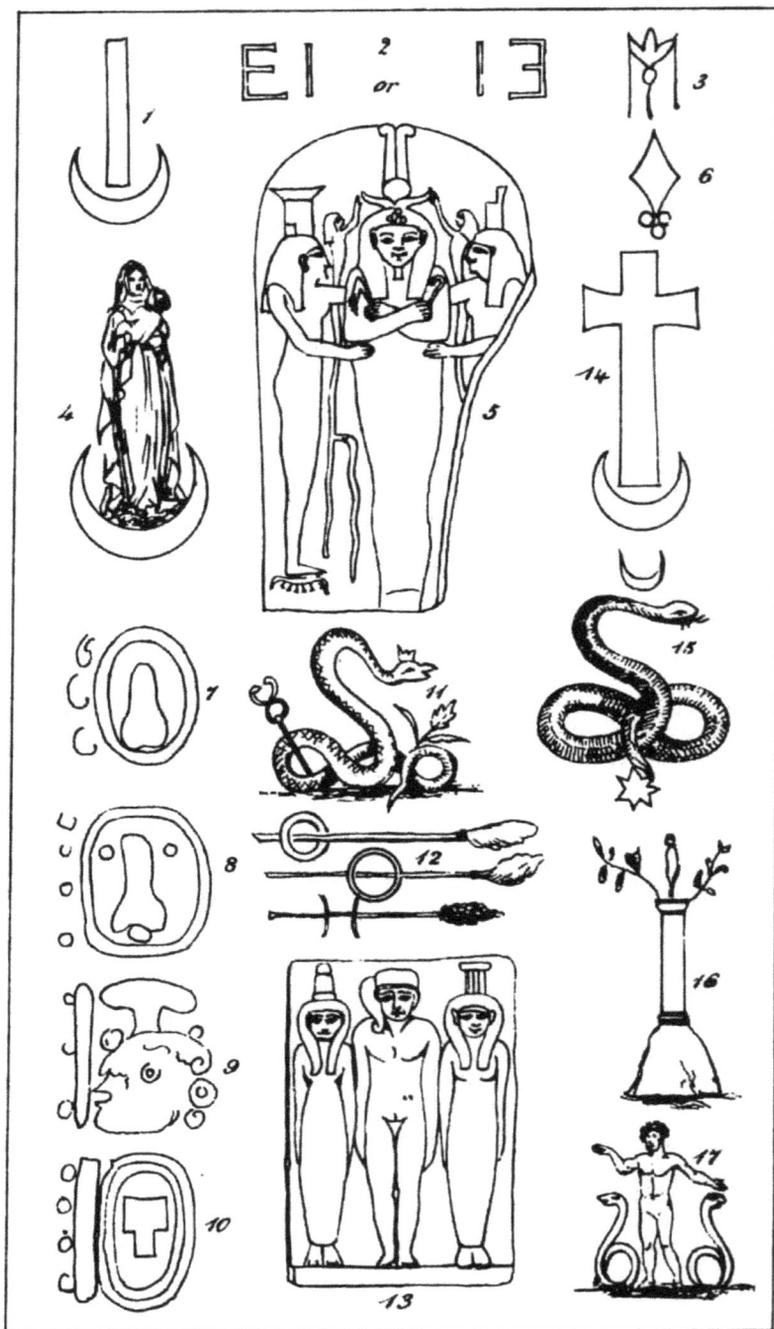

Plate IX.

Consists of six figures, copied from Maurice's *Indian Antiquities*, vol. vi., p. 278, and two from Bryant's *Mythology*, vol. ii., third edition, pp. 203 and 409. All are symbolic of the idea of the male triad: a central figure, erect, and rising above the other two. In one an altar and fire indicate, mystically, the linga; in another, the same is portrayed as a man, as Madaheva always is; in another, there is a tree stump and serpent, to indicate the same idea. The two appendages of the linga are variously described; in two instances as serpents, in other two as tree and *concha*, and snake and shell. The two last seem to embody the idea that the right "egg" of the male germinates boys, whilst the left produces girls; a theory common amongst ancient physiologists. The figure of the tree encircled by the serpent, and supported by two stones resembling "tolmen," is very significant. The whole of these figures seem to point unmistakably to the origin of the very common belief that the male Creator is triune. In Assyrian theology the central figure is Bel, Baal, or Asher; the one on the right Ann, that on the left Hea. See *Ancient Faiths*, second edition, Vol. i., pp. 88-85. [2]

There are some authors who have treated of tree and serpent worship, and of its prevalence in ancient times, without having, so far as I can see, any idea of that which the two things typify. The tree of knowledge, the tree of life, the serpent that tempted Eve, and still tempts man by his subtlety, are so many figures of speech which the wise understand, but which to the vulgar are simply trees and snakes. In a fine old bas-relief over the door of the Cathedral at Berne, we see an ancient representation of the last judgment. An angel is dividing the sheep from the goats, and devils are drawing men and women to perdition, by fixing hooks or pincers on the portions of the body whence their sins sprang. One fat priest, nude as our risen bodies must be, is being savagely pulled to hell by the part symbolised by tree and serpent, whilst she whom he has adored and vainly sought to disgrace, is rising to take her place amongst the blest. It is not those of the sex of Eve alone that are inveigled to destruction by the serpent.

Plate X.

Contains pagan symbols of the trinity or linga, with or without the unity or yoni.

Fig. 1 represents a symbol frequently met with in ancient architecture, etc. It represents the male and female elements, the pillar and the half moon.

Fig. 2 represents the mystic letters said to have been placed on the portal of the oracle of Delphi. By some it is proposed to read the two letters as signifying "he or she is;" by others the letters are taken to be symbolic of the triad and the unit. If they be, the pillar is a very unusual form for the yoni. An ingenious friend of mine regards the upright portion as a "slit," but I cannot

wholly agree with him, for in Fig. 1 the pillar cannot be looked upon as an aperture.

Fig. 3 is a Hindoo sectarial mark, copied from Moor's *Hindu Pantheon*, and is one out of many indicating the union of the male and female.

Fig. 4 is emblematic of the virgin and child. It identifies the two with the crescent. It is singular that some designers should unite the moon with the solar symbol, and others with the virgin. We believe that the first indicate ideas like that associated with Baalim, and Ashtaroth in the plural, the second that of Astarte or Venus in the singular. Or, as we may otherwise express it, the married and the immaculate virgin.

Fig. 5 is copied from Sharpe's *Egyptian Mythology*, p. 15. It represents one of the Egyptian trinities, and is highly symbolic, not only indicating the triad, here Osiris, Isis, and Nepthys, but its union with the female element. The central god Osiris is himself triune, as he bears the horns symbolic of the goddess Athor and the feathers of the god Ra.

Fig. 6 is a Hindoo sectarial mark, from Moor's *Hindu Pantheon*. The lozenge indicates the yoni. For this assertion we not only have evidence in Babylonian gems, copied by Lajard, but in Indian and Etruscan designs. We find, for example, in vol. v., plate xlv., of *Antiquités Etrusques*, etc., par. F. A. David (Paris, 1785), a draped female, wearing on her breast a half moon and mural crown, holding her hands over the middle spot of the body, so as to form a "lozenge" with the forefingers and thumbs. The triad in this figure is very distinct; and we may add that a trinity expressed by three balls or three circles is to be met with in the remotest times and in most distant countries.

Figs. 7, 8, 9 and 10 are copied from Cabrera's account of an ancient city discovered near Palenque, in Guatemala, Spanish America (London, 1822). Although they appear to have a sexual design, yet I doubt whether the similarity is not accidental. After a close examination of the plates given by Cabrera, I am inclined to think that nothing of the ling-yoni element prevailed in the mind of the ancient American sculptors. All the males are carefully draped in appropriate girdles, although in some a grotesque or other ornament, such as a human or bestial head, a flower, etc., is attached to the apron or "fall" of the girdle, resembling the sporran of the Highlander and the codpiece of mediæval knights and others. I may, however, mention some very remarkable sculptures copied; one is a tree, whose trunk is surrounded by a serpent, and whose fruit is shaped like the *vesica piscis*; in another is seen a youth wholly unclothed, save by a cap and gaiters, who kneels before a similar tree, being threatened before and behind by some fierce animal. This figure is peculiar, differing from all the rest in having an European rather than an American head and face. Indeed, the features, etc., remind me of the late Mr. Cobden, and the cap is such as yachting sailors usually wear. There is also another remarkable group, consisting apparently of a man and woman standing before a cross, proportioned like the conventional one in use amongst Christians. Everything indicates American ideas, and there are ornaments or designs wholly unlike any that I have seen elsewhere. The man

appears to offer to the cross a grotesque human figure, with a head not much unlike Punch, with a turned-up nose, and a short pipe shaped like a fig in his mouth. The body is well formed, but the arms and thighs are rounded off like "flippers" or "fins." Besting at the top of the cross is a bird, like a game cock, ornamented by a necklace. The male in this and the other sculptures is beardless, and that women are depicted, can only be guessed at by the inferior size of some of the figures. It would be unprofitable to carry the description farther.

Figs. 11, 12 are from vol. i., plates xix. and xxiii. of a remarkably interesting work, *Recherches sur l' origine, l' esprit, et les progrès des Arts de la Grèce*, said to be written by D'Harcanville, published at London, 1785. The first represents a serpent, coiled so as to symbolise the male triad, and the crescent, the emblem of the yoni.

Fig. 12 accompanies the bull on certain coins, and symbolises the sexual elements, *le baton et l'anneau*. They were used, as the horse-shoe is now, as a charm against bad luck, or vicious demons or fairies.

Fig. 13 is, like figure 5, from Sharpe's *Egyptian Mythology*, p. 14, and is said to represent Isis, Nepthys, and Osiris; it is one of the many Mizraite triads. The Christian trinity is of Egyptian origin, and is as surely a pagan doctrine as the belief in heaven and hell, the existence of a devil, of archangels, angels, spirits and saints, martyrs and virgins, intercessors in heaven, gods and demigods, and other forms of faith which deface the greater part of modern religions.

Figure 14 is a symbol frequently seen in Greek churches, but appears to be of pre-Christian origin. [3] The cross we have elsewhere described as being a compound male emblem, whilst the crescent symbolises the female element in creation.

Figure 15 is from D'Harcanville, *Op. Cit.*, vol. i., plate xxiii. It resembles Figure 11, *supra*, and enables us by the introduction of the sun and moon to verify the deduction drawn from the arrangement of the serpent's coils. If the snake's body, instead of being curved above the 8 like tail, were straight, it would simply indicate the linga and the sun; the bend in its neck, however, indicates the yoni and the moon.

Figure 16 is copied from plate xvi., fig. 2, of *Recueil de Pierres Antiques Gravés*, folio, by J. M. Raponi (Rome, 1786). The gem represents a sacrifice to Priapus, indicated by the rock, pillar, figure, and branches given in our plate. A nude male sacrifices a goat; a draped female holds a kid ready for immolation; a second man, nude, plays the double pipe, and a second woman, draped, bears a vessel on her head, probably containing wine for a libation.

Figure 17 is from vol. i. *Récherches*, etc., plate xxii. In this medal the triad is formed by a man and two coiled serpents on the one side of the medal, whilst on the reverse are seen a tree, surrounded by a snake, situated between two rounded stones, with a dog and a conch shell below. See *supra*, Plate ix., Fig. 6.

PLATE XI.

Plate XI.

With two exceptions, Figs. 4 and 9,—exhibits Christian emblems of the trinity or linga, and the unity or yoni, alone or combined; the whole being copied from Pugin's *Glossary of Ecclesiastical Ornament* (London, 1869).

Fig. 1 is copied from Pugin, plate xvii., and indicates a double union of the trinity with the unity, here represented as a ring, *l'anneau*.

Figs. 2, 8, are from Pagin, plate xiv. In figure 2, the two covered balls at the base of each limb of the cross are extremely significant, and if the artist had not mystified the free end, the most obtuse worshipper must have recognised the symbol. We may add here that in the two forms of the Maltese cross, the position of the lingam is reversed, and the egg-shaped bodies, with their cover, are at the free end of each limb, whilst the natural end of the organ is left unchanged. See figs. 85 and 86. This form of cross is Etruscan. Fig. 8 is essentially the same as the preceding, and both may be compared with Fig. 4. The balls in this cross are uncovered, and the free end of each limb of the cross is but slightly modified.

Fig. 4 is copied in a conventional form from plate xxxv., fig. 4, of *Two Essays on the Worship of Priapus* (London, 1865). It is thus described (page 147): "The object was found at St. Agati di Goti, near Naples.......It is a *crux ansata* formed by four phalli, with a circle of female organs round the centre; and appears by the look to have been intended for suspension. As this cross is of gold, it had no doubt been made for some personage of rank, possibly an ecclesiastic." We see here very distinctly the design of the egg- and sistrum-shaped bodies. When we have such an unmistakable bi-sexual cross before our eyes, it is impossible to ignore the signification of Figs. 2 and 8, and Plate xii., Figs. 4 and 7.

Figs. 5, 6 are from Pugin, plates xiv. and xv., and represent the trinity with the unity, the triune god and the virgin united in one.

Fig. 7 represents the central lozenge and one limb of a cross, figured plate xiv. of Pugin. In this instance the Maltese cross is united with the symbol of the virgin, being essentially the same as Fig. 9, *infra*. It is a modified form of the *crux ansata*.

Fig. 8 is a compound trinity, being the finial of each limb of an ornamental cross. Pugin, plate xv.

Fig. 9 is a well-known Egyptian symbol, borne in the hand of almost every divinity. It is a cross, with one limb made to represent the female element in creation. The name that it technically bears is *crux ansata*, or "the cross with a handle." A reference to Fig. 4 serves to verify the idea which it involves.

Fig. 10 is from Pugin, plate xxxv. In this figure the cross is made by the intersection of two ovals, each a *vesica piscis*, an emblem of the yoni. Within each limb a symbol of the trinity is seen, each of which is associated with the central ring.

Fig. 11 is from Pugin, plate xix., and represents the *arbor vitæ*, the *branch*, or tree of life, as a triad, with which the ring is united.

PLATE XII.

It has been said by some critics that the figures above referred to are mere architectural fancies, which never had pretensions to embody a mystery; and that any designer would pitch upon such a style of ornamentation although profoundly ignorant of the doctrine of the trinity and unity. But this assumption is not borne out by fact; the ornaments on Buddhist topes have nothing in common with those of Christian churches; whilst in the ruined temple of the sun at Marttand, India, the trefoil emblem of the trinity is common. Grecian temples were profusely ornamented therewith, and so are innumerable Etruscan sculptures, but they do not represent the trinity and unity. It has been reserved for Christian art to crowd our churches with the emblems of Bel and Astarte, Baalim and Ashtoreth, linga and yoni, and to elevate the phallus to the position of the supreme deity, and assign to him a virgin as a companion, who can cajole him by her blandishment, weary him by wailing, or induce him to change his mind by her intercessions. Christianity certainly requires to be purged of its heathenisms.

Plate XII.

Contains both pagan and Christian emblems.

Fig. 1 is from Pugin, plate xviii., and is a very common finial representing the trinity. Its shape is too significant to require an explanation; yet with such emblems our Christian churches abound, that the Trinity may never be absent from the minds of man or woman!

Fig. 2 is from Pugin, plate xxi. It is a combination of ideas concealing the union patent in Fig. 4, Plate xi., *supra*.

Fig. 3 is from Moor's *Hindu Pantheon*. It is an ornament borne by Devi, and symbolises the union of the triad with the unit.

Fig. 4 is from Pugin, plate xxxii. It is a double cross made up of the male and female emblems. It is a conventionalised form of Fig. 4, Plate xi., *supra*. Such eight-rayed figures, made like stars, seem to have been very ancient, and to have been designed to indicate the junction of male and female.

Fig. 5 is from Pugin, plate xvii., and represents the trinity and the unity.

Fig. 6 is a Buddhist emblem from Birmah, *Journal of Royal Asiatic Society*, vol. xviii., p. 392, plate i., fig. 62. It represents the short sword, *le bracquemard*, a male symbol.

Fig. 7. is from Pagin, plate xvii. See Plate xi., Fig. 3, *supra*.

Figs. 8, 9, 10, 11, 12 are Buddhist (see Fig. 6, supra), and symbolise the triad.

Figs. 13, 14, 15, 16, 17 are from Pugin, and simply represent the trinity.

Figs. 18 and 19 are common Grecian emblems. The first is associated with Neptune and water, the second with Bacchus. With the one we see dolphins, emblems of the womb, the name of the two being assonant in Greek; with the other, the saying, *sine Baccho et Cerere friget Venus*, must be coupled.

PLATE XIII.

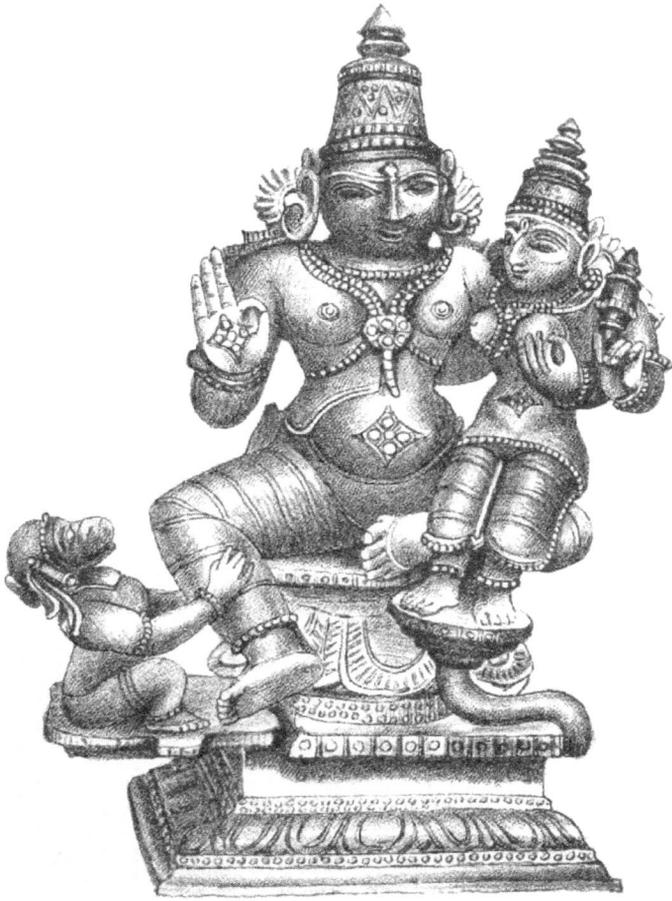

PLATE XIV.

PLATE XV.

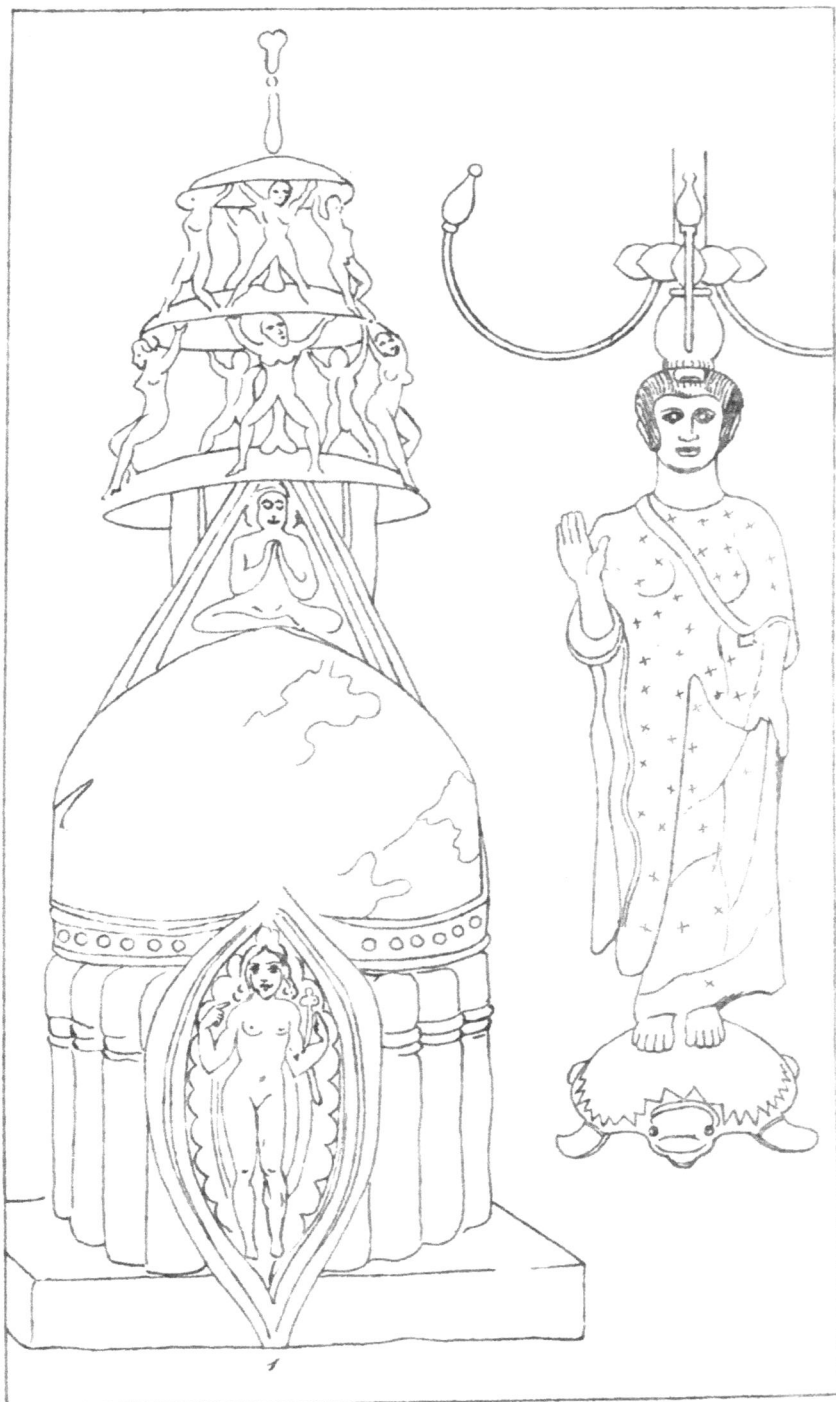

PLATE XVI.

Plate XIII.

Consists of various emblems of the triad and the unit, drawn almost exclusively from Grecian, Etruscan, Roman, and Indian gems, figures, coins, or sculptures, Maffei's *Gemme Antiche Figurate*, Raponi's *Recueil*, and Moor's *Hindu Pantheon*, being the chief authorities.

Plate XIV.

Is a copy of a small Hindoo statuette in the Mayer Collection in the Free Museum, Liverpool. It probably represents Parvati, the Hindoo virgin, and her child. The right hand of the figure makes the symbol of the yoni with the forefinger and thumb, the rest of the fingers typifying the triad. In the palm and on the navel is a lozenge, emblematic of woman. The child, perhaps Crishna, equivalent to the Egyptian Horus and the Christian Jesus, bears in its hand one of the many emblems of the linga, and stands upon a lotus. The monkey introduced into the group plays the same part as the cat, cow, lioness, and ape in the Egyptian mythology, being emblematic of that desire which eventuates in the production of offspring.

Plate XV.

Fig. 1, the cupola, is well known in modern Europe; it is equally so in Hindostan, where it is sometimes accompanied by pillars of a peculiar shape. In one such compound the design is that of a cupola, supported by closely placed pillars, each of which has a "capital," resembling "the glans" of physiologists; in the centre there is a door, wherein a nude female stands, resembling in all respects Figure 61, except in dress and the presence of the child. This was copied by the late Mr. Sellon, from a Buddhist Dagopa in the Jumnar Cave, Bombay Presidency, a tracing of his sketch having been given to me by William Simpson, Esq., London.

The same emblem may be found amongst the ancient Italians. Whilst I was staying in Malta during the carnival time in 1872, I saw in all directions men and women selling cakes shaped like the yoni shown in Fig. 1. These sweetmeats had no special name, but they came in and went out with the carnival.

Fig. 2 represents Venus standing on a tortoise, whose symbolic import will be seen by referring to Fig. 74, *infra*. It is copied from Lajard, *Sur le Culte de Venus*, plate iiia., fig. 5, and is stated by him to be a drawing of an Etruscan candelabrum, existing in the Royal Museum at Berlin. In his account of Greece, Pausanias mentions that he saw one figure of Venus standing on a tortoise, and another upon a ram, but he declines to give the reason of the conjunction.

Plate XVI.

Is a representation of Siva, taken from Moor's *Hindu Pantheon*, plate xiii. Siva is supposed to be the oldest of the Indian deities, and to have been worshipped by the aborigines of Hindostan, before the Aryans invaded that country. It is thought that the Vedic religion opposed this degrading conception at the first, but was powerless to eradicate it. Though he is yet the most popular of all the gods, Siva is venerated, I understand, chiefly by the vulgar. Though he personifies the male principle, there is not anything indecent in pictorial representations of him. In one of his hands is seen the trident, one of the emblems of the masculine triad; whilst in another is to be seen an oval sistram-shaped loop, a symbol of the feminine unit. On his forehead he bears an eye, symbolic of the Omniscient, the sun, and the union of the sexes.

As it has been doubted by some readers, whether I am justified in regarding the sistrum as a female emblem, I append here a quotation from Socrates' *Ecclesiastical History*, Bohn's translation, p. 281, seq. In Rome, in the early time of Theodosius, "when a woman was detected in adultery.... they shut her up in a narrow brothel, and obliged her to prostitute herself in a most disgusting manner; causing little bells to be rang at the time.... As soon as the emperor was apprised of this indecent usage, he would by no means tolerate it; but having ordered the *Sistra* (for so these places of penal prostitution were denominated) to be pulled down," &c. One can as easily see why a female emblem should mark a brothel in Rome as a male symbol did at Pompeii.

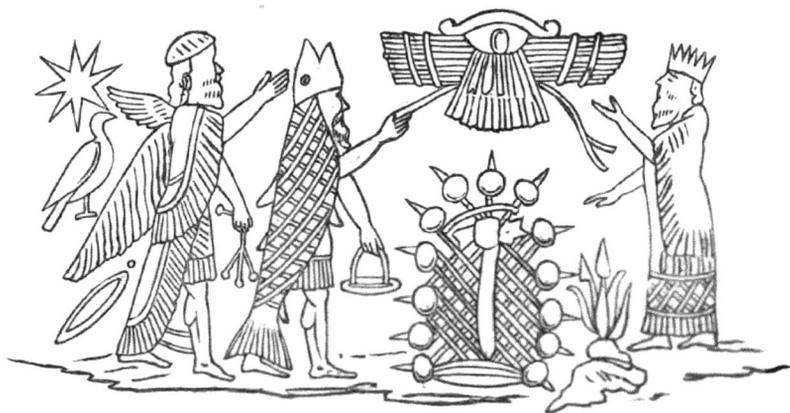

Figure 1.

This Figure represents Assyrian priests offering in the presence of what is supposed to be Baal—or the representative of the sun god and of the grove. The first is typified by the eye, with wings and a tail, which make it symbolic of the male triad and the female unit. The eye, with the central pupil, is in

itself emblematic of the same. The grove represents mystically *le verger de Cypris*. On the right stands the king; on the left are two priests, the foremost clothed with a fish's skin, the head forming the mitre, thus showing the origin of modern Christian bishops' peculiar head-dress. Arranged about the figures are, the sun; a bird, perhaps the sacred dove, whose note, *coa* or *coo*, has, in the Shemitic, some resemblance to an invitation to amorous gratification; in Latin *coi, coite*; the oval, symbol of the yoni; the basket, or bag, emblematic of the scrotum, and apparently the lotus. The trinity and unity are carried by the second priest.

Figure 2 is copied from an ancient copper vase, covered with Egyptian hieroglyphic characters, found at Cairo, and figured in a book entitled *Explication des divers monument singuliers, qui ont rapport à la religion des plus anciens peuples*, par le R. P. Dom.......á Paris, 1739.

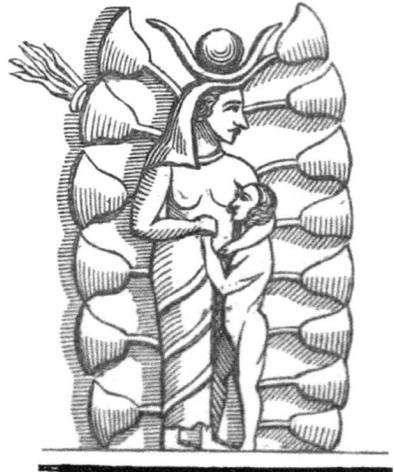

Figure 2.

The group of figures represents Isis and Horus in an unusual attitude. They are enclosed in a framework of the flowers of the Egyptian bean, or of the lotus. This framework may be compared to the Assyrian "grove," and another in which the Virgin Mary stands. The bell was of old a symbol of virginity, for Eastern maidens wore them until marriage (see Isa. iii. 16). The origin of this custom was the desire that every maiden should have at her marriage, or sale, that which is spoken of in the Pentateuch as "the token of virginity." It was supposed that this membrane, technically called "the *hymen*" might be broken by too long a stride in walking or running, or by clambering over a stile or wall. To prevent such a catastrophe, a light chain or cord was worn, under or over the dress, at the level of the knees or just above. Its length only permitted a short step and a mincing gait. Slight bells were used as a sort of ornament, and when the bearer was walking their tinkling was a sort of proclamation that the lady who bore them was in the market as a virgin. After "the flower" had been plucked, the bells were no longer of use. They were analogous to the virgin snood worn on the head of Scotch maidens. Isis bears the horns of a cow, because that animal is equally noted for its propensity to seek the male and its care to preserve the offspring. As the bull with a human head, so a human being with cow's horns, was made to represent a deity. The solar orb between the horns, and the serpent round the body, indicate the union with the male; an incongruous conjunction with the emblem of the sacred Virgin, nevertheless a very common one. In some of the coins pictured by E. P. Knight, in *Worship of Priapus*, etc., a cow caressing her sucking calf

replaces Isis and Horus, just as a bull on other coins replaces Dionysus. The group is described in full in *Ancient Faiths*, second edition, Vol. i., pp. 53, 54.

Figure 3.

Figure 4

Figures 3, 4, are taken from Ginsburg's *Kabbalah*, and illustrate that in the arrangement of "potencies" two unite, like parents, to form a third. Sometimes we see also how three such male attributes as splendour, firmness, and solidity join with beauty to form the mystic *arba*, the trinity and unity.

Figures 5, 6, are copies from figures found in Carthage and in Scotland, from Forbes Leslie's Early *Races of Scotland*, vol. i., plate vi., p. 46 (London, 1866). This book is one to which the reader's attention should be directed. The amount of valuable information which it contains is very large, and it is classified in a philosophical, and, we may add, attractive manner. The figures represent the *arbor vitæ*.

Figure 5. **Figure 6.**

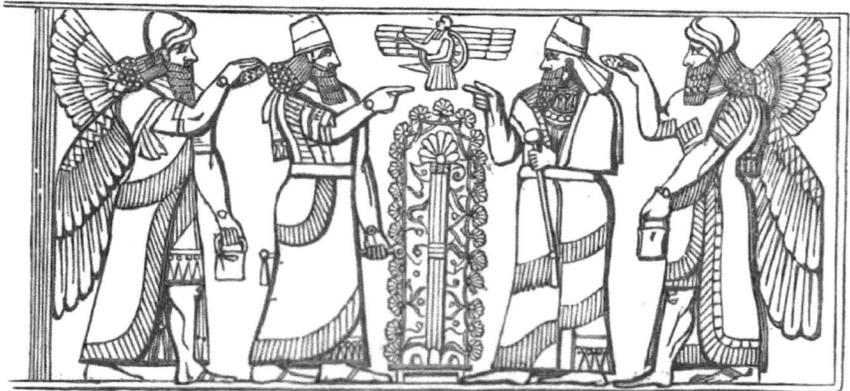

Figure 7.

Figure 7 is from Bonomi, page 292, *Nineveh and its Palaces* (London, 1865). It apparently represents the mystic yoni, door, or delta; and it may be regarded as an earlier form of the framework in Plate iv. It will be remarked, by those learned in symbols, that the outline of the hands of the priests who are nearest to the figure is a suggestive one, being analogous to the figure of a key and its shank, whilst those who stand behind these officers present the pine cone and bag, symbolic of Ann, Hea, and their residence.

It is to be noticed, and once for all let us assert our belief, that every detail in a sculpture relating to religion has a signification; that the first right hand figure carries a peculiarly shaped staff; and that the winged symbol above the yoni consists of a male archer in a winged circle, analogous to the symbolic bow, arrow, and target. The bow was an emblem amongst the Romans, and *arcum tendere* was equivalent to *arrigere*. In the *Golden Ass* of Apuleius we find the metaphor used in his account of his dealings with amorous frolicsome Fotis, "Ubi primam sagittam sævi cupidinis in ima procordia mea delapsam excepi, *arcum* meum et ipse vigore *tetendi*."

Again, we find in Petronius—

Astra igitur mea mens *arcum* dum *tendit* in ilia.
Ex imo ad summum viva sagitta volat.

Figures 8 to 14 are representations of the goddess mother, the virgin and child, Ishtar or Astarte, Mylitta, Ceres, Rhea, Venus, Sacti, Mary, Yoni, Juno, Mama Ocello.

Fig. 8 is a copy of the deified woman or celestial mother, from Idalium, in Cyprus. Fig. 9 is from Egypt, and is remarkable for the cow's horns (for whose signification see Vol. i., p. 54, Ancient Faiths, second edition), which here replace the lunar crescent, in conjunction with the sun, the two being symbolic of hermaphroditism, whilst above is a seat or throne,

 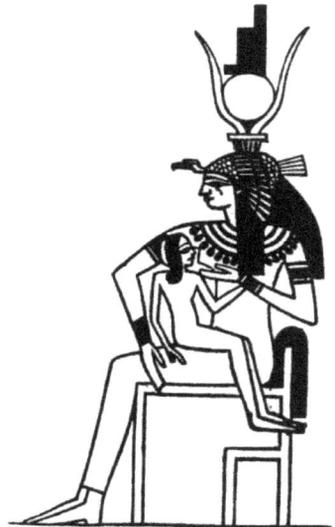

Figure 8. **Figure 9.**

emblematic of royalty. The two figures are copied from Rawlinson's *Herodotus*, vol. ii., p. 447, in an essay by Sir Gardiner Wilkinson, wherein other illustrations of the celestial virgin are given. Fig. 10 is a copy of plate 59, Moor's Hindu Pantheon, wherein it is entitled, "Crishna nursed by Devaki, from a highly finished picture." In the account of Crishna's birth and early history, as given by Moor (Op. Cit., pp. 197, et seq.), there is as strong a resemblance to the story of Christ as the picture here described has to papal paintings of Mary and Jesus. Fig. 11 is an enlarged representation of Devaki. Fig. 12 is copied from Rawlinson's *Ancient Monarchies*, vol. iii., p. 899. Fig. 13 is a figure of the mother and child found in ancient Etruria at Volaterra; it is depicted in Fabretti's Italian Glossary, plate xxvi., figure 349.

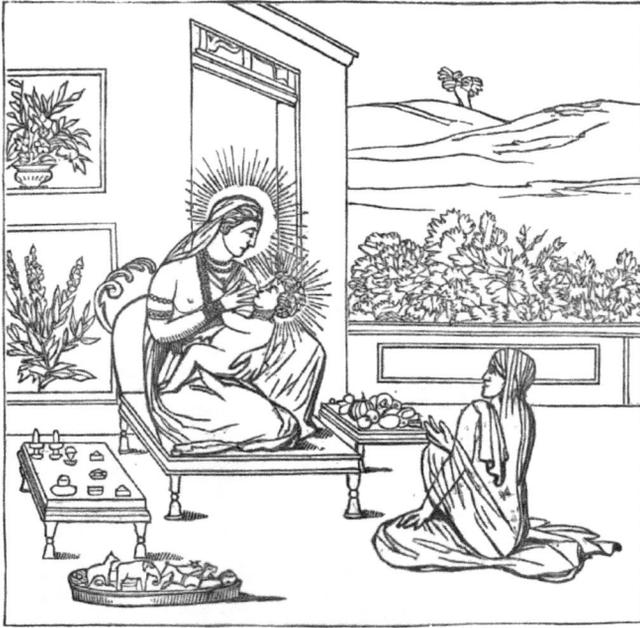

Figure 10.

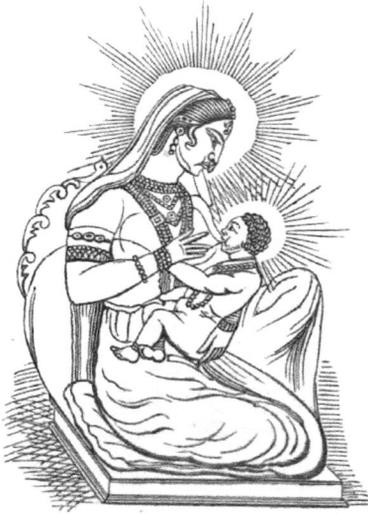

Figure 11.

Figure 12.

Figure 13.

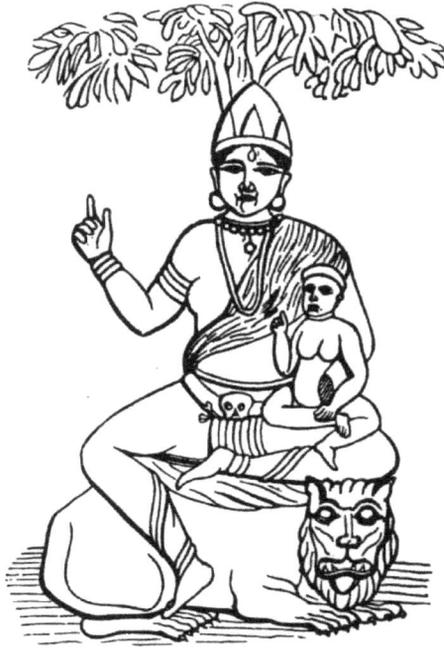

Figure 14.

It is described as a marble statue, now in the Guarnacci Museum. The letters, which are Etruscan, and read from right to left, may be thus rendered into the ordinary Latin characters from left to right, MI: GANA: LARTHIAS ZANL: VELKINEI: ME - SE.; the translation I take to be, "the votive offering of Larthias (a female) of Zanal, (= Zancle = Messana in Sicily), (wife) of Velcinius, in the sixth month." It is uncertain whether we are to regard the statue as an effigy of the celestial mother and child, or as the representation of some devout lady who has been spared during her pregnancy, her parturition, or from some disease affecting herself and child. Analogy would lead us to infer that the Queen of Heaven is intended. Figure 14 is copied from Hislop's *Two Babylons*; it represents Indranee, the wife of Indra or Indur, and is to be found in Indur Subba, the south front of the Caves of Ellora, Asiatic Researches, vol. vi., p. 893.

Indra is equivalent to Jupiter Tonans, and is represented as seated on an elephant; "the waterspout is the trunk of this elephant, and the iris is his bow, which it is not auspicious to point out," Moor's *Pantheon*, p. 260. He is represented very much as if he were a satyr, Moor's *Pantheon*, p. 264; but his wife is always spoken of as personified chastity and propriety. Indranee is seated on a lioness, which replaces the cow of Isis, the former resembling the latter in her feminine and maternal instincts.

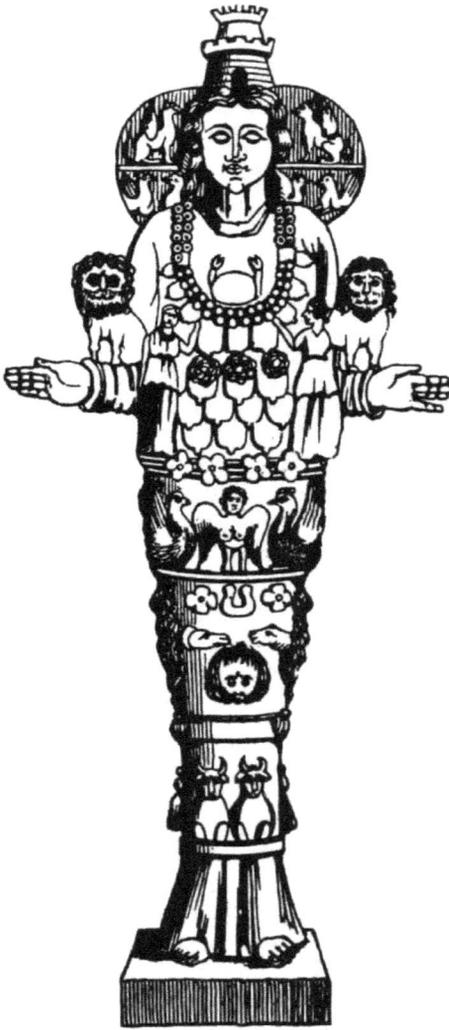
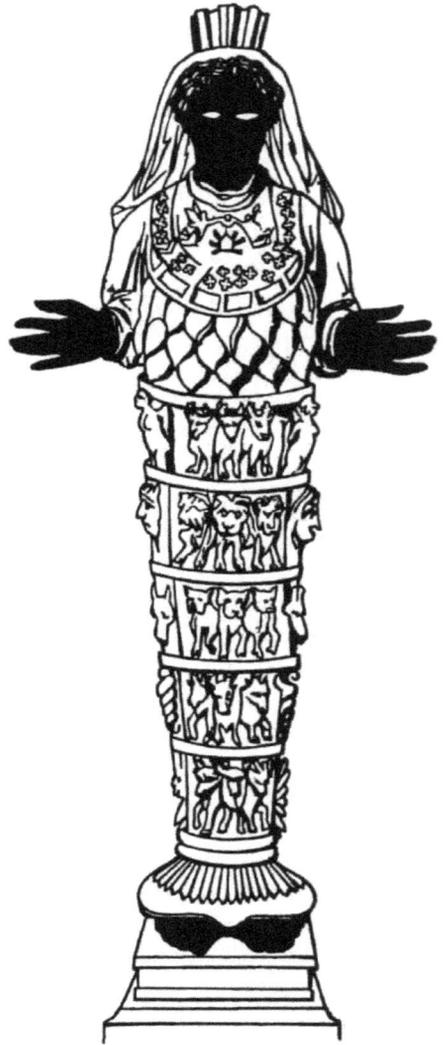



Figure 15. **Figure 16.**



Figures 15, 16, are copies of Diana of the Ephesians; the first is from Hislop, who quotes Kitto's *Illustrated Commentary*, vol. v., p. 250; the second from Higgins' *Anacalypsis*, who quotes Montfauçon, plate 47. I remember to have seen a figure similar to these in the Royal Museum at Naples.

The tower upon the head represents virginity (see *Ancient Faiths*, second edition, Vol. i., p. 144); the position of the hand forms a cross with the body: the numerous breasts indicate abundance; the black colour of Figure 16 indicates the ordinary tint of the feminine *lanugo*, the almost universal colour of the hair of the Orientals being black about the yoni as well as on the head; or, as some mythologists imagine, "Night," who is said to be one of the mothers of creation. (See *Ancient Faiths*, second edition, Vol. II., p. 882.) The emblems

upon the body indicate the attributes or symbols of the male and female creators.

Figure 17.

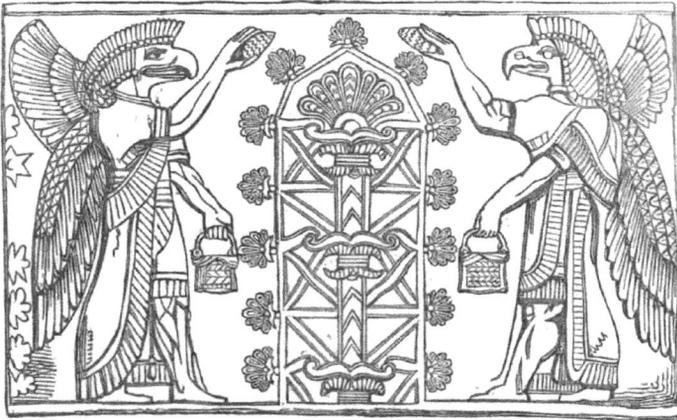

Figure 18.

Figure 17 is a complicated sign of the yoni, delta, or door of life. It is copied from Bonomi's *Palaces of Nineveh*, p. 809.

Figure 18 signifies the same thing; the priests adoring it present the pine cone and basket, symbolic of Ann, Hea, and their residence. Compare the object of the Assyrian priest's adoration with that adored by a Christian divine, in a subsequent figure. (See *Ancient Faiths*, second edition, Vol. I., p. 83, *et seq., and* Vol. II., p. 648.)

Figure 19 is copied from Lajard (Op. Cit.), plate xxii., fig. 5. It is the impression of an ancient gem, and represents a man clothed with a fish, the head being the mitre; priests thus clothed, often bearing

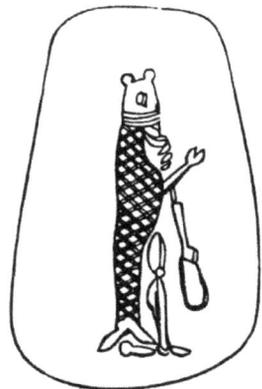

Figure 19.

in their hand the mystic bag, are common in Mesopotamian sculptures; two

such are figured on Figs. 63, 64, *infra.* In almost every instance it will be recognised that the fish's head is represented as of the same form as the modern bishop's mitre.

Figure 20 represents two equilateral triangles, infolded so as to make a six-rayed star, the idea embodied being the androgyne nature of the deity, the pyramid with its apex upwards signifying the male, that with the apex downwards the female. The line at the central junction is not always seen, but the shape of the three parallel bars reappears in Hindoo frontlet signs in conjunction with a delta or door, shaped like the "grove" in Fig. 17; thus showing that the lines serve also to indicate the masculine triad. The two triangles are also understood as representing fire,

Figure 20.

which mounts upwards, and water, which flows downwards. Fire again is an emblem of the sun, and water of the passive or yielding element in nature. Fire also typifies Eros or Cupid. Hymen is always represented carrying a torch. It is also symbolic of love; *e.g.,* Southey writes.

"But love is indestructible,
 Its holy flame for ever burneth;
 From heaven it came,
 To heaven returneth."

And again, Scott writes—

"It is not phantasy's hot fire
 Whose wishes, soon as granted, fly," &c.

Figures 21, 22, are other indications of the same fundamental idea. The first represents Nebo, the Nahbi, or the navel, characterised by a ring with a central

Figure 21.

Figure 22.

mound. The second represents the circular and upright stone so common in Oriental villages. The two indicate the male and female; and a medical friend resident in India has told me, that he has seen women mount upon the lower stone and seat themselves reverently upon the upright one, having first adjusted their dress so as to prevent it interfering with their perfect contact with the miniature obelisc. During the sitting, a short prayer seemed flitting over the worshippers' lips, but the whole affair was soon over.

62

Whilst upon this subject, it is right to call attention to the fact that animate as well as inorganic representatives of the Creator have been used by women with the same definite purpose. The dominant idea is that contact with the emblem, a mundane representative of the deity, of itself gives a blessing. Just as many Hindoo females seek a benefaction by placing their own yoni upon the consecrated linga, so a few regard intercourse with certain high priests of the Maharajah sect as incarnations of Vishnu, and pay for the privilege of being spouses of the god. In Egypt, where the goat was a sacred animal, there were some religious women who sought good luck by uniting themselves therewith. We have heard of British professors of religion endeavouring to persuade their penitents to procure purity by what others would call defilement and disgrace. And the "cord of St. Francis" replaces the stone "linga." Sometimes with this "cord" the rod is associated; and those who have read the trial of Father Gerard, for his seduction of Miss Cadiére under a saintly guise, will know that Christianity does not always go hand in hand with propriety.

With the Hindoo custom compare that which was done by Liber on the grave of Prosumnus (*Arnobius adverma Gentes*, translated by Bryce and Campbell, T. and T. Clark, Edinburgh, pp. 252, 258), which is far too gross to be described here; and as regards the sanctity of a stone whose top had been anointed with oil, see first sentence of paragraph 89, ibid, page 81. The whole book will well repay perusal.

Figure 23. **Figure 24.**

Figures 23, 24, are discs, circles, aureoles, and wheels, to represent the sun. Sometimes the emblem of this luminary is associated with rays, as in Plate iii., Fig. 8, and in another Figure elsewhere. Occasionally, as in some of the ancient temples in Egypt discovered in 1854, the sun's rays are represented by lines terminating in hands. Sometimes one or more of these contain objects as if they were gifts sent by the god; amongst other objects, the *crux ansata* is shown conspicuously. In a remarkable plate in the Transactions of the *Royal Society of Literature* (second series, vol. i., p. 140), the sun is identified with the serpent; its rays terminate in hands, some holding the handled cross or *tau*, and before it a queen, apparently, worships. She is offering what seems to be a lighted tobacco pipe, the bowl being of the same shape as that

commonly used in Turkey; from this a wavy pyramid of flame rises. Behind her, two female slaves elevate the sistrum; whilst before her, and apparently between herself and her husband, are two altars occupied by round cakes and one crescent-shaped emblem. The aureole was used in ancient days by Babylonian artists or sculptors, when they wished to represent a being, apparently human, as a god. The same plan has been adopted by the moderns, who have varied the symbol by representing it now as a golden disc, now as a terrestrial orb, again as a rayed sphere. A writer, when describing a god as a man, can say that the object he sketches is divine; but a painter thinks too much of his art to put on any of his designs, "this woman is a goddess," or "this creature is a god"; he therefore adds an aureole round the head of his subject, and thus converts a very ordinary man, woman, or child into a deity to be reverenced; modern artists thus proving themselves to be far more skilful in depicting the Almighty than the carpenters and goldsmiths of the time of Isaiah (xl. 18, 19, xli. 6, 7, xliv. 9-19), who used no such contrivance.

Figure 24 is another representation of the solar disc, in which it is marked with a cross. This probably originated in the wheel of a chariot having four spokes, and the sun being likened to a charioteer. The chariots of the sun are referred to in 2 Kings xxiii. 11 as idolatrous emblems. Of these the wheel was symbolic. The identification of this emblem with the sun is very easy, for it has repeatedly been found in Mesopotamian gems in conjunction with the moon. In a very remarkable one figured in Rawlinson's *Ancient Monarchies*, vol. ii., p. 249, the cross is contrived as five circles. It is remarkable that in many papal pictures the wafer and the cup are depicted precisely as the sun and moon in conjunction. See Pugin's *Architectural Glossary*, plate iv., fig. 5.

Figure 25.

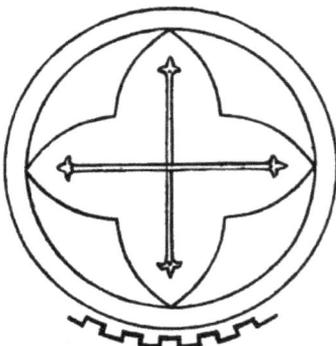

Figure 26.

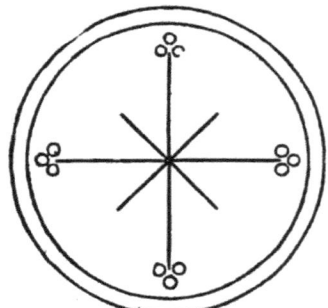

Figure 27.

Figures 25, 26, 27, are simply varieties of the solar wheel, intended to represent the idea of the sun and moon, the mystic triad and unit, the "arba," or

four. In Figure 26, the mural ornament is introduced, that being symbolic of feminine virginity. For explanation of Figure 27, see Figures 85, 86.

Figure 28.

Figure 28 is copied from Lajard, Op. Cit., plate xiv. F. That author states that he has taken it from a drawing of an Egyptian stèle, made by M. E. Prisse (*Monum. Egypt.*, plate xxxvii.), and that the original is in the British Museum. There is an imperfect copy of it in Rawlinson's *Herodotus*, vol. ii.

The original is too indelicate to be represented fully. Isis, the central figure, is wholly nude, with the exception of her head-dress, and neck and breast ornaments. In one hand she holds two blades of corn apparently, whilst in the other she has three lotus flowers, two being egg-shaped, but the central one fully expanded; with these, which evidently symbolise the mystic triad, is associated a circle emblematic of the yoni, thus indicating the fourfold creator. Isis stands upon a lioness; on one side of her stands a clothed male figure, holding in one hand the *crux ansata*, and in the other an upright spear. On the opposite side is a male figure wholly nude, like the goddess, save his head-dress and collar, the ends of which are arranged so as to form a cross. His hand points to a flagellum; behind him is a covert reference to the triad, whilst in front Osiris offers undisguised homage to Isis. The head-dress of the goddess appears to be a modified form of the crescent moon inverted. It is not exclusively Egyptian, as it has been found in conjunction with other emblems on an Assyrian obelisc of Phallic form.

Figures 29, 30, 31, 32, represent the various triangles and their union, which have been adopted in worship. Figure 29 is said to represent fire, which amongst the ancient Persians was depicted as a cone, whilst the figure inverted represents water.

Figure 33 is an ancient Hindoo emblem, called Sri Iantra. The circle represents the world, in which the living exist; the triangle pointing upwards shows the male creator; and the triangle with the apex downwards the female; distinct, yet united. These have a world within themselves, in which the male is uppermost. In the central circle the image to be worshipped is placed. When used, the figure is placed on the ground, with Brahma to the east, and Laksmi to the west. Then a relic of any saint, or image of Buddha, like a modern papal crucifix, is added, and the shrine for worship is complete. It has now been adopted in Christian churches and Freemasons' lodges.

It will be noticed that the male emblem points to the rising sun, and the female triangle points to the setting sun, when the earth seems to receive the god into her couch.

Figure 29.

Figure 30.

Figure 31.

Figure 32.

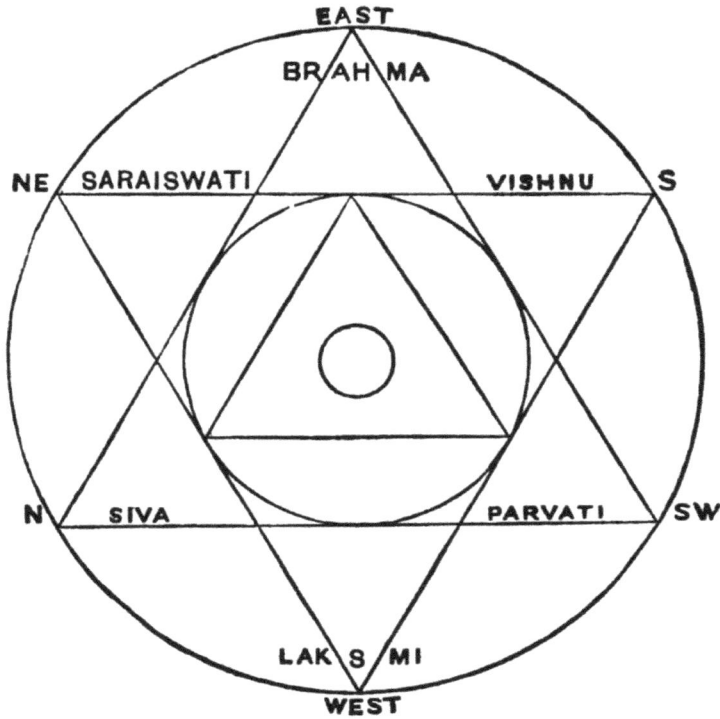

Figure 33.

Figure 34 is a very ancient Hindoo emblem, whose real signification I am unable to divine. It is used in calculation; it forms the basis of some game, and it is a sign of vast import in sacti worship.

A coin, bearing this figure upon it, and having a central cavity with the Etruscan letters SUPEN placed one between each two of the angles, was found in a fictile urn, at Volaterræ, and is depicted in Fabretti's *Italian Glossary*, plate xxvi., fig. 358, *bis a*. As the coin is round, the reader will see that these letters may be read as Supen, Upens, Pensu, Ensup, or Nsupe. A search through Fabretti's *Lexicon* affords no clue to any meaning except for the third. There seems, indeed, strong reason to believe that *pensu* was the Etruscan form of the Pali *panca*, the Sanscrit *pânch*, the Bengalli *pânch*, and the Greek *penta*, i. e., five. Five, certainly, would be an appropriate word for the pentangle. It is almost impossible to avoid speculating upon the value of this fragment of archæological evidence in support of the idea that the Greeks, Aryans, and Etruscans had something in common; but into the question it would be unprofitable to enter here.

Figure 34.

But, although declining to enter upon this wide field of inquiry, I would notice that whilst searching Fabretti's *Glossary* my eye fell upon the figure of an equilateral triangle with the apex upwards, depicted plate xliii., fig. 2440 *ter.* The triangle is of brass, and was found in the territory of the Falisci. It bears a rude representation of the outlines of the soles of two human feet, in this respect resembling a Buddhist emblem; and there is on its edge an inscription which may be rendered thus in Roman letters, KAYI: TERTINEI. POSTIKNU, which probably signifies "Gavia, the wife of Tertius, offered it."

The occurrence of two Hindoo symbols in ancient Italy is very remarkable. It must, however, be noticed that similar symbols have been found on ancient sculptured stones in Ireland and Scotland. There may be no emblematic ideas whatever conveyed by the design; but when the marks appear on Gnostic gems, they are supposed to indicate death, *i.e.,* the impressions left by the feet of the individual as he springs from earth to heaven.

Figure 35.

Figure 36.

Figures 35, 36, are Maltese crosses. In a large book of Etrurian antiquities, which came casually under my notice about twenty years ago, when I was endeavouring to master the language, theology, etc., of the Etruscans, but whose name, and other particulars of which, I cannot now remember; I found depicted two crosses, made up of four masculine triads, each *asher* being erect, and united to its fellows by the gland, forming a central diamond, emblem of the yoni. In one instance, the limbs of the cross were of equal length; in the other, one *asher* was three times as long as the others. A somewhat similar cross, but one united with the circle, was found some time ago near Naples. It is made of gold, and has apparently been used as an amulet and suspended to the neck. It is figured in plate 35 of *An Essay on the Worship of the Generative Powers during the Middle Ages* (London, privately printed, 1865). It may be thus described: the centre of the circle is occupied by four oblate spheres arranged like a square; from the salient curves of each of these springs a yoni (shaped as in Figure 59), with the point outwards, thus forming a cross, each ray of which is an egg and fig. At each junction of the ovoids a yoni is inserted with the apex inwards, whilst from the broad end arise four ashers, which project beyond the shield, each terminating in a few golden bead-like drops. The whole is a graphic natural representation of the intimate union of the male and female, sun and moon, cross and circle, Ouranos and Ge. The same idea is embodied in Figure 27, p. 86, but in that the mystery is deeply veiled, in that the long arms of the cross represent the sun, or male, indicated by the triad; the short ones, the moon, or the female (see Plate xi. Fig. 4).

The Maltese cross, a Phoenician emblem, was discovered cut on a rock in the island from which it takes its name. Though cruciform, it had nothing Christian about it; for, like the Etruscan ones referred to above, it consisted of four lingas united together by the heads, the "eggs" being at the outside. It was an easy thing for an unscrupulous priesthood to represent this "invention" of the cross as a miracle, and to make it presentable to the eyes of the faithful by leaving the outlines of Anu and Hea incomplete. Sometimes this cross is figured as four triangles meeting at the points, which has the same meaning, Generally, however, the Church (as may be seen by a reference to Pugin's *Glossary of Ecclesiastical Ornament*) adopts the use of crosses where the inferior members of the trinity are more or less central, as in our Plate xi., Figs. 2, 8, and as in the Figures 40, 41, 42, *infra*. When once a person knows the true origin of the doctrine of the Trinity—one which is far too improper to have been adopted by the writers of the New Testament—it is impossible not to recognise in the signs which are symbolic of it the thing which is signified.

It may readily be supposed that those who have knowledge of the heathenish origin of many of the cherished doctrines of the so-called Christian church, cannot remain enthusiastic members of her communion; and it is equally easy for the enlightened philosopher to understand why such persons are detested and abused by the ignorant, and charged with being freethinkers, sceptics, or atheists. Sciolism is ever intolerant, and theological hatred is

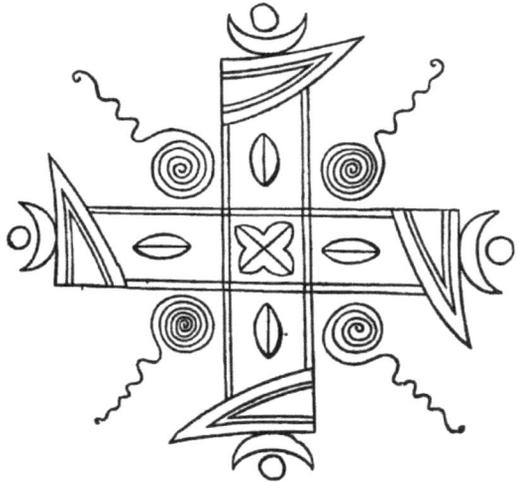

Figure 37.

generally to be measured by the mental incapacity of those who indulge in the luxury. But no amount of abuse can reduce the intrinsic value of facts. Nor will the most fiery persecution demonstrate that the religion of Christ, as it appears in our churches and cathedrals, especially if they are papal, is not tainted by a mass of paganism of disgusting origin.

Figure 37 is copied from the *Journal of the Royal Asiatic Society*, vol. xviii., p 898, plate 4. It is a Buddhist emblem, and represents the same idea under different aspects. Each limb of the cross represents the *fascinum* at right angles with the body, and presented towards a barleycorn, one of the symbols of the yoni. Each limb is marked by the same female emblem, and terminates with the triad triangle; beyond this again is seen the conjunction of the sun and moon. The whole therefore represents the mystic curba, the creative four, by some called Thor's hammer. Copies of a cross similar to this have

69

been recently found by Dr. Schliemann in a very ancient city, buried under the remains of two others, which he identifies as the Troy of Homer's Iliad.

Figure 38.

Figure 39.

Figure 40.

Figure 41.

Figure 42.

Figure 43.

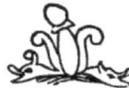
Figure 44.

Figure 45.

Figures 38 to 42 are developments of the triad triangle, or trinity. If the horizontal limb on the free end of the arm were to be prolonged to twice its length, the most obtuse would recognise *Asher*, and the inferior or lower members of the "triune."

Figure 43 is by Egyptologists called the 'symbol of life.'

It is also called the 'handled cross,' or *crux ansata*. It represents the male triad and the female unit, under a decent form. There are few symbols more commonly met with in Egyptian art than this. In some remarkable sculptures, where the sun's rays are represented as terminating in hands, the offerings which these bring are many a *crux ansata*, emblematic of the truth that a fruitful union is a gift from the deity.

Figures 44, 45, are ancient designs, in which the male and female elements are more disguised than is usual. In Fig. 44 the woman is indicated by the dolphin.

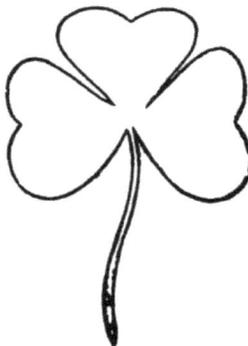
Figure 48.

Figure 46.

Figure 47.

Figure 49.

Figures 46, 47, are representatives of the ancient male triad, adopted by moderns to symbolize the Trinity.

70

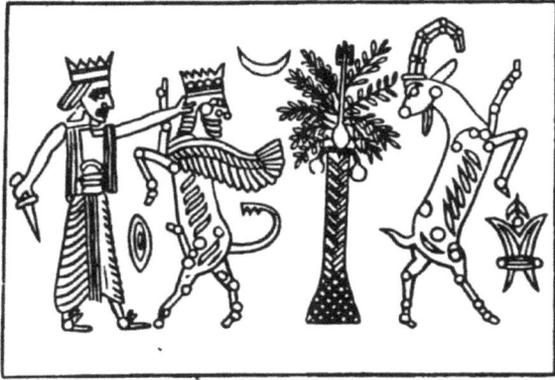

Figure 50.

Fig 51.

Fig. 52.

Figure 53.

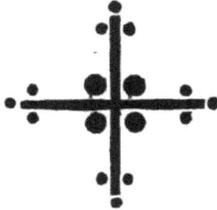

Figure 54.

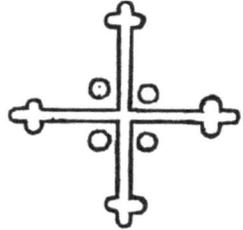

Figure 55.

Figure 56.

Fig. 57.

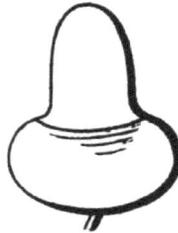

Figure 58.

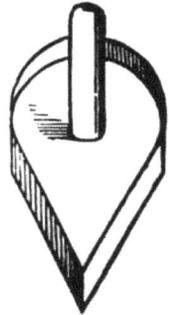

Figure 59.

Figure 60.

Figures 48, 49, represent the trefoil which was used by the ancient Hindoos as emblematic of the celestial triad, and adopted by modern Christians.

71

It will be seen that from one stem arise three curiously-shaped segments, each of which is supposed to resemble the male *scrotum,* "*purse,*" "*bag,*" or "*basket.*".

Figure 50 is copied from Lajard, Culte de Venus, plate i., fig. 2. He states that it is from a gem cylinder in the British Museum. It represents a male and female figure dancing before the mystic palm-tree, into whose signification we need not enter beyond saying that it is a symbol of Asher. Opposite to a particular part of the figures is to be seen a diamond, or oval, and a *fleur de lys*, or symbolic triad. This gem is peculiarly valuable, as it illustrates in a graphic manner the meaning of the emblems in question and how the "lillies of France" had a pagan origin.

Figures 51 to 60 are varions representations of the union of the four, the arba, the androgyne, or the linga-yoni.

Figure 61.

Figure 61. In modern Christian art this symbol is called *vesica piscis*, and is sometimes surrounded with rays. It commonly serves as a sort of framework in which female saints are placed, who are generally the representatives of the older Juno, Ceres, Diana, Venus, or other impersonations of the feminine element in creation. We should not feel obliged to demonstrate the truth of this assertion if decency permitted us to reproduce here designs which naughty youths so frequently chalk upon walls to the disgust of the proper part of the community. We must, therefore, have resort to a religious book, and in a subsequent figure demonstrate the meaning of the symbol unequivocally.

Figure 62 represents one of the forms assumed by the sistrum of Isis. Sometimes the instrument is oval, and occasionally it terminates below in a horizontal line, instead of in an acute angle. The inquirer can very readily recognise in the emblem the symbol of the female creator. If there should be any doubt in his mind, he will be satisfied after a reference to Maffei's *Gemme Antiche Figurate* (Rome, 1707), vol. ii., plate 61, wherein Diana of the Ephesians is depicted as having a body of the exact shape of the sistrum figured in Payne Knight's work on the remains of the worship of Priapus, etc. The bars across the sistrum show that it denotes a pure virgin (see *Ancient Faiths*, second edition, Vol. II., pp. 743-746). On its handle is seen the figure of a cat—a sacred animal amongst the Egyptians, for the same reason that Isis was figured sometimes as a cow—viz., for its salacity and its love for its offspring.

Figures 63 to 66 are all drawn from Assyrian sources.

Figure 62.

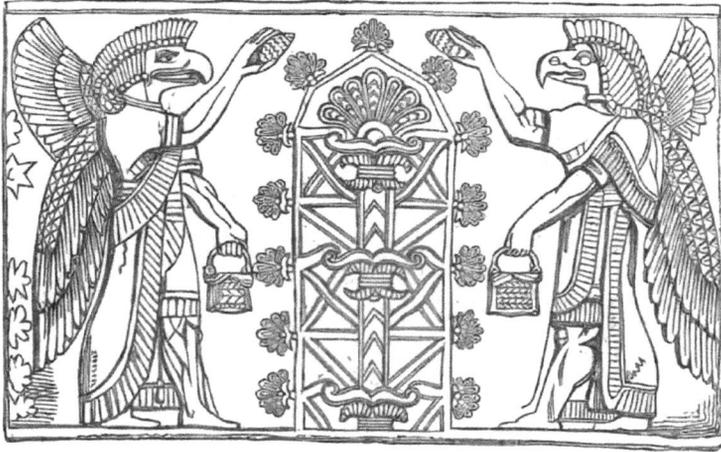
Figure 63.

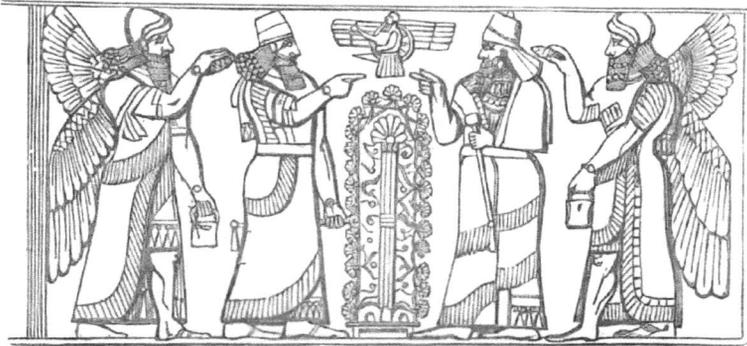
Figure 64.

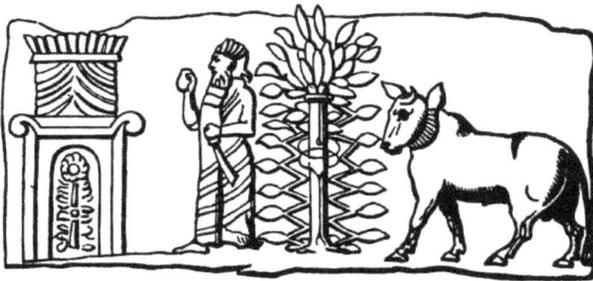
Figure 65.

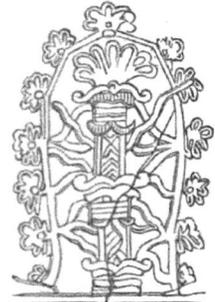
Figure 66.

The central figure, which is probably the biblical "grove," represents the delta, or female "door." To it the attendant genii offer the pine cone and basket. The signification of these is explained subsequently. I was unable at first to quote any authority to demonstrate that the pine cone was a distinct masculine symbol, but now the reader may be referred to Maffei, *Gemme Antiche Figurate* (Rome, 1708), where, in vol. iii., he will see a Venus Tirsigera.

The goddess in plate 8, is nude, and carries in her hand the tripliform arrow, emblem of the male triad, whilst in the other she bears a thyrsus, terminating in a pine or fir cone. Now this cone and stem are carried in the Bacchic festivities, and can be readily recognised as *virga cum ovo*. Sometimes the thyrsus is replaced by ivy leaves, which, like the fig, are symbolic of the triple creator. Occasionally the thyrsus was a lance or pike, round which vine leaves and berries were clustered; Bacchus *cum vino* being the companion of Venus *cum cerere*. But a stronger confirmation of my views may be found in a remarkable group (see Fig. 124 *infra*). This is entitled *Sacrifizio di Priapo*, and represents a female offering to Priapus. The figure of the god stands upon a pillar of three stones, and it bears a thyrsus from which depend two ribbons. The devotee is accompanied by a boy, who carries a pine- or fir- cone in his hand, and a basket on his head, in which may be recognised a male effigy. In Figure 64 the position of the advanced hand of each of the priests nearest to the grove is very suggestive to the physiologist. It resembles one limb of the Buddhist cross, Fig. 37, *supra*. The finger or thumb when thus pointed

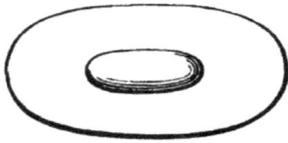

Figure 67.

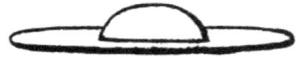

Figure 68.

Figure 69.

are figurative of Asher, in a horizontal position, with Anu or Hea hanging from one end. Figure 65 is explained similarly. It is to be noticed that a door is adopted amongst modern Hindoos as an emblem of the sacti (see Figs. 152, 153, *infra*).

My friend Mr. Newton, who has taken great interest in the subject of

Figure 70.

Figure 71.

symbolism, regards these "groves" as not being simply emblems of the yoni, but of the union of that part with the lingam, or mystic palm tree. As his ideas are extremely ingenious, and his theory perfect, I have requested him to introduce them at the end of this work.

Figures 67, 68, 69, are fancy sketches intended to represent the "sacred shields" spoken of in Jewish and other history. The last is drawn from memory, and represents a Templar's shield. According to the method in which the shield is viewed, it appears like the *os tincæ* or the navel.

Figures 70, 71, represent the shape of the sistrum of Isis, the fruit of the fig, and the yoni. When a garment of this shape is made and worn, it becomes the

"pallium" donned alike by the male and female individuals consecrated to Roman worship.

King, in his *Ancient Gnostics*, remarks: "The circle of the sun is the navel, which marks the natural position of the womb—the navel being considered in the microcosm as corresponding to the sun in the universe, an idea more fully exemplified in the famous hallucination of the Greek anchorites touching the mystical 'Light of Tabor,' which was revealed to the devotee after a fast of many days, all the time staring fixedly upon the region of the navel, whence at length this light streamed as from a focus." Pages 158, 154.

Figure 72.　　　　　　　　　Figure 73.

Figures 72, 73, represent an ancient Christian bishop, and a modern nun wearing the emblem of the female sex. In the former, said (in *Old England Pictorially Illustrated*, by Knight) to be a drawing of St. Augustine, the amount of symbolism is great. The "nimbus" and the tonsure are solar emblems; the pallium, the feminine sign, is studded with phallic crosses; its lower end is the ancient T the mark of the masculine triad; the right hand has the forefinger extended, like the Assyrian priests whilst doing homage to the grove, and within it is the fruit, *tappuach*, which is said to have tempted Eve. When a male dons the pallium in worship, he becomes the representative of the trinity in the unity, the *arba*, or mystic four. See *Ancient Faiths*, second edition, Vol. II., pp. 915-918.

I take this opportunity to quote here a pregnant page of King's *Gnostics and their Remains*, (Bell & Daldy, London, 1864). To this period belongs a beautiful sard in my collection representing Serapis,... whilst before him *stands* Isis, holding in one hand the sistrum, in the other a wheatsheaf, with the legend...

'Immaculate is our lady Isis,' the very terms applied afterwards to that personage who succeeded to her form (the 'Black Virgins,' so highly reverenced in certain French Cathedrals during the middle ages, proved, when examined critically, basalt figures of Isis), her symbols, rites, and ceremonies.... Her devotees carried into the new priesthood the former badges of their profession, the obligation to celibacy, the tonsure, and the surplice, omitting, unfortunately, the frequent ablutions prescribed by the ancient creed. The sacred image still moves in procession as when Juvenal laughed at it, vi. 530. 'Escorted by the tonsured surpliced train.' Her proper title, Domina, the exact translation of Sanscrit *Isi*, survives with slight change in the modern Madonna, Mater Domina.

| Figure 74. | Figure 75. | Figure 76. | Figure 77. | Figure 78. |

By a singular permutation the flower borne by each, the lotus—ancient emblem of the sun and fecundity—now re-named the lily, is interpreted as significant of the opposing quality. The tinkling sistrum...is replaced by...the bell, taken from Buddhist usages...The erect oval symbol of the Female Principle of Nature became the Vesica Piscis, and the Crux Ansata, testifying the union of the male and female in the most obvious manner, is transformed into the orb surmounted by the cross, as an ensign of royalty. Pp. 71, 72.

Figure 74 is a well-known Christian emblem, called "a foul anchor." The anchor, as a symbol, is of great antiquity. It may be seen on an old Etruscan coin in the British Museum, depicted in *Veterum Populorum et Regum Nummi*, etc. (London, 1814), plate ii., fig. 1. On the reverse there is a chariot wheel. The foul anchor represents the crescent moon, the yoni, ark, navis, or boat; in this is placed the mast, round which the serpent, the emblem of life in the "verge," entwines itself. The cross beam completes the mystic four, symbolic alike of the sun and of androgeneity. The whole is a covert emblem of that union which results in fecundity. It is said by Christians to be the anchor of the soul, sure and steadfast. This it certainly cannot be, for a foul anchor will not hold the ground.

Figures 75 to 79 are Asiatic and Egyptian emblems in use amongst ourselves, and receive their explanation similarly to preceding ones.

Figure 80 is copied from Godfrey Higgins' *Anacalypsis*, vol. ii., fig. 27. It is drawn from Montfauçon, vol. ii., pi. cxxxii., fig. 6. In his text, Higgins refers to two similar groups, one which exists in the Egyptian temple of Ipsambal in Nubia, and is described by Wilson, *On Buddhists and Jeynes*, p. 127, another, found in a cave temple in the south of India, described by Col. Tod, in his *History of Raj-pootanah*. The group is not explained by Montfauçon. It is apparently Greek, and combines the story of Hercules with the seductiveness of Circe. The tree and serpent are common emblems, and have even been found in Indian temples in central America, grouped as in the woodcut.

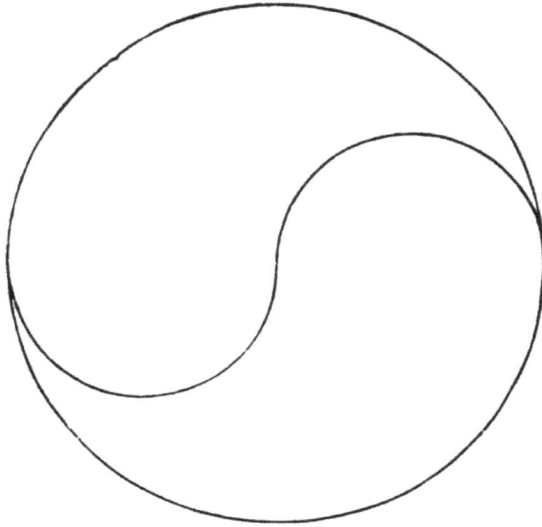

Figure 79.

Figure 80.

Figure 81 is copied from Lajard, *Culte de Venus*, plate xix., fig. 11, The origin of this, which is a silver statuette in that author's possession, is unknown. The female represents Venus bearing in one hand an apple; her arm rests upon what seems to be a representative of the mystic triad (the two additions to the upright stem not being seen in a front view) round which a dolphin for 'womb' is entwined, from whose mouth comes the stream of life. The apple plays a strange part in Greek and Hebrew mythology. The story of "the apple of discord," awarded by Paris to Venus, seems to indicate that where beauty contends against majesty and wisdom for the love of youth, it

77

is sure to win the day. We learn from Arnobius that a certain Nana conceived a son by an apple (Op, Cit., p. 286), although in another place the prolific fruit is said to have been a pomegranate. Mythologically, that writer sees no difficulty in the story, for those who affirm that rocks and hard stones have brought forth. In the Song of Solomon, apples and the tree that bears them are often referred to; and we have in Ch. ii. 5 the curious expression, "Comfort me with apples, for I am sick of love." We are familiar with the account of Eve being tempted by the same fruit. Critics imagine that as the apple in Palestine is not good eating, the quince is meant; if so, we know that a leaf of that tree is to be seen in every amorous picture found in Pompeii, the plant having been supposed to increase virile power. Others imagine that the citron is intended, whose shape makes it an emblem of the testis. However this may be decided, it is tolerably clear, from all the tales and pictures in which a fruit

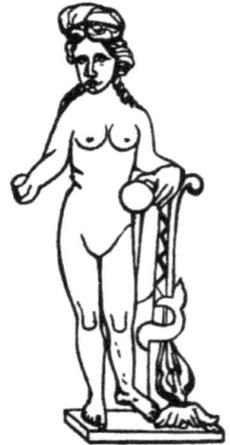

Figure 81.

like the apple figures, that the emblem symbolised a desire for an intimate union between the sexes. The reader will doubtless remember how, in Genesis xxx, Leah is represented as purchasing her husband's company for a night by means of mandrakes, the result being the birth of Issachar; and in the well-known story of the Creation we find that the apple gives birth to desire, as shown in the recognition for the first time of the respective nudity of the couple, which was followed immediately, or as soon as it was possible afterwards, by sexual intercourse and the conception of Cain.

Figure 82 is from Lajard (*Op. Cit.*), plate xiv*b*, fig. 3. The gem is of unknown origin, but is apparently Babylonish; it represents the male and female in conjunction: each appears

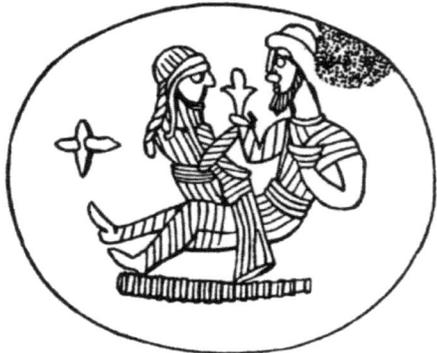

Figure 82.

to be holding the symbol of the triad in much respect, whilst the curious cross suggests a new reading to an ancient symbol.

I have of late heard it asserted, by a man of considerable learning, though of a very narrow mind in everything which bears upon religious subjects, that there is no proof that the sun was commonly regarded as a male, or the moon as a female; and he based his strange assertion solely upon the ground that in German and some other languages the sun was represented by a feminine, and the moon by a masculine noun. The argument is of no value, for σάβυττος χοῖρος and other Greek and Latin names of the yoni, are masculine nouns, and Virga and Mentula, the Roman words for the Linga, are feminine.

78

In Hindostan, the sun is always represented as a God; the moon is occasionally a male, and sometimes a female deity. In ancient Gaulish and Scandinavian figures, the sun was always a male, and the moon a female. Their identification will be seen in Figure 113—as their conjunction is in the one before us—in the position of the individuals, and in the *fleur-de-lys* and oval symbol.

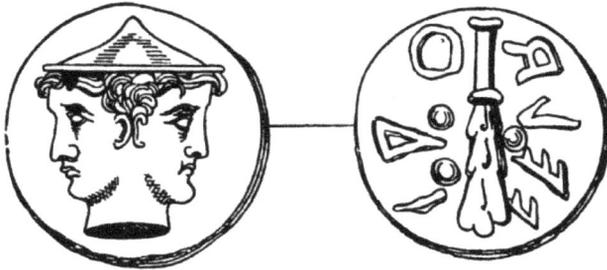

Figure 88.

Figure 83 may be found in Fabretti's *Corpus Inscriptionum Italicarum* (Turin, 1867), plate xxv., fig. 303 f. The coins which bear the figures are of brass, and were found at Volaterræ. In one the double head is associated with a dolphin and crescent moon on the reverse, and the letters Velathri, in Etruscan. A similar inscription exists on the one containing the club. The club, formed as in Figure 88, occurs frequently on Etruscan coins. For example, two clubs are joined with four balls on a Tudertine coin, having on the reverse a hand apparently gauntleted for fighting, and four balls arranged in a square. On other coins are to be seen a bee, a trident, a spear head, and other tripliform figures, associated with three balls in a triangle; sometimes two, and sometimes one. The double head with two balls is seen on a Telamonian coin, having on the reverse what appears to be a leg with the foot turned upwards. In a coin of Populonia the club is associated with a spear and two balls, whilst on the reverse is a single head. I must notice, too, that on other coins a hammer and pincers, or tongs, appear, as if the idea was to show that a maker, fabricator, or heavy hitter was intended to be symbolised. What that was is further indicated by other coins, on which a head appears thrusting out the tongue. At Cortona two statuettes of silver have been found, representing a double-faced individual. A lion's head for a cap, a collar, and buskins are the sole articles of dress worn. One face appears to be feminine, and the other masculine, but neither is bearded. The pectorals and the general form indicate the male, but the usual marks of sex are absent. On these have been found Etruscan inscriptions (1) v. CVINTI ARNTIAS CULPIANSI ALPAN TURCE; (2) V. CVINTE ARNTIAS SELANSE TEZ ALPAN TURCE. Which may be rendered (1) "V. Quintus of Aruntia, to Culpian pleasing, a gift"; (2) "V. Quintus of Aruntia to Vulcan pleasing gave a gift," evidently showing that they were *ex voto* offerings.

Figure 84. The figure here repsented is, under one form or another, extremely common

Figure 84.

79

amongst the sculptured stones in Scotland. Four varieties may be seen in plate 48 of Col. Forbes Leslie's *Early Races of Scotland.* In plate 49 it is associated with a serpent, apparently the cobra. The design is spoken of as "the spectacle ornament," and it is very commonly associated with another figure closely resembling the letter Z. It is very natural for the inquirer to associate the twin circles with the sun and earth, or the sun common amongst the sculptured stones in Scotland. Four varieties may be seen in plate 48 of sun and moon. On one Scottish monument the circles represent wheels, and they probably indicate the solar chariot. As yet I have only been able to meet with the Z and "spectacle ornament" once out of Scotland; it is figured on apparently a Gnostic gem (*The Gnostics and their Remains*, by C. W. King, London, 1864, plate ii., fig. 5). In that we see in a serpent cartouche two Z figures, each having the down stroke crossed by a horizontal line, both ends terminating in a circle; besides them is a six-rayed star, each ray terminating in a circle, precisely resembling the star in Plate in., Fig. 3, *supra.* I can offer no satisfactory explanation of the emblem.

Figure 85.

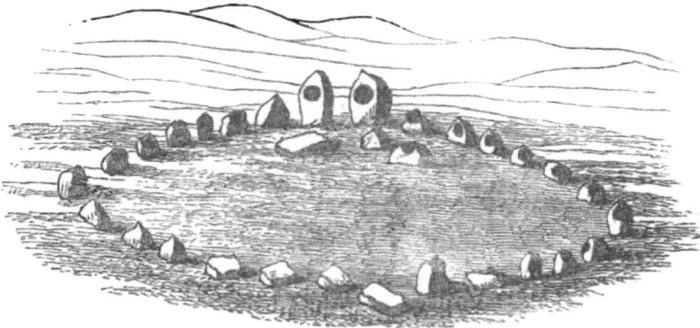

Figure 86.

Figures 85, 86, represent a Yorkshire and an Indian stone circle. The first is copied from *Descriptions of Cairns, Cromlechs, Kistvaens, and other Celtic, Druidical, or Scythian Monuments in the Dekkan*, by Col. Meadows Taylor, *Transactions of the Royal Irish Academy*, vol. xxiv. The mound exists at Twizell, Yorkshire, and the centre of the circle indicates an ancient tomb, very similar to those found by Taylor in the Dekkan; this contained only one single urn,

but many of the Indian ones contained, besides the skeleton of the great man buried therein, skeletons of other individuals who had been slaughtered over his tomb, and buried above the kistvaen containing his bones; in one instance two bodies and three heads were found in the principal grave, and twenty other skeletons above and beside it. A perusal of this very interesting paper will well repay the study bestowed upon it. Figure 86 is copied from Forbes Leslie's book mentioned above, plate 59. It represents a modern stone circle in the Dekkan, of very recent construction. The dots upon the stones represent dabs of red paint, which again represent blood. The circles are similar to some which have been found in Palestine, and give evidence of the presence of the same religious ideas existing in ancient England and Hindostan, as well as in modern India. The name of the god worshipped in these recent shrines is Vetal, or Betal. It is worth mentioning, in passing, that there is a celebrated monolith in Scotland called the Newton Stone, on which are inscribed, evidently with a graving tool, an inscription in the Ogham, and another in some ancient Aryan character (see Moore's *Ancient Pillar Stones of Scotland*).

Figure 87.

Figure 87 indicates the solar wheel, emblem of the chariot of Apollo. This sign is a very common one upon ancient coins; sometimes the rays or spokes are four, at others they are more numerous. Occasionally the tire of the wheel is absent, and amongst the Etruscans the nave is omitted. The solar cross is very common in Ireland, and amongst the Romanists generally as a head dress for male saints.

Figure 88 is copied from Hyslop, who gives it on the authority of Col. Hamilton Smith, who copied it from the original collection made by the artists of the French Institute of Cairo. It is said to represent Osiris, but this is doubtful. There is much that is intensely mystical about the figure. The whip, or flagellum, placed over the tail, and the head passing through the yoni, the circular spots with their central dot, the

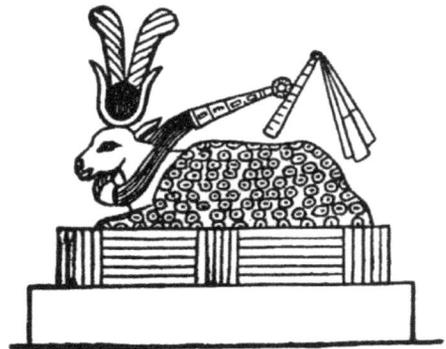

Figure 88.

horns with solar disc, and two curiously shaped feathers (?), the calf reclining upon a plinth, wherein a division into three is conspicuous, all have a meaning in reference to the mystic four.

I have long had a doubt respecting the symbolic meaning of the scourge. Some inquirers have asserted that it is simply an emblem of power or supe-

81

riority, inasmuch as he who can castigate must be in a higher position than the one who is punished. But of this view I can find no proof. On the other hand, any one who is familiar with the effect upon the male produced by flagellation, and who notices that the representations of Osiris and the scourge show evidence that the deity is in the same condition as one who has been subjected to the rod, will be disposed to believe that the flagellum is an indication or symbol of the god who gives to man the power to reproduce his like, or who can restore the faculty after it has faded. It is not for a moment to be supposed that a deity who was to be worshipped would be depicted as a task-master, whose hands are more familiar with punishment than blessing.

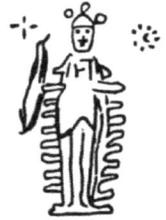

Figure 89.

Figure 89 is taken from Lajard's *Culte de Venus*, plate i., fig. 14, and is an enlarged impression of a gem. A similar figure is to be found in Payne Knight's work *On the Worship of Priapus*. In both instances the female is fringed with male emblems. In the one before us a fish, apparently a dolphin, is borne in one hand. In the other the woman is bearded. These are representations of Ashtaroth—the androgyne deity in which the female predominates.

Fig. 90 represents an ancient Italian form of the Indian Ling Yoni. It is copied from a part of the Frontispiece of Faber's *Dissertation on the Cabiri*, where it is stated that the plate is a copy of a picture of a nymphoeum found when excavating a foundation for the Barbarini Palace at Rome. It deserves notice,

Figure 90.

because the round mound of masonry surmounted by the short pillars is precisely similar to similar erections found in Hindostan on the East and America on the West, as well as in varions parts of Europe. The oval in the pediment and the solitary pillar have the same meaning as the Caaba and hole—the upright stone and pit revered at Mecca long before Mahomet's time—the tree serves to identify the pillar, and *vice versa*. Apertures were common in ancient sepulchral monuments, alike in Hindostan and England; one perforated stone is preserved as a relic in the precincts of an old church in modern Rome. The aperture is blackish with the grease of many hands, which have been put therein whilst their owners took a sacred oath. We have already remarked how ancient Abraham and a modern Arab have sworn by the Linga; it is therefore by no means remarkable that some of a different form of faith should swear by the Yoni.

Figure 91.

Figure 91 is stated by Higgins, *Anacalypsis,* p. 217, to be a mark on the breast of an Egyptian mummy in the Museum of University College, London. It is essentially the same symbol as the *crux ansata*, and is emblematic of the male triad and the female unit.

Figure 92 is simply introduced to show that the papal tiara has not about it anything particularly Christian, a similar head-dress having been worn by gods or angels in ancient Assyria, where it appeared crowned by an emblem of "the trinity." We may mention, in passing, that as the Romanists adopted the mitre and the tiara from "the cursed brood of Ham," so they adopted the episcopalian crook from the augurs of Etruria, and the artistic form with which they

Figure 92.

clothe their angels from the painters and urn-makers of Magna Gracia and Central Italy.

Figure 93 is the Mithraic lion. It may be seen in Hyde's *Religion of the Ancient Persians*, second edition, plate i. It may also be seen in vol. ii., plates 10 and 11, of Maffei's *Gemme Antiche Figurate* (Rome, 1707). In plate 10 the Mithraic lion has seven stars above it, around which are placed respectively, words written in Greek, Etruscan and Phoenician characters, ZEDCH. TELKAN. TELKON. TELKON. QIDEKH. UNEULK. LNKELLP., apparently showing that the emblem was adopted by the Gnostics. It would be unprofitable to dwell upon the meaning of these letters. After puzzling over them, I fancy that "Bad spirits, pity us," "Just one, I call on thee," may be made out by considering the words to be very bad Greek, and the letters to be much transposed.

Figure 94 is copied by Higgins, *Anacalypsis*, on the authority of

Figure 93.

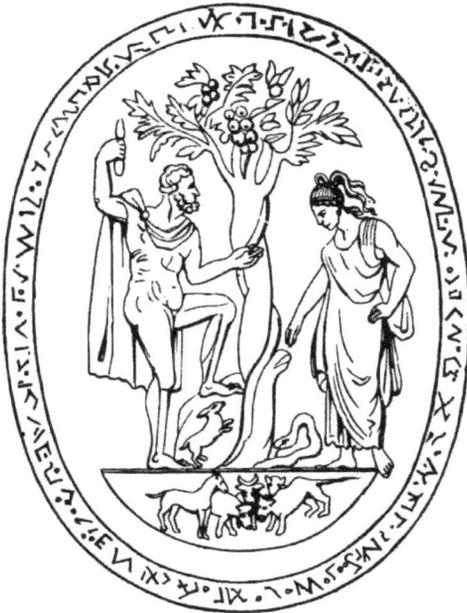

Figure 94.

Dubois, who states, vol. iii., p. 88, that it was found on a stone in a church in France, where it had been kept religiously for six hundred years. Dubois regards it as wholly astrological, and as having no reference to the story told in Genesis. It is unprofitable to speculate on the draped figures as representatives of Adam and Eve. We have introduced it to show how such tales are intermingled with Sabeanism.

Figure 95 is a copy of a gem figured by Layard (*Nineveh and Babylon*, p. 156), and represents Harpocrates seated on a lotus, adoring the mundane representative of the mother of creation. I have not yet met with any ancient gem or sculpture which seems to identify the yoni so completely with various goddesses.

Figure 95.

Compare this with Figure 138, *infra*, wherein the Figure 95. emblem is even more strikingly identified with woman, and with the virgin Mary. Those who are familiar with the rude designs too often chalked on hoardings, will see that learned ancients and boorish moderns represent certain ideas in precisely similar fashion, and will understand the mystic meaning of **O** and ⅂ have elsewhere called attention to the idea that a sight of the yoni is a source of health, and a charm against evil spirits; however grotesque the idea may be, it has existed in all ages, and in civilised and savage nations alike. A rude image of a woman who shamelessly exhibits herself has been found over the doors of churches in Ireland, and at Servatos, in Spain, where she is standing on one side of the doorway, and an equally conspicuous man on the other. The same has been found in Mexico, Peru, and in North America. Nor must we forget how Baubo cured the intense grief of Ceres by exposing herself in a strange fashion to the distressed goddess. Arnobius, *Op. Cit.*, pp. 249, 250.

Figure 96.

As I have already noticed modern notions on the influence produced by the exhibition of the yoni on those who are suffering, the legend referred to may be shortly described. The goddess, in the story, was miserable in consequence of her daughter, Proserpine, having been stolen away by Pluto. In her agony, snatching two Etna-lighted torches, she wanders round the earth in

84

search of the lost one, and in due course visits Eleusis. Baubo receives her hospitably; but nothing that the hostess does induces the guest to depose her grief for a moment. In despair the mortal bethinks her of a scheme, shaves off what is called in Isaiah "the hair of the feet" and then exposes herself to the goddess. Ceres fixes her eyes upon the denuded spot, is pleased with the strange form of consolation, consents to take food and is restored to comfort.

Figure 96 is copied from plate 22, fig. 8, of Lajard's *Culte de Venus*. He states that it is an impression of a cornelian cylinder, in the collection of the late Sir William Ouseley, and is supposed to represent Oannes, or Bel and two fish gods, the authors of fecundity. It is thought that Dagon of the Philistines resembled the two figures supporting the central one.

Figure 97 is a side view of plate 1. The idol represents a female. Dagon, the fish god, male above, piscine below, was one of the many symbols of an androgyne creator. In the first of the Avatars of Vishnu, he is represented as emerging from the mouth of a fish, and being a fish himself; the legend being that he was to

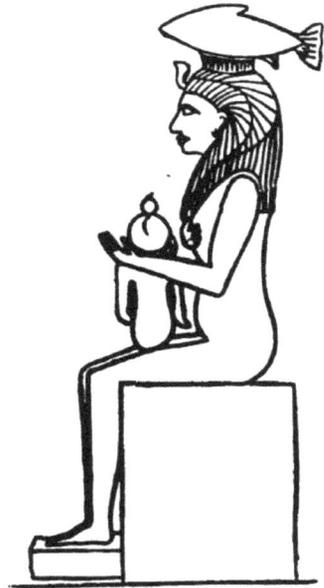

Figure 97.

be the saviour of the world in a deluge which was to follow. See Moor's *Hindu Pantheon*, and Coleman's *Mythology of the Hindus*.

Figure 98

Figure 98 is a fancy sketch of the *fleur-de-lys*, the lily of France. It symbolises the male triad, whilst the ring around it represents the female. The identification of this emblem of the trinity with the tripliform Mahadeva, and of the ring with his sacti, may be seen in the next figure.

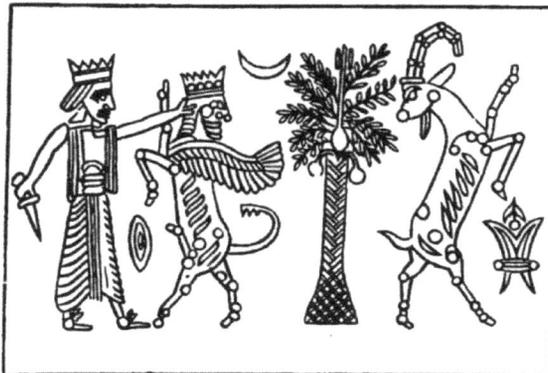

Figure 99.

Figure 99, which we have already given, is one of great value to the inquirer into the signification of certain symbols. It has been reintroduced here to show the identification of the eye, fish, or oval shape, with the yoni, and of the *fleur-de-lys* with the lingam, which is recognised by the respective positions of the emblems in front of particular parts of the mystic animals, who both, on their part, adore the symbolic palm tree, with its pistil and stamens. The rayed branches of the upper part of the tree, and the nearness to it of the crescent moon, seem to indicate that the palm was a solar as well as a sexual emblem.

The great similarity of the palm tree to the ancient round towers in Ireland and elsewhere will naturally strike the observer. He will perhaps remember also that on certain occasions dancing, feasting, and debauchery were practised about a round tower in Wicklow, such as were practised round the English may-pole, the modern substitute of the mystic palm tree. We have now humanised our practice, but we have not purified our land of all its veiled symbols.

In some parts, where probably the palm tree does not flourish, the pine takes its place as an emblem. It was sacred to the mother of the gods, whose names, Rhoea, Ceres, Cybele, are paraphrastic of the yoni. We learn from Araobius, *Op. Cit.*, p. 239, that on fixed days that tree was introduced into the sanctuary of that august personage, being decorated by fleeces and violets. It does not require any recondite knowledge to understand the signification of the entrance of the pine into the temple of the divine mother, nor what the tree when buried in the midst of a fleece depicts. Those who have heard of the origin of the Spanish Royal Order of the Golden Fleece know that the word is an enphemism for the *lanugo* of the Romans. Parsley round a carrot root is a modern symbol, and the violet is as good an emblem of the lingam as the modern pistol.

It has long been known that the ancient custom of erecting a may-pole, surrounding it with wreaths of flowers, and then dancing round it in wild orgy, was a relic of the ancient custom of reverencing the symbol of creation, invigorated by the returning spring time, without whose powers the flocks and herds would fail to increase. It will not fail to attract the notice of my readers, that a pine cone is constantly being offered to the sacred "grove" by the priests of Assyria.

Figures 100, 101, represent the Buddhist cross and one of its arms. The first

Figure 102. Figure 108. Figure 104.

Figure 101.

Figure 100.

shows the union of four phalli. The single one being a conventional form of a well-known organ. This form of cross does not essentially differ from the

86

Maltese cross. In the latter, Asher stands perpendicularly to Anu and Hea; in the former it is at right angles to them. "The pistol" is a well-known name amongst our soldiery, and four such joined together by the muzzle would form the Buddhist cross. Compare Figure 37, *ante*.

Figures 102, 103, 104, indicate the union of the four creators, the trinity and the unity. Not having at hand any copy of an ancient key, I have used a modern one; but this makes no essential difference in the symbol.

Figures 105, 106, are copied from Lajard, *Sur le Culte de Venus*, plate ii. They represent ornaments held in the hands of a great female figure, sculptured in bas relief on a rock at Yazili Kaia, near to Boghaz Keni, in Anatolia, and described by M. C. Texier in 1834. The goddess is crowned with a tower, to indicate virginity; in her right hand she holds a staff, shown in Figure 106; in the other, that given in Figure 105, she stands upon a lioness, and is attended by an antelope. Figure 105 is a complicated emblem of the four.

Figure 105. Figure 106.

Figures 107, 108, 109, are copied from Moor's *Hindu Pantheon*, plate lxxxiii. They represent the lingam and then yoni, which amongst the Indians are regarded as holy emblems, much in the same way as a crucifix is esteemed by certain modern Christians.

In worship, *ghee*, or oil, or water, is poured over the pillar, and allowed to run off by the spout. Sometimes the pillar is adorned by a necklace, and is associated with the serpent emblem. In Lucian's account of Alexander, the false prophet, which we have

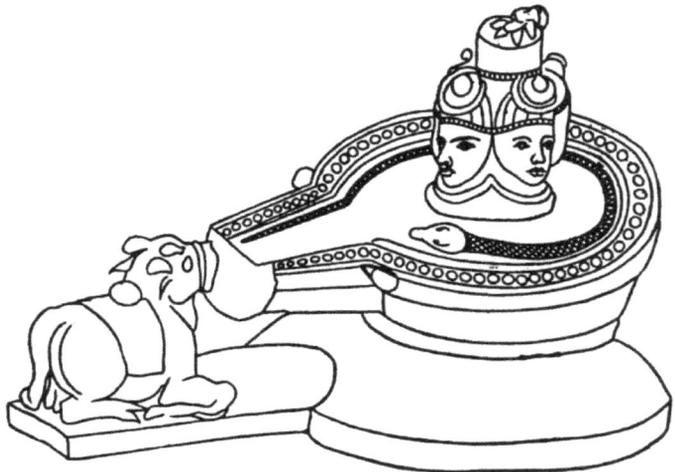

Figure 107.

condensed in *Ancient Faiths*, second edition, there is a reference to one of his dupes, who was a distinguished Roman officer, but so very superstitious, or, as he would say of himself, so deeply imbued with religion, that at the sight of a stone he would fall prostrate and adore it for a considerable time, offering prayers and vows thereto. This may by some be thought quite as reasonable as the practice once enforced in Christian Rome, which obliged all per-

87

sons in the street to kneel in reverence when an ugly black doll, called "the bambino," or a bit of bread, over which some cabalistic words had been muttered, was being carried in procession past them. Arnobins, *Op, Cit.*, p. 81, says, "I worshipped images produced from the furnace, gods made on anvils and by hammers, the bones of elephants, paintings, wreaths on aged trees; whenever I espied an anointed stone, and one bedaubed with olive oil, as if some person resided in it, I worshipped it, I addressed myself to it, and begged blessings from a senseless stock." Compare Gen. xxviii. 18, wherein we find that Jacob set up a stone and anointed it with oil, and called the place Bethel, and Is. xxvii. 19, xl. 20, xliv. 10-20.

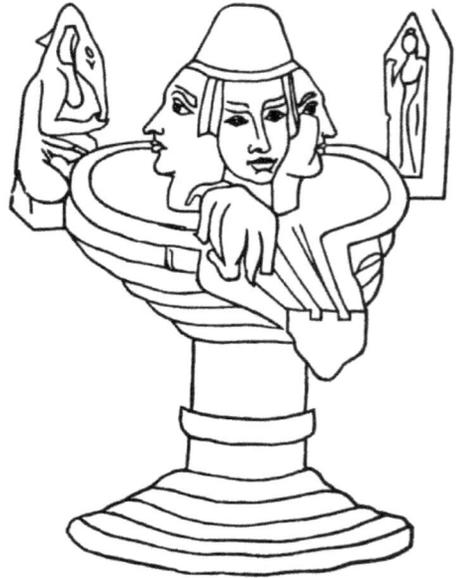

Figure 108.

I copy the following remarks from a paper by Mr. Sellon, in *Memoirs of the London Anthropological Society*, for 1868-4. Speaking of Hindostan, he remarks, "As every village has its temple so every temple has its Lingam, and these parochial Lingams are usually from two to three feet in height, and rather broad at the base. Here the village girls, who are anxious for lovers or husbands, repair early in the morning. They make a lustration by sprinkling the god with water brought from the Ganges; they deck the Linga with garlands of the sweet-smelling bilwa flower; they perform the *mudra*, or

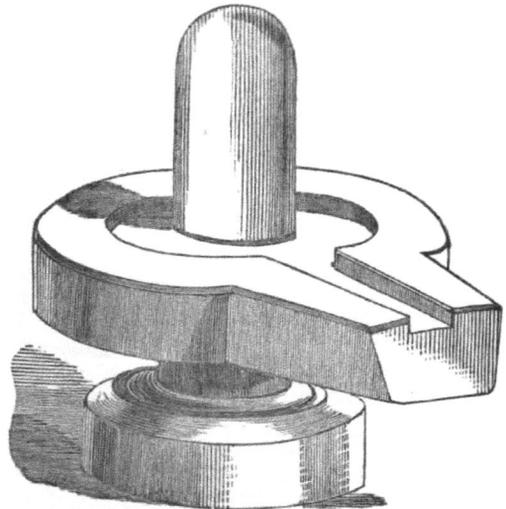

Figure 109.

gesticulation with the fingers, and, reciting the prescribed *mantras*, or incantations, they rub themselves against the emblem, and entreat the deity to make them fruitful mothers of *pulee-pullum* (i.e., child fruit).

"This is the celebrated Linga puja, during the performance of which the *panchaty*, or five lamps, must be lighted, and the *gantha*, or bell, be frequently rung to scare away the evil demons. The *mala*, or rosary of a hundred and eight round beads, is also used in this puja."

See also Moor's *Hindu Pantheon*, plate xxii, pp. 68, 69, 70. Again, in the *Dabistan*, a work written in the Persian language, by a travelled Mahometan, about a. d. 1660, and translated by David Shea, for the Oriental Translation Fund of Great Britain and Ireland (8 vols., 8vo., Allen and Co., Leadenhall Street, London), we read, vol. ii., pp. 148-160, "The belief of the Saktian is that Siva, that is, Mahadeva, who with little exception is the highest of deities and the greatest of the spirits, has a spouse whom they call *Maya* Sakti.....With them the power of Mahadeva's wife, who is Bhavani, surpasses that of the husband. The zealous of this sect worship the *Siva Linga*, although other Hindoos also venerate it. *Linga* is called the virile organ, and they say, on behalf of this worship, that as men and all living beings derive their existence from it, adoration is duly bestowed upon it. As the linga of Mahadeva, so do they venerate the *bhaga*, that is, the female organ. A man very familiar with them gave the information that, according to their belief, the high altar, or principal place in a mosque of the Mussulmans, is an emblem of the *bhaga*. Another man among them said that as the just-named place emblems the bhaga, the minar or turret of the mosque represents the linga." The author then goes on to describe the practices of the sect, which may be summed up in the words—the most absolute freedom of love.

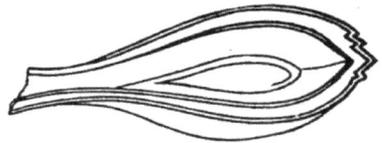
Figure 110.

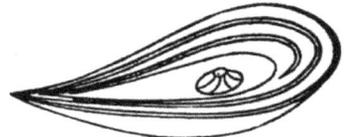
Figure 111.

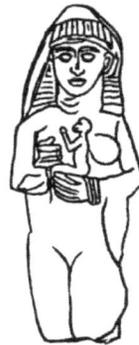
Figure 112.

Apropos of the Mahometan minaret and Christian church towers and spires, I may mention that Lucian describes the magnificent temple of the Syrian goddess as having two vast phalli before its main entrance, and how at certain seasons men ascended to their summit, and remained there some days, so as to utter from thence the prayers of the faithful.

Figures 110, 111, both from Moor, plate lxxxvi., are forms of the *argha*, or sacred sacrificial cup, bowl, or basin, which represent the yoni, and some other things besides. See Moor, *Hindu Pantheon*, pp. 898, 894.

Figure 112. Copied from Rawlinson's *Ancient Monarchies*, vol. i., p. 176, symbolises Ishtar, the Assyrian representative of Devi, Parvati, Isis, Astarte,

Venus, and Mary. The virgin and child are to be found everywhere, even in ancient Mexico.

Figure 113 is copied from Lajard, *Sur le Culte de Venus*, plate xix., fig. 6, and represents the male and female as the sun and moon, thus identifying the symbolic sex of those luminaries. The legend in the Pehlevi characters has not been interpreted.

Figure 114 is taken from a mediæval woodcut, lent to me by my friend, Mr. John Newton, to whom I am indebted for the sight of, and the privilege to copy, many other figures. In it the virgin Mary

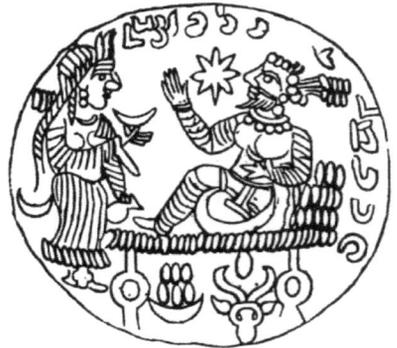

Figure 113.

is seen as the Queen of Heaven, nursing her infant, and identified with the crescent moon, the emblem of virginity. Being before the sun, she almost eclipses its light. Than this, nothing could more completely identify the Christian mother and child with Isis and Horus, Ishtar, Venus, Juno, and a host of other pagan goddesses, who have been called 'Queen of Heaven,' 'Queen of the Universe' 'Mother of God,' 'Spouse of God,' the 'Celestial Virgin,' the 'Heavenly Peace Maker,' etc.

Figures 115, 116, are common devices in papal church-

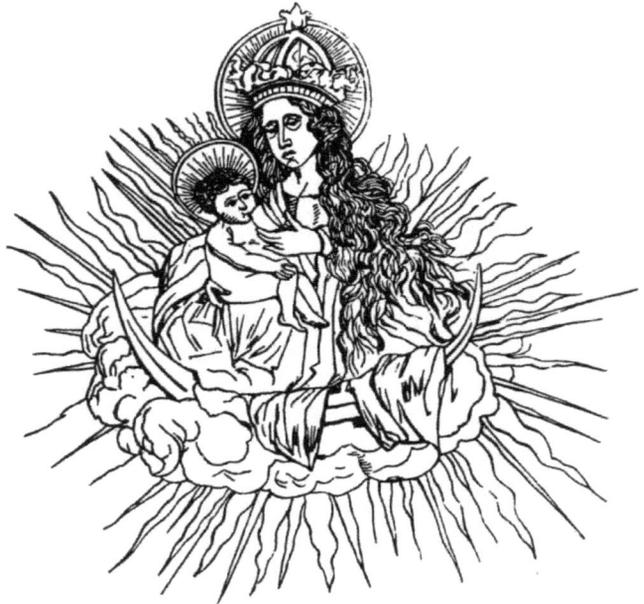

Figure 114.

Figure 115.

Figure 116.

es and pagan symbolism. They are intended to indicate the sun and moon in conjunction, the union of the triad with the unit. I may notice, in passing, that Mr. Newton has showed to me some mediæval woodcuts, in which the young unmarried women in a mixed assemblage were indicated by wearing upon their foreheads a crescent moon.

Figure 117 is a Buddhist symbol, or rather a copy of Maityna Bodhisatwa, from the monastery of Gopach, in the valley of Nepaul.

It is taken from Journal of Royal Asiatic Society, vol. xviii., p. 894. The horse-shoe, like the *vesica piscis* of the Roman church, indicates the yoni; the last, taken from some cow, mare, or donkey, being used in eastern parts where we now use their shoes, to keep off the evil eye. It is remarkable that some nations should use the female organ, or an effigy thereof, as a charm against ill luck, whilst others adopt the male symbol. In Ireland, as we have previously remarked, a female shamelessly exhibiting herself, and called Shelah-na-gig, was to be seen in stone over the door of certain churches, within the last century.

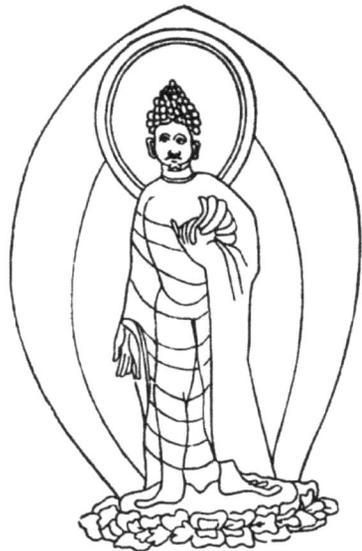

Figure 117.

From the resemblance in the shape of the horse-shoe to the "grove" of the Assyrian worshippers, and from the man standing within it as the symbolic pine tree stands in the Mesopotamian, "Asherah," I think we may fairly conclude that the Indian, like the Shemitic emblem, typifies the union of the sexes—the androgyne creator.

That some Buddhists have mingled sexuality with their ideas of religion, may be seen in plate ii. of Emil Schlagintweit's *Atlas of Buddhism in Tibet*, wherein Vajarsattva, "The God above all," is represented as a male and female conjoined. Rays, as of the sun, pass from the group; and all are enclosed in an ornate oval, or horse-shoe, like that in this figure. Few, however, but the initiated would recognise the nature of the group at first sight.

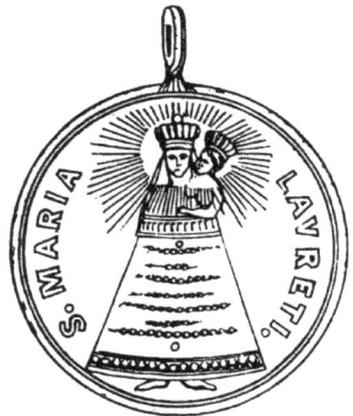

Figure 118.

I may also notice, in passing, that the goddess Doljang (a.d. 617-98) has the *stigmata* in her hands and feet, like those assigned to Jesus of Nazareth and Francis of Assisi.

Figure 118 is a copy of the medal issued to pilgrims at the shrine of the virgin at Loretto. It was lent to me by Mr. Newton, but the engraver has omitted to make the face of the mother and child black, as the most ancient and renowned ones usually are.

Instead of the explanation given in *Ancient Faiths*, Vol. ii., p. 262, of the adoption of a black skin for Mary and her son, D'Harcanville suggests that it represents night, the period during which the feminine creator is most propitious or attentive to her duties. It is unnecessary to contest the point, for almost every symbol has more interpretations given to it than one. I have sought in vain for even a plausi-

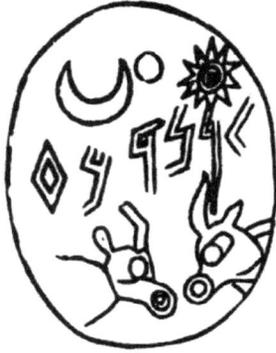

Figure 119.

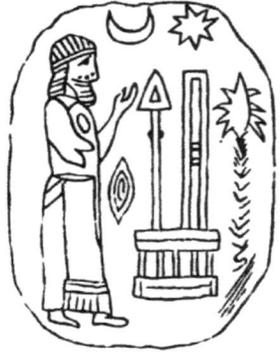

Figure 120.

ble reason for the blackness of sacred virgins and children, in certain papal shrines, which is compatible with decency and Christianity. It is clear that the matter will not bear the light.

Figure 119 is from Lajard, *Op. Cit,* plate iii., fig. 8. It represents the sun, moon, and a star, probably Venus.

The legend is in Phoenician, and may be read LNBRB. Levy, in *Siegel und Gemmen,* Breslau, 1869, reads the legend לכברעע, LKBRBO, but does not attempt to explain it.

Figure 120 is also from Lajard, plate i., fig. 8. It represents an act of worship before the symbols of the male and female creators, arranged in three pairs. Above are the heavenly symbols of the sun and moon. Below are the male palm tree, and the barred χτείς, identical in meaning with the sistrum, *i.e., virgo intacta*. Next come the male emblem, the cone, and the female symbol, the lozenge or yoni.

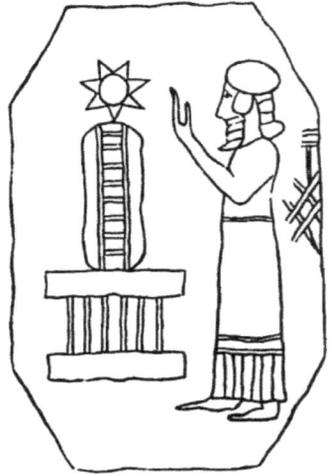

Figure 121.

Figure 121 represents also a worshipper before the barred female symbol, surmounted by the seven-rayed star, emblem of the male potency, and of the sun or the heavens. It will be noticed—and the matter is significant—that the hand which is raised in adoration is exactly opposite the conjunction of the two. Compare this with Fig. 95, where the female alone is the object of reverence.

Lajard and others state that homage, such as is here depicted, is actually paid in some parts of Palestine and India to the living symbol; the worshipper on bended knees offering to it, *la bouche inférieure*, with or without a silent prayer, his food before he eats it. A corresponding homage is paid by female devotees to the masculine emblem of any very peculiarly holy fakir, one of whose peculiarities is, that no amount of excitement stimulates the organ into what may be called creative energy. It has long been a problem how such a state of apathy is brought about, but modern observation has proved that it is by the habitual use of weights. Such homage is depicted in Picart's *Religious Ceremonies of all the People in the World*, original French edition, plate 71.

Figure 122 is copied from Bryant's *Ancient Mythology*, third edition, vol. iii., p. 193. That author states that he copied it from Spanheim, but gives no other reference. It is apparently from a Greek medal, and has the word CAMIÛN as an inscription. It is said to represent Juno, Sami, or Selenitis, with the sacred peplum. The figure is remarkable for showing the identity of the moon, the lozenge, and the female. It is doubtful whether the attitude of the goddess is intended to represent the cross.

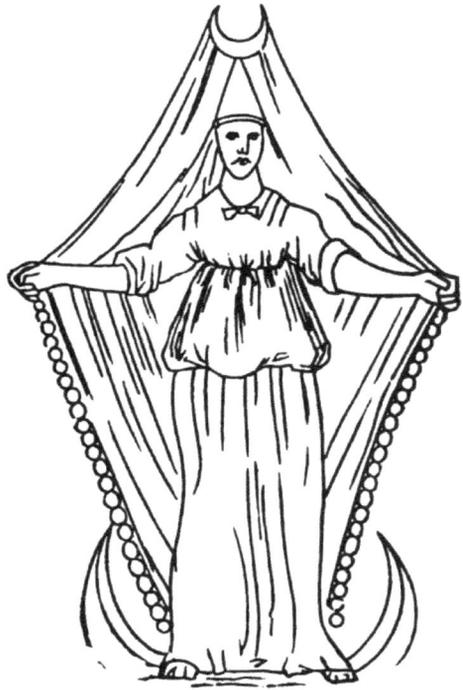

Figure 122.

As in religious Symbolism every detail has a signification, we naturally speculate upon the meaning of the beads which fringe the lower part of the diamond-shaped garment. We have noticed in a previous article that the Linga when worshipped was sometimes adorned with beads, which were the fruit of a tree sacred to Mahadeva; in the original of fig. 4, plate xi. *supra*, the four arms of the cross have a series of beads depending from them. On a very ancient coin of Citium, a rosary of beads, with a cross, has been found arranged round a horse-shoe form; and beads are common ornaments on Hindoo Divinities. They may only be used for decoration and without religious signification; if they have the last, I have not been able to discover it.

Figure 123 is a composition taken from Bryant, vol. iv., p. 286. The rock, the water, the crescent moon as an ark, and the dove hovering over it, are all symbolical; but though the author of it is right in his grouping, it is clear that he is not aware of its full signification. The reader will readily gather their

true meaning from our articles upon the Ark and Water, and from our re-marks upon the Dove in *Ancient Faiths*, second edition.

Figure 123.

Figure 124 is copied from Maffei's *Gemme Antiche Figurate*, vol. 8, plate xl. In the original, the figure upon the pillar is very conspicuously phallic, and the whole composition indicates what was associated with the worship of Priapus.

Figure 124.

This so-called god was regarded much in the same light as 'St. Cosmo and St. Damian were at Iseraia, and St. Foutin in Christian France. And it is not at all surprising that a church, which has deified or made saints of a spear and cloak, under the names Longinus and Amphibolus, should also adopt the "god of the gardens," and consecrate him as an object for Christian worship, and give him an appropriate name and emblem. But the patron saint of Lampsacus was not really a deity, only a sort of saint, whose business it was to attend to certain parts. The idea of guardian angels was once common, see Matt, xviii. 10, where we read, that each child has a guardian in heaven, who looks after his infantile charge. As the pagan Hymen and Lucina attended upon weddings and parturitions, so the Christian Cosmo and Damian attended to spouses, and assisted in making them fruitful. To the last two were offered, by sterile wives, wax effigies of the part left out from the nude figure in our plate. To the heathen saint, we see a female votary offer quince leaves, equivalent to *la feuille de sage*, egg-shaped bread, apparently a cake; also an ass's

Figure 125. Figure 126. Figure 127.

head; whilst her attendant offers a pine cone. This amongst the Greeks was sacred to Cybele, as it was in Assyria to Astarte or Ishtar, the name given there to 'the mother of all saints.' The basket contains apples and phalli, which may have been made of pastry. See Martial's *Epigrams*, b. xiv. 69. This gem is valuable, inasmuch as it assists us to understand the signification of the pine cone offered to the 'grove,' the equivalent of *le Verger de Cypris*. The pillar and its base are curiously significant, and demonstrate how completely an artist can appear innocent, whilst to the initiated he unveils a mystery.

Figure 128.

Figures 125, 126, 127, are various contrivances for indicating decently that which it was generally thought religious to conceal, *la bequile, au les instrumens*.

Figure 128 represents the same subject; the cuts

Figure 129. Figure 130. Figure 131.

are grouped iso as to show how the knobbed stick, *le bâton*, becomes con-

verted either into a bent rod, *la verge*, or a priestly crook, *le bâton pastoral*. There is no doubt that the episcopal crozier is a presentable effigy of a very private and once highly venerated portion of the human frame, which was used in long by-gone days by Etruscan augurs, when they mapped out the sky, prior to noticing the flight of birds. Perhaps we ought to be grateful to Popery for having consecrated to Christ what was so long used in that which divines call the service of the devil.

Figures 129, 130, 131, are, like the preceding four, copied from various antique gems; Fig. 129 represents a steering oar, *le timon*, and is usually held in the hand of good fortune, or as moderns would say "Saint Luck," or *bonnes fortunes*; Fig. 180 is emblematic of Cupid, or Saint Desire; it is synonymous with *le dard, or la pique*; Fig. 131 is a form less common in gems; it represents the hammer, *le marteau qui frappe l'enclume et forge les enfans*. The ancients had as many pictorial euphemisms as ourselves, and when these are understood they enable us to comprehend many a legend otherwise dim; *e.g.,*

when Fortuna, or luck, always depicted as a woman, has for her characteristic *le timon*, and for her motto the proverb, "Fortune favours the bold." we readily understand the *double entente*. The steering oar indicates power, knowledge, skill, and bravery in him who wields it; without such a guide, few boats would attain a prosperous haven.

Figure 132 is copied from plate xxix. of Pugin's *Glossary of Ecclesiastical Ornament* (Lond., 1868). The plate represents "a

Figure 132.

pattern for diapering," and is, I presume, thoroughly orthodox. It consists of the double triangle, see Figures 20, 80, 81, 82, pp. 82, 88, the emblems of Siva and Parvati, the male and female; of Rimmon the pomegranate, the emblem

96

of the womb, which is seen to be full of seed through the *"vesica piscis,"* la *fente, or la porte de la vie*. There are also two new moons, emblems of Venus, or *la nature*, introduced. The crown above the pomegranate represents the triad, and the number four; whilst in the original the group which we copy is surrounded by various forms of the triad, all of which are as characteristic of man as Rimmon is of woman. There are also circles enclosing the triad, analogous to other symbols common in Hindostan.

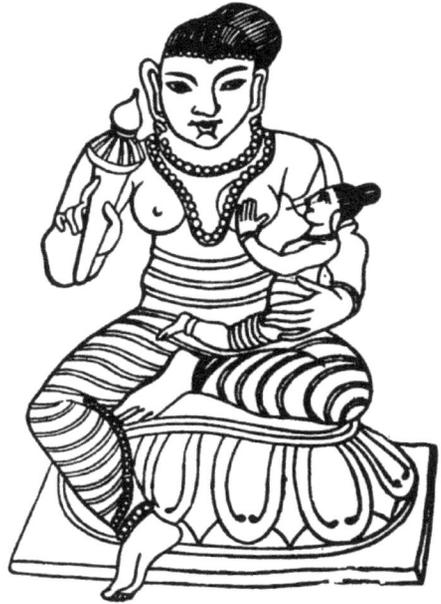

Figure 133.

Figure 133 is copied from Moor's *Hindu, Pantheon*, pi. ix., fig. 8. It represents Bhavhani, Maia, Devi, Lakshmi, or Kamala, one of the many forms given to female nature. She bears in one hand the lotus, emblem of self-fructification,—in other similar figures an effigy of the phallus is placed,—whilst in the other she holds her infant Krishna, Crishna, or Vishnu. Such groups are as common in India as in Italy, in pagan temples as in Christian churches. The idea of the mother and child is pictured in every ancient country of whose art any remains exist.

Figure 134 is taken from plate xxiv., fig. 1, of Moor's *Hindu Pantheon*. It represents a subject often depicted by the Hindoos and the Greeks, viz., androgynism, the union of the male and female creators. The technical word is Arddha-Nari. The male on the right side bears the emblems of Siva or Mahadeva, the female on the left those of Parvati or Sacti. The bull and lioness are emblematic of the masculine and feminine powers. The mark on the temple indicates the union of the two; an aureole is seen around the head, as in modern pictures of saints. In this drawing the Ganges rises from the male, the idea being that the stream from Mahadeva is as copious and fertilising as that mighty river. The metaphor here depicted is common in the East, and is precisely the same as that quoted in Num. xxiv. 7, and also from some lost Hebrew book in John vii. 38. It will be noticed, that the Hindoos express androgyneity quite as conspicuously, but generally much less indelicately, than the Grecian artists.

Figure 135 is a common Egyptian emblem, said to signify eternity, but in truth it has another meaning. The serpent and the ring indicate *l' andouille and l' anneau*. The tail of the animal, which the mouth appears to swallow, is *la queue dans la bouche*. The symbol resembles the *crux ansata* in its signification, and imports that life upon the earth is rendered perpetual by means

97

of the union of the sexes. A ring, or circle, is one of the symbols of Venus, who carries indifferently this, or the triad emblem of the male. See Maffei's *Gemme*, vol. iii., page 1, plate viii.

Figure 136 is the *vesica piscis*, or fish's bladder; the emblem of woman and of the virgin, as may be seen in the two following woodcuts.

Figures 137, 138, are copied from an ancient Rosary of the Blessed Virgin Mary, printed at Venice, 1524,

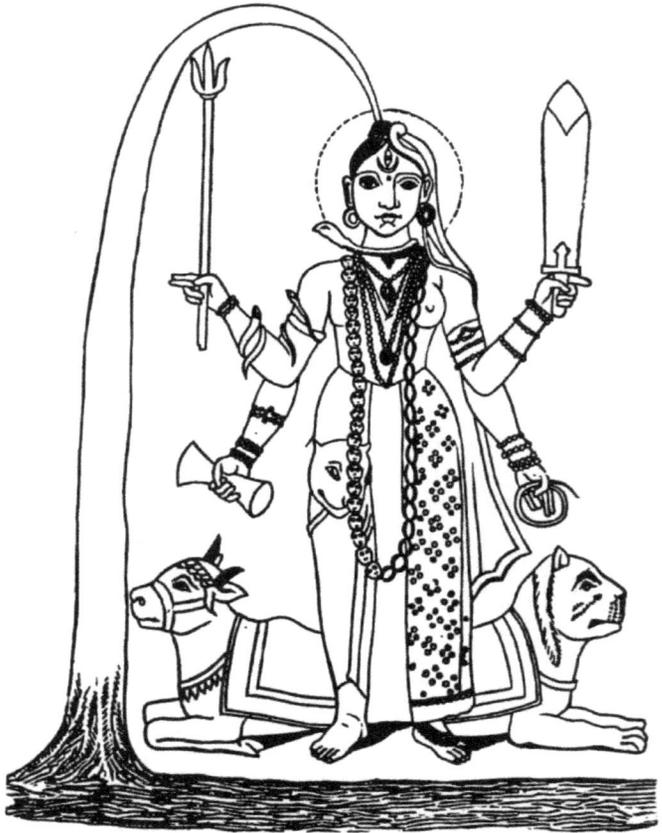

Figure 134.

with a license from the Inquisition; the book being lent to me by my friend, Mr. Newton. The first represents the same part as the Assyrian "grove." It may appropriately be called the Holy Yoni. The book in question contains numerous figures, all resembling closely the Mesopotamian emblem of Ishtar. The presence of the woman therein identifies the two as symbolic of Isis, or *la nature*; and a man bowing down in adoration thereof shows the same idea as is depicted in Assyrian sculptures, where males offer to the goddess symbols of themselves. Compare Figs. 68, 64, 65, 66, pp. 48 seq.

Figure 135. Figure 136.

If I had been able to search through the once celebrated Alexandrian library, it is doubtful whether I could have found any pictorial representation more illustrative of the relationship of certain symbolic forms to each other than is Figure 138. A circle of angelic heads, forming a sort of sun, having luminous rays outside,

and a dove, the emblem of Venus, dart a spear (*la pique*) down upon the earth (*la terré*), or the virgin. This being received, fertility follows.

In Grecian story, Ouranos and Ge, or heaven and earth, were the parents of creation; and Jupiter came from heaven to impregnate Alcmena. The same mythos prevailed throughout all civilised nations. Christianity adopted the idea, merely altering the names of the respective parents, and attributed the regeneration of the world to "holy breath" and Mary. Every individual, indeed, extraordinarily conspicuous for wisdom, power, goodness, etc., is said to have been begotten on a woman by a celestial father. Within the *vesica piscis*, artists usually represent the virgin herself, with or without the child; in the figure before us the child takes her place. It is difficult to believe that the ecclesiastics who sanctioned the publication of such a print could have been as ignorant as modern ritualists. It is equally difficult to believe that the latter, if they knew the real meaning of the symbols commonly used by the Roman church, would adopt them.

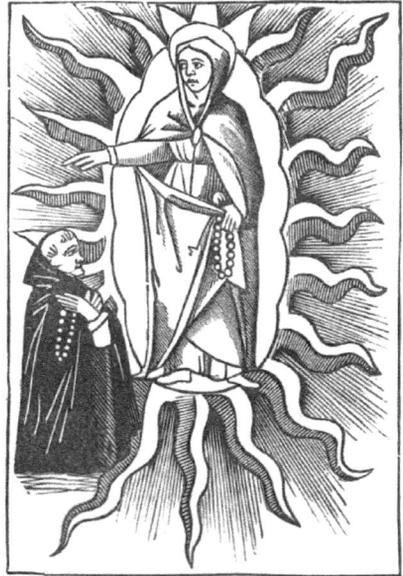

Figure 187.

The last two figures, symbolic of adoration before divine sexual emblems, afford me the opportunity to give a description of a similar worship existent in Hindostan at the present time. My authority is H. H. Wilson, in *Essays on the Religion of the Hindoos*, Trübner and Co., London. "The worshippers," he remarks, vol. i., p. 240, "of the Sakti, the power or energy of the divine nature in action, are exceedingly numerous amongst all classes of Hindoos—about three-fourths are of this sect, while only a fifth are Vaishnavas and a sixteenth

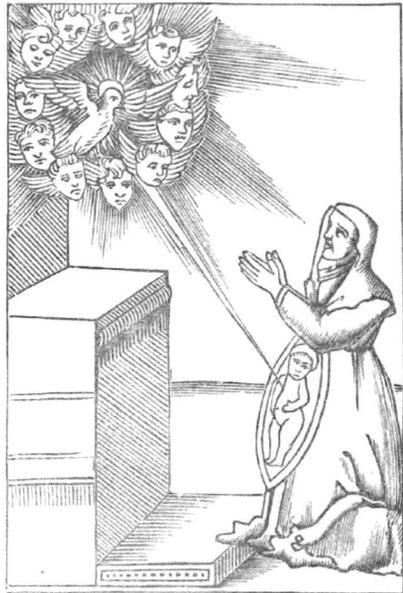

Figure 188.

Saivas. This active energy is personified, and the form with which it is invested depends upon the bias of the individuals. The most favourite form is that of Parvati, Bhavani, or Durga, the wife of Siva, or Mahadeva."

"The worship of the female principle, as distinct from the divinity, appears to have originated in the literal interpretation of the metaphorical language of the Vedas, in which the *will or purpose to create* the universe is represented as originating from the creator, and consistent with him as his bride." "The Samaveda for example, says, the creator felt not delight being alone; he wished another, and caused his own self to fall in twain, and thus became husband and wife. He approached her, and thus were human beings produced." A sentiment or statement which we may notice in passing is very similar to that propounded in Genesis, ch. i. 27, and v. 1, 2, respecting Elohim—viz., that he created man and woman in his own image, i.e., as male and female, bisexual but united—an androgyne.

"This female principle goes by innumerable cognomens, inasmuch as every goddess, every nymph, and all women are identified with it. She—the principle personified—is the mother of all, as Mahadeva, the male principle, is the father of all."

"The homage rendered to the Sakti may be done before an image of any goddess—Prakriti, Lakshmi, Bhavani, Durga, Maya, Parvati, or Devi—just in the same way as Romanists may pray to a local Mary, or any other. But in accordance with the weakness of human nature, there are many who consider it right to pay their devotions to the thing itself rather than to an abstraction. In this form of worship six elements are required, flesh, fish, wine, women, gesticulations and *mantras* which consist of various unmeaning monosyllabic combinations of letters of great imaginary efficacy."

"The ceremonies are mostly gone through in a mixed society, the Sakti being personified by a naked female, to whom meat and wine are offered and then distributed amongst the company. These eat and drink alternately with gesticulations and mantras—and when the religious part of the business is over, the males and females rush together and indulge in a wild orgy. This ceremony is entitled the *Sri Chakra or Purnabhisheka*, the Ring or Full Initiation."

In a note apparently by the editor, Dr. Rost, a full account is given in Sanscrit of the *Sakti Sodhana*, as they are prescribed in the *Devi Rahasya*, a section of the *Rudra Yâmala*, so as to prove to his readers that the *Sri Chakra* is performed under a religious prescription.

We learn that the woman should be an actress, dancing girl, a courtesan, washerwoman, barber's wife, flower-girl, milk-maid, or a female devotee. The ceremony is to take place at midnight with eight, nine, or eleven couples. At first there are sundry mantras said, then the female is disrobed, but richly ornamented, and is placed on the left of a circle (Chakra) described for the purpose, and after sundry gesticulations, mantras, and formulas she is purified by being sprinkled over with wine. If a novice, the girl has the radical mantra whispered thrice in her ear. Feasting then follows, lest Venus should languish in the absence of Ceres and Bacchus, and now, when the veins are full of rich blood, the actors are urged to do what desire dictates, but never to

be so carried away by their zeal as to neglect the holy mantras appropriate to every act and to every stage thereof. [4]

It is natural that such a religion should be popular, especially amongst the young of both sexes.

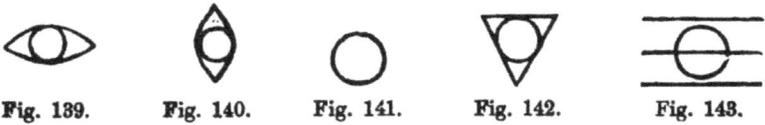

| Fig. 139. | Fig. 140. | Fig. 141. | Fig. 142. | Fig. 143. |

| Fig. 144. | Fig. 145. | Fig. 146. | Fig. 147. | Fig. 148. |

| Fig. 149. | Fig. 150. | Fig. 151. |

| Fig. 152. | Fig. 153. |

Figures 139 to 153 are copied from Moor's *Hindu Pantheon*; they are sectarial marks in India, and are usually traced on the forehead. Many resemble what are known as "mason's marks," i. e., designs found on tooled stones, in various ancient edifices, like our own, "trade marks." They are introduced here to illustrate the various designs employed to indicate the union of the "trinity" with the "unity," and the numerous forms representative of "*la nature*" A priori, it appears absurd to suppose that the eye could ever have been symbolical of anything but sight; but the mythos of Indra, given in *Ancient Faiths*, second edition, Vol. II., p. 649, and p. 7 *supra*, proves that it has another and a hidden meaning. These figures are alike emblematic of the "trinity," "the virgin," and the "four."

Figure 154.

Figure 154 is from Pugin, plate v., figure 3. It is the outline of a pectoral ornament worn by some Roman ecclesiastic in Italy, A.D. 1400; it represents the Egyptian crux ansata under another form, the T signifying the triad.

Figures 155, 156, are different forms of the sistrum, one of the emblems of Isis. In the latter, the triple bars have one signification, which will readily suggest itself to those who know the meaning of the triad. In the former, the emblem of the trinity, which we have been obliged to conventionalise, is

shown in a distinct manner. The cross bars indicate that Isis is a virgin. The cat at the top of the instrument indicates "desire," Cupid, or Eros. Fig. 155 is copied from plate ix., R. P. Knight's *Worship of Priapus*.

Figure 157 represents the cup and wafer, to be found in the hands of many effigies of papal bishops; they are alike symbolic of the sun and moon, and of the elements in the Eucharist. See Pugin, plate iv., figs. 5, 6, represents a temple in a conventional form; whilst below, Ceres appears seated within a horse-shoe shaped ornament.

Figure 156. Figure 157.

Figure 158.

This, amongst other symbols, tends to show what we have so frequently before observed, that the female in creation is characterised by a great variety of designs, of which the succeeding woodcuts give us additional evidence.

Figure 155.

Figure 159 represents the various forms symbolic of Juno, Isis, Parvati, Ishtar, Mary, or woman, or the virgin.

Figures 160, 161, 162, are copied from Audsley's *Christian Symbolism* (London, 1868). They are ornaments worn by the Virgin Mary, and represent her as the crescent moon, conjoined with the cross (in Fig. 160), with the collar of Isis (in Fig. 161), and with the double triangle (in Fig. 162).

Figure 159.

Figure 160. Figure 161. Figure 162.

Figure 163.

Figure 163 represents a tortoise. When one sees a resemblance between this creature's head and neck and the linga, one can understand why both in India and in Greece the animal should be regarded as sacred to the goddess personifying the female creator, and why in Hindoo myths it is said to support the world.

In the British Museum there are three Assyrian obeliscs, all of which represent, in the most conspicuous way, the phallus, one of which has been apparently circumcised. The body is occupied with an inscription recording the sale of land, and also a figure of the reigning king, whilst upon the part known as the *glans penis* are a number of symbols, which are intended apparently to designate the generative powers in creation. The male is indicated by a serpent, a spear head, a hare, a tiara, a cock, and a tortoise. The female appears under precisely the same form as is seen on the head of the Egyptian Isis, Fig. 28. The tortoise is to this day a masculine emblem in Japan. See Figs. 174, 175.

But there is no necessity for the animal itself always to be depicted, inasmuch as I have discovered that both in Assyrian and Greek art the tortoise is

portrayed under the figure ▣ which resembles somewhat the markings upon the segments into which the shell is divided. In symbolism it is a very

103

common thing for a part to stand for the whole; thus an egg is made to do duty for the triad; and a man is sometimes represented by a spade. A woman is in like manner represented by a comb, or a mirror; and a golden fleece typifies in the first place the "grove," which it overshadows, and the female who possesses both.

It has been stated on page 19 *supra*, that Pausanias mentions having seen at some place in Greece one figure of Venus standing on a tortoise, and another upon a ram, but he leaves to the ingenious to discover why the association takes place.

Figure 164. **Figure 165.**

It was this intimation which led me to identify the tortoise as a male symbol. Any person who has ever watched this creature in repose, and seen the action of the head and neck when the quadruped is excited, will recognise why the animal is dear to the goddess of amorous delight, and that which it may remind her of. In like manner, those who are familiar with the ram will know that it is remarkable for persistent and excessive vigour. Like the cat, whose salacity caused it to be honoured in Egypt, the ram was in that country also sacred, as the bull was in Assyria and Hindostan.

In fact, everything which in shape, habits, or sound could remind mankind of the creators and of the first part of creation was regarded with reverence. Thus tall stones or natural pinnacles of rock, the palm, pine, and oak trees, the fig tree and the ivy, with their tripliform leaves, the mandrake, with its strange human form, the thumb and finger, symbolised Bel, Baal, Asher, or Mahadeva. In like manner a hole in the ground, a crevice in a rock, a deep cave, the myrtle from the shape of its leaf, the fish from its scent, the dolphin and the mullet from their names, the dove from its note, and any umbrageous retreat surrounded with thick bushes, were symbolic of woman.

Figure 166.

So also the sword and sheath, the arrow and target, the spear and shield, the plough and furrow, the spade and trench, the pillar by a well, the thumb thrust between the two forefingers or grasped by the hand, and a host of other things were typical of the union which brings about the formation of a new being.

I cannot help regarding the sexual element as the key which opens almost every lock of symbolism, and however much we may dislike the idea that modern religionists have adopted emblems of an obscene worship, we cannot deny the fact that it is so, and we may hope that with a knowledge of

their impurity we shall cease to have a faith based upon a trinity and virgin—a lingam and a yoni. Some may cling still to such a doctrine, but to me it is simply horrible—blasphemous and heathenish.

Figures 164, 165, represent a pagan and Christian cross and trinity. The first is copied from B. P. Knight (plate x., fig. 1), and represents a figure found on an ancient coin of Apollonia. The second may be seen in any of our churches to-day.

Figure 166 is from an old papal book lent to me by Mr. Newton, *Missale Romanum*, illustrated by a monk (Venice, 1509). It represents a confessor of the Roman church, who wears the *crux ansata*, the Egyptian symbol of life, the emblem of the four creators, in the place of the usual *pallium*.

It is remarkable that a Christian church should have adopted so many pagan symbols as Rome has done. Figure 167 is copied from a small bronze figure in the Mayer collection in the Free Museum, Liverpool. It represents the feminine creator holding a well marked lingam in her hand, and is this emblematic of the four, or the trinity and the virgin.

Figure 168 represents two Egyptian deities in worship before an emblem of the male, which closely resembles an Irish round tower.

Figure 169 represents the modern *pallium* worn by Roman priests. It represents the ancient sistrum of Isis, and the yoni of the Hindoos. It is symbolic of the celestial virgin, and the unit in the creative four. When donned by a Christian priest, he resembles the pagan male worshippers, who wore a female dress when they ministered before the altar or shrine of a goddess. Possibly the Hebrew ephod was of this form and nature.

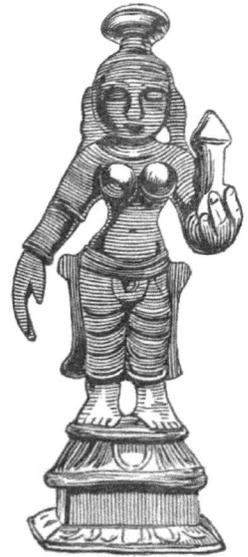

Figure 168.

Figure 169.

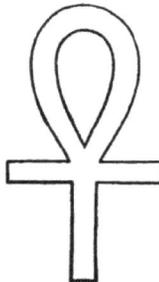

Figure 170.

Figure 167.

Figure 170 is a copy of an ancient *pallium*, worn by papal ecclesiastics three or four centuries ago.. It is the old Egyptian symbol described above. Its common name is *crux ansata*, or the cross with a handle.

Figure 171 is the *albe* worn by Roman and other ecclesiastics when officiating at mass, etc. It is simply a copy of the chemise ordinarily worn by women as an under garment.

Figure 172 represents the *chasuble* worn by papal hierarchs. It is copied from Pugin's *Glossary*, etc. Its form is that of the *vesica piscis*, one of the most common emblems of the yoni. It is adorned by the triad. When worn by the priest, he forms the male element, and with the chasuble completes the sacred four. When worshipping the ancient goddesses, whom Mary has displaced, the officiating ministers clothed themselves in feminine attire. Hence the use of the chemise, etc. Even the tonsured head, adopted from the priests of the Egyptian Isis, represents "l'anneau;" so that on head, shoulders, breast and body, we may see on Christian priests the relics of the worship of Venus, and the adoration of woman! How horrible all this would sound if, instead of using veiled language, we had employed vulgar words. The idea of a man adorning himself, when minis-

Figure 171.

tering before God and the people, with the effigies of those parts which nature as well as civilisation teaches us to conceal, would be simply disgusting, but when all is said to be mysterious and connected with hidden signification, almost everybody tolerates and many eulogise or admire it!

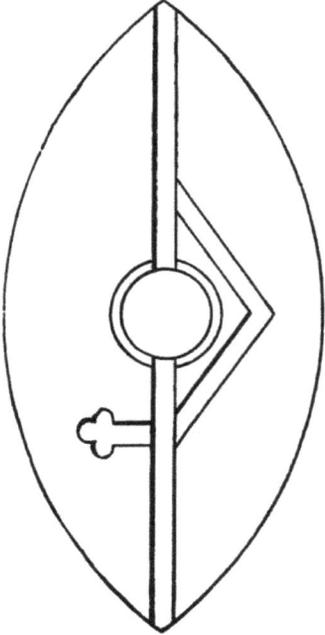

Figure 172.

[1] A friend has informed me, for example, that he happened, whilst at Pesth, to look at a gorgeously dressed and handsome young woman. To his astonishment she pointed her thumb precisely in the manner adopted by the Assyrian priests; this surprised the young man still farther, and being, as it were, fascinated, he continued to gaze. The damsel then grasped the thumb by the other hand; thus indicating her profession. My friend, who was wholly inexperienced in the ways of the world, only understood what was meant when he saw my explanation of Fig. 1.

[2] For those who have not an opportunity of consulting the work referred to, I may observe that the Assyrian godhead consisted of four persons, three being male and one female. The principal god was *Asher,* the upright one, the equivalent of the Hindoo Mahadeva, the great holy one, and of the more modern Priapus. He was associated with Anu, lord of solids and of the lower world, equivalent to the "testis," or egg on the right side. *Hea* was lord of waters, and represented the left "stone." The three formed the trinity or triad. The female was named Ishtar or Astarte, and was equivalent to the female organ, the yoni or vulva—the [Greek] of the Greeks. The male god in Egypt was Osiris, the female Isis, and these names are frequently used as being euphemistic, and preferable to the names which are in vulgar use to describe the male and female parts.

[3] There is an able essay on this subject in No. 267 of the *Edinburgh Review* — which almost exhausts the subject — but is too long for quotation here.

[4] The above quotations from Wilson's work are selections from his and his Editor's account. In the original the observations extend over eighteen pages, and are too long to be given in their entirety: the parts omitted are of no consequence.

Appendix: The Assyrian "Grove" And Other Emblems

By John Newton, M.R.C.S.

The study of sacred symbols is as yet in its infancy. It has hitherto been almost ignored by sacerdotal historians; and thus a rich mine of knowledge on the most interesting of all subjects—the history of the Religious Idea in man—remains comparatively unexplored. The topic has a two-fold interest, for it equally applies to the present and the past. As nothing on earth is more conservative than religion, we have still a world of symbolism existing amongst us which is far older than our sects and books, our creeds and articles, a relic of a forgotten, pre-historic past. Untold ages before writing was invented, it is believed that men attempted to express their ideas in visible forms. Yet how can a savage, who is unable to count his fingers up to five, and has no idea of abstract number, apart from things, whose habits and thoughts are of the earth, earthy, form a conception of the high and holy One who inhabiteth eternity? Even under the highest forms of ancient civilisation, abundant proofs exist that the imagination of men, brooding over the idea of the Unseen and the Infinite, were bounded by the things which were presented in their daily experience, and which most moved their passions, hopes and fears. Through these, then, they attempted to embody such religious ideas as they felt. They could not teach others without visible symbols to assist their conceptions; and emblems were rather crutches for the halting than wings to help the healthy to soar. Mankind in all ages has clung to the visible and tangible. The people care little for the abstract and unseen. The Israelites preferred a calf of gold to the invisible Jehovah; and sensuous forms of worship still fascinate the multitude.

Whilst studying a collection of symbols, gathered from many climes and ages, such as this volume presents, I feel sure that every intelligent student will have asked himself more than once—Is there not some key which unlocks these enigmas, some grand idea which runs through them all, connecting them like a string of beads? I believe that there is, and that it is not far to seek. What do men desire and long for most? *Life*. "Skin for skin; all that a man hath will he give for his life," is a saying as true now as in the days of Job. "Give me back my youth, and I will give you all I possess," was said by the aged Voltaire to his physician. And our poet laureate has sung,

'Tis Life, whereof our nerves are scant,
O life, not death, for which we pant;
More life, and fuller, that I want.

108

But we must add, as necessarily contained in the idea of Life in its highest sense, *those things which make Life desirable.*

This fulness of life has been the *summum bonum*, the highest good, which mankind has sighed for in every age and clime. For this the alchemists toiled, not to advance chemistry, but to discover the Elixir of Life and the Philosopher's Stone. But what nature refused to science, the gods, it was believed, would surely give to the pious! and the glorious prize referred to has been promised by every religion. "I am come that they might have Life, and that they might have it more abundantly." Life is the reward which has been promised under every system, including that of the founder of Christianity. A Tree of Life stood in the midst of that Paradise which is described in the book of Genesis; and when the first human couple disobeyed their Maker's command, they were punished by being cut off from the perennial fount of vitality, lest they should eat its fruit and thus live for ever; and in a second Paradise, which is promised to the blessed by the author of the book of Revelation, a tree of life shall stand once more "for the healing of the nations." To the good man is promised, in the Hebrew Scriptures, long life, prosperity, and a numerous offspring. "Thy youth is renewed like the eagle's." [1] Ps. ciii. 5.

In the wondrous theology of Ancient Egypt, which at length is open to us, the "Ritual of the Dead" celebrates the mystical reconstruction of the body of the deceased, whose parts are to be reunited, as those of Osiris were by Isis; the trials are recorded through which the deceased passes, and by which all remaining stains of corruption are wiped away; and the record ends when the defunct is born again glorious, like that Sun which typified the Egyptian resurrection. [2]

In the ancient mythology of India, it is recounted that of old the gods in council united together to procure, by one supreme effort, the Amrita cup of immortality, which, after the success of their scheme, they partake of with their worshippers. Even for the Buddhist, his cold, atheistical creed promises a Nirvana, an escape from the horrors of metempsychosis, a haven of eternal calm, where "there shall be no more death, neither sorrow nor crying, neither shall there be any more pain, for the former things are passed away;" "there the weary be at rest." Rev. xxi. 4, Job iii. 17.

This idea of tranquillity is in striking contrast to the heaven promised by the religion of the north of Europe, which was the one most congenial to a people whose delight was in conquest and battle. Those who had led a life of heroism, or perished bravely in fight, ascended to Valhalla; and the eternal manhood which awaited them there was to be passed in scenes that were rapture to the imagination of a Dane or a Saxon. Every day in that abode of bliss was to be spent in furious conflict, in the struggle of armies and the cleaving of shields; but at evening the conflict was to cease; every wound to be suddenly healed. Then the contending warriors were to sit down to a banquet, where, attended by lovely maidens, they could feast on the exhaust-

less flesh of the boar Sæhrimnir, and drink huge draughts of mead from the skulls of those enemies who had not attained to the glories of Valhalla.

The paradise promised to the faithful by Mahomet is full of sensuous delights. The Arabian prophet dwells with rapture on its gardens and palaces, its rivers and bowers. Seventy-two houris, or black-eyed girls, rejoicing in beauty and ever-blooming youth, will be created for the use of the meanest believer; a moment of pleasure will be prolonged to a thousand years, and his powers will be increased a hundred-fold to render him worthy of his felicity.

Thus we see that in all these great historical faiths the prize held out to the true believer has this in common, viz., *Life, overflowing, ever-renewed, with the addition of those things which make life desirable for men*; whether they are sensuous pleasures, or those which, under the loftier ideal of Christianity, are summed up in *Life, both temporal and eternal, in the light of God*.

Such being the case, we might anticipate that the symbols of every religion would reproduce, in some shape or other, the ideal which is common to all. The earliest and rudest faiths were content with gross and simple emblems of life. In the later and more refined forms of worship, the ruder types were highly conventionalised, and replaced by a more intricate and less obvious symbolism.

We proceed now to investigate the more primitive emblems. The origin of life is, even to us, with all our lights, as great a mystery as it was to the ancients. To the primitive races of mankind the formation of a new being appeared to be a constant miracle, and men very naturally used as tokens of life, and even worshipped, those objects or organs by which the miracle appeared to be wrought. Thus, the glorious sun, that "god of this world," the source of life and light to our earth, was early adored, and an effigy thereof used as a symbol. Mankind watched with rapture its rays gain strength daily in the Spring, until the golden glories of Midsummer had arrived, when the earth was bathed during the longest days in his beams, which ripened the fruits that his returning course had started into life. When the sun once more began its course downwards to the Winter solstice, his votaries sorrowed, for he seemed to sicken and grow paler at the advent of December, when his rays scarcely reached the earth, and all nature, benumbed and cold, sunk into a death-like sleep. Hence feasts and fasts were instituted to mark the commencement of the various phases of the solar year, which have continued from the earliest known period, under various names, to our own times.

The daily disappearance and the subsequent rise of the sun, appeared to many of the ancients as a true resurrection; thus, while the east came to be regarded as the source of light and warmth, happiness and glory, the west was associated with darkness and chill, decay and death. This led to the common custom of burying the dead so as to face the east when they rose again, and of building temples and shrines with an opening towards the east. To effect this, Vitruvius, two thousand years ago, gave precise rules, which are still followed by Christian architects.

Sun-worship was spread all over the ancient world. It mingled with other faiths and assumed many forms. [3] Of the elements, fire was naturally chosen as its earthly symbol. A sacred fire, at first miraculously kindled, and subsequently kept up by the sedulous care of priests or priestesses, formed an important part of the religions of Judea, Babylonia, Persia, Greece and Rome, and the superstition lingers amongst us still.

So late as the advent of the Reformation, a sacred fire was kept ever burning on a shrine at Kildare, in Ireland, and attended by virgins of high rank, called "*inghean au dagha*," or daughters of fire. Every year is the ceremony repeated at Jerusalem of the miraculous kindling of the Holy Fire at the reputed sepulchre, and men and women crowd to light tapers at the sacred flame, which they pass through with a naked body. Indeed, solar myths form no unimportant part of ancient mythology. Thus the death of nature in the winter time, through the withdrawal of the sun, was supposed to be caused by the mourning of the earth-goddess over the sickness and disappearance into the realms of darkness of her husband and mate, the sun.

Mr. Fox Talbot has lately given the translation of an Egyptian poem, more than three thousand years old, and having for its subject the descent of Ishtar into Hades. To this region of darkness and death the goddess goes in search of her beloved Osiris, or Tammuz. This Ishtar is identical with the Assyrian female in the celestial quartette, the later Phoenician Astarte, "The Queen of Heaven with crescent horns," the moon-goddess, also with the Greek Aphrodite and Roman Venus; and the Egyptian legend reappears in the west as the mourning of Venus for the loss of Adonis.

Again, the fable of Ceres mourning the death of her daughter Proserpine is another sun-myth. The Roman Ceres was the Greek Δημήτηρ, or γή μήτηρ, Mother Earth, who through the winter time wanders inconsolable. Persephone, her daughter, is the vegetable world, whose seeds or roots lie concealed underground in the darkness of winter. These, when Spring comes with its brightness, bud forth and dwell in the realms of light during a part of the year, and provide ample nourishment for men and animals with their fruits. The sun, being the active fructifying cause in nature, was generally regarded as male. Thus, in the Jewish scriptures, he is compared to "a bridegroom coming out of his chamber" (Ps. xix. 5), *i.e.,* as a man full of generative, procreative vigour. The moon and the earth, being receptive were naturally regarded as female.

At the vernal equinox, the ancients celebrated the bridal of the sun and the earth. Yet, inasmuch as the orbs of heaven and the face of nature remain the same from year to year, and perpetually renew light and life, themselves remaining fresh in vigour and unharmed by age, the ancients conceived the bride and mate of the sun-god as continuing ever virgin. Again, as the ancient month was always reckoned by the interval between one new moon and the next,—an interval which also marks a certain recurring event in women, that ceases at once on the occurrence of pregnancy,—the lunar crescent became a symbol of virginity, and as such adorns the brow of the Greek Artemis and

Roman Diana. This was used as a talisman at a very remote period, and was fixed over the doors of the early lake-dwellers in Switzerland, like the horse-shoe is to modern side-posts. With the sun and moon were often associated the five visible planets, forming a sacred seven,—a figure which is continually cropping up in religious emblems.

So much for the great cosmic symbols of Life. But the primitive races of mankind found others nearer home, and still more suggestive—the generative parts in the two sexes, by the union of which all animated life, and mankind, the most interesting of all to human beings, appeared to be created. This reverence for, or worship of, the organs of generation, has been traced to a very early period in the history of the human race. In a bone-cave recently excavated near Venice, and beneath its ten feet of stalagmite, were found bones of animals, flint implements, a bone needle, and a phallus in baked clay. And if we turn to those savage tribes who still reproduce for us the prehistoric past, this form of religious symbolism meets as everywhere. In Dahomey, beyond the Ashantees, it is, according to Captain Barton, most uncomfortably prominent. In every street of their settlements are priapic figures. The "Tree of Life" is anointed with palm oil, which drips into a pot or shard placed below it, and the would-be mother of children prays before the image that the great god Legba would make her fertile.

Burton tells us that he peeped into an Egba temple or lodge, and found it a building with three courts, of which the innermost was a sort of holy of holies. Its doors had carvings on them of a leopard, a fish, a serpent, and a land tortoise. The first two of these are female symbols, the two latter emblems of the male. There were also two rude figures representing their god Obatala, the deity of life, who is worshipped under two forms, a male and a female. Opposite to these was the male symbol or phallus, conjoined *in coitu* with the female emblem. Du Chaillu met with some tribes in Africa who adore the female only. His guide, he informs us, carried a hideous little image of wood with him, and at every meal he would take the little fetish out of his pocket, and pour a libation over its *feet* before he would drink himself.

We know that a similar superstition prevailed in Ireland long after the advent of Christianity. There a female, pointing to her symbol, was placed over the portal of many a church as a protector from evil spirits; and the elaborate though rude manner in which these figures were sculptured shows that they were considered as objects of great importance. It was the universal practice among the Arabs of Northern Africa to stick up over the door of their house or tent the genital parts of a cow, mare, or female camel, as a talisman to avert the influence of the evil eye. The figure of this organ being less definite than that of the male, it has assumed in symbolism very various forms. The commonest substitution for the part itself has been a horse-shoe, which is to this day fastened over many of the doors of stables and shippons in the country, and was formerly supposed to protect the cattle from witchcraft. From a lively story by Beroalde de Verville, we learn that in France a sight of the female organ was believed, as late as the sixteenth century, to be a powerful

charm in curing any disease in, and for prolonging the life of, the fortunate beholder.

As civilisation advanced, the gross symbols of creative power were cast aside, and priestly ingenuity was taxed to the utmost in inventing a crowd of less obvious emblems, which should represent the ancient ideas in a decorous manner. The old belief was retained, but in a mysterious or sublimated form. As symbols of the male, or active element in creation, the sun, light, fire, a torch, the phallus or linga, an erect serpent, a tall straight tree, especially the palm and the fir or pine, were adopted. Equally useful for symbolism were a tall upright stone (menhir), a cone, a pyramid, a thumb or finger pointed straight, a mast, a rod, a trident, a narrow bottle or amphora, a bow, an arrow, a lance, a horse, a bull, a lion, and many other animals conspicuous for masculine power. As symbols of the female, the passive though fruitful element in creation, the crescent moon, the earth, darkness, water, and its emblem a triangle with the apex downwards, "the yoni," a shallow vessel or cup for pouring fluid into (*cratera*), a ring or oval, a lozenge, any narrow cleft, either natural or artificial, an arch or doorway, were employed. In the same category of symbols came a ship or boat, the female date-palm bearing fruit, a cow with her calf by her side, the fish, fruits having many seeds, such as the pomegranate, a shell (*concha*), a cavern, a garden, a fountain, a bower, a rose, a fig, and other things of suggestive form, etc.

These two great classes of conventional symbols were often represented *in conjunction with* each other, and thus symbolised in the highest degree the great source of life, ever originating, ever renewed. The Egyptian temple at Denderah has lately been explored by M. Mariette. In a niche of the Holy of Holies he discovered the sacred secret. This was simply a golden sistrum, an emblem formed by uniting the female oval **0** with the male sacred Tau **T**; and thus identical in meaning with the coarse emblem seen by Captain Burton in the African idol temple. A similar emblem is the linga standing in the centre of a yoni, the adoration of which is to this day characteristic of the leading dogma of Hindu religion. There is scarcely a temple in India which has not its lingam; and in numerous instances this symbol is the only form under which the great god Siva is worshipped. (See *ante*, pp. 72, 78.)

The linga is generally a tall, polished, cylindrical, black stone, apparently inserted into another stone formed like an elongated saucer, though in reality the whole is sculptured out of one block of basalt. The outline of the frame, which reminds us of a Jew's harp (the conventional form of the female member), is termed *argha or yoni*. The former, or round perpendicular stone, the type of the virile organ, is the *linga*. The entire symbol, to which the name *lingyoni* is given, is also occasionally called *lingam*. This representative of the union of the sexes typifies the divine *sacti*, or productive energy, in union with the procreative, generative power seen throughout nature. The earth was the primitive *pudendum, or yoni*, which is fecundated by the solar heat, the sun, the primitive *linga*, to whose vivifying rays man and animals, plants and the fruits of the earth, owe their being and continued existence. These

"lingas" vary in size from the tiny amulets worn about the neck, to the great monoliths of the temples. Thus the lingam is an emblem of the Creator, the fountain of all life, who is represented in Hindu mythology as uniting in Himself the two sexes.

Another symbol, the *caduceus*, older than Greek and Roman art, in which it is associated with Esculapius and Hermes, the gods of health and fertility, has precisely the same signification as the sistrum and the lingam. This is made clear enough in the following extract from a letter by Dr. C. E. Balfour, published in Fergusson's *Tree and Serpent Worship*, 1878. "I have only once seen living snakes in the form of the Esculapian rod. It was at Ahmednuggar, in 1841, on a clear moonlight night. They dropped into the garden from the thatched roof of my house, *and stood erect.*" They were all cobras, and *no one could have seen them without at once recognising that they were in congress.* Natives of India consider that it is most fortunate to witness serpents so engaged, and believe that if a person can throw a cloth at the pair so as to touch them with it, the material becomes a representative form of Lakshmi, [4] of the highest virtue, and is preserved as such." The serpent, which casts its skin and seems to renew its youth every year, has been used from remotest times as a living symbol of generative energy, and of immortality; indeed, in the most ancient Eastern languages, the name for the serpent also signifies life. [5] It has been usually worshipped as the *Agathodoemon*, the god of good fortune, life, and health; though in the Hebrew scriptures, and elsewhere, we meet with a good and a bad serpent—Oriental dualism. The *Kakodoemon*, however, is usually represented as winged—the Dragon, as in the following example.

Fig. 173.

In the remarkable Babylonian seal, Plate iv., Fig. 8, the deity is represented as uniting in himself the male and the female. On each side is a serpent, as the emblem of the life flowing from the Creator; that on the male side, having round his head the solar glory, is compared to the sun-god, as the active principle in creation; that on the female side, over whose head is the lunar crescent, to the moon- and earth- goddess, the passive principle in creation. Both are attacked by a winged dragon, the kakodoemon, or the evil principle. This is according to the ancient Chaldean doctrine of two creations of living beings, the one good and the other malign. The Chinese still think that an eclipse is caused by the efforts of a furious dragon to destroy the sun and moon; and Apollo, the sun-god, destroying the serpent Python, has reappeared on our coin as St. George killing the dragon. Even Apollyon appears in old paintings with huge wings, like those of a bat.

Having thus explained what appears to be the key to a wide range of religious symbolism, and shown its application in many cases, we shall further apply it to unlock the famous object of Assyrian worship. Soon after the discoveries of Botta and Layard were published, it was conjectured that this strange object, so continually represented as being adored, might be the *asherah* of the Hebrew scriptures, translated "grove" in the English version. How far the view was correct we shall now proceed to examine.

The religion of the East at a very remote period appears to have been the worship of one God, under several names. The most primitive was *El, Il, or Al,* = the strong, the mighty one; or its plural *Elohim,* as expressing His many powers and manifestations. Another name was *Baal or Bel,*—the lord, which also had a plural form, *Baalim.* The first word is continually used in the Hebrew scriptures, and applied both to the true God and the gods of the nations. Baal is only once thus applied, Hosea ii. 16; yet Balaam, inspired by God, prophesies from the high places of Baal. This name, though so appropriate to the Almighty, became abhorrent to the Jews when it was so frequently associated with idolatry, and a new cognomen, or "the Supreme," was adopted by them, viz., Jehovah, = the Eternal, the Ever-Living One, the Creator; see Exod. iii. 14. "Baal" was the supreme god of all the great Syro-Phoenician nations, with the insignificant exception of the Jews; and when the latter migrated into Canaan they were surrounded on all sides by his worshippers. Towns, temples, men, including even a son of Saul, of David and of Jonathan, viz., Eshbaal, Meribbaal, and Beelida, were called after him. As the sun-god, Baal-Hammon, Song of Sol. viii. 11; 2 Kings xxiii. 5; he was worshipped on high places, Num. xxii. 41; and an image of the sun appeared over his altars, 2 Chron. xxxiv. 4. As the generative and productive power, he was worshipped under the form of the phallus, Baal-Peor; and youths and maidens, even of high birth, prostituted themselves in his honour or service; Num. xxv.; 2 Kings xxiii. 7. As the creator, he was represented to be of either or of both sexes; and Arnobius tells us that his worshippers invoked him thus:

"Hear us, Baal! whether thou be a god or a goddess."

Though he is of the masculine gender in the Hebrew, הַבַּעַל, the lord, yet Baal is called ἡ Βάαλ, = the lady, in the Septuagint; Hos. ii. 8; Zeph. i. 4; and in the New Testament, Romans xi. 4. At the licentious worship of this androgyne, or two-sexed god, the men on certain occasions wore female garments, whilst the women appeared in male attire, brandishing weapons. Each of this god's names had a female counterpart; and the feminine form of *Baal was Beltis, Ishtar, and Ashtarte.* As he was the sun-god, she was the moon-goddess. Now, whilst the masculine name (as Bël or Bâl, Baal, Baalim,) appears nearly one hundred times in the Hebrew Old Testament, the feminine equivalent is only found three times in the singular אַשְׁתֹרֶת, Ashtoreth, and six times in the plural אַשְׁתָרוֹת, Ashtaroth; always in association with Baal-worship. Knowing, as we do, the immense diffusion of her worship amongst the Babylonians, Assyrians, and Phoenicians, this appears strange. There is a word of the feminine gender occurring in the Hebrew twenty-four times, viz., Asherah or *Asharah;* plural, *Asharth* translated in the Septuagint and Latin vulgate, a tree, or "grove," in which they have been followed by most modern versions, including the English. This supplies the void, for *Asharah* may be regarded as another name for the goddess *Ashtoreth*, as is plainly seen by the following passages: "They forsook Jehovah and served Baal and Ashtoreth;"

Judges ii. 18; whilst in the following chapter we read, "They forgot Jehovah their God, and served the Baalim and the Asharoth;" iii. 7. What, then, was the *Asharah*? It was of wood, and of large size; the Jews were ordered to cut it down; Exod. xxxiv. 18, etc.; and Gideon offered a bullock as a burnt sacrifice with the wood of the Asherah. Occasionally it was of stone. It was carved or graven as an image; 2 Kings xxi. 7. It often stood close to the altar of Baal; Judges vi. 25 and 80; 1 Kings xvi. 82, 88; 2 Chron. xxxiii. 8. Usually on high places and under shady trees; 1 Kings xiv. 28; Jer. xvii. 2; but one was erected in the temple of Jehovah by Manasseh; 2 Kings xxi. 7. It had priests; 1 Kings xviii. 19; and its worship was as popular as that of Baal; for whilst the priests of "the Baal" were four hundred and fifty, those of "the Asherah" were four hundred, who ate at the table of Queen Jezebel, daughter of Ethbaal, king of Sidon. It was sometimes surrounded with hangings, and was worshipped by both sexes with licentious rites; 2 Kings xxiii. 7; Ezek. xvi. 16. As Baal was associated with sun-worship, so was the Asherah with that of the moon; 2 Kings xxi. 8; 2 Chron. xxxiv. 4.

Besides these Asheroth, female emblems of Baal, there were Asherim, אֲשֵׁרִים, male emblems of Baal, "symbolising his generative power" (Fürst, *Hebrew Lexicon*), which are mentioned sixteen times in the Hebrew scriptures. It is only found in the plural, and must have been a multiple representation of the singular, Asher, אָשֵׁר, which means "to be firm, strong, straight, prosperous, happy," [6] and cognate with the Phoenician אסר (Osir), "husband," "lord," an epithet of Baal.

Doubtless this was also identical with the Egyptian Osiris, = the sun, = the phallus. He was said to have suffered death like the sun; and Plutarch tells us that Isis, unable to discover all the remains of her husband, consecrated the phallus as his representative. Thus "the Asharim" were male symbols used in Baal-worship, and sometimes consisted of multiple phalli, of which the branch carried by an Assyrian priest, in Plate iii. Fig. 4, is a conventional form. They were then counterparts of the "*multimammia*" of Greek and Roman worship. [7] This is confirmed by a curious passage, 1 Kings xv. 13 (repeated 2 Chron. xv. 16). We learn (xiv. 28) that the Jews, under Rehoboam, son of Solomon, having lapsed into idolatry, had "built them high places, images, and Asharim ("groves," A. V.) on every high hill, and under every green tree; and that there were also consecrated ones ("sodomites," A. V.) in the land." But Asa, his brother, on succeeding to the throne, swept away all these things, and (xv. 18) deposed the queen mother, Maachah, because she had made a *miphletzeth* to an Asherah ("an idol in a grove," A. V.) מִפְלֶצֶת, *miphletzeth*, is rendered by the Vulgate "simulacrum Priapi." The word is derived from פָּלַץ *palatz*, "to be broken," "terrified," or the cognate פָּלַשׁ, *phalash*, *palash*, "to break or go through," "to open up a way;" a word or root found in the Hebrew, Phoenician, Syriac, and Ethiopie. Doubtless the Greek φαλλος *phallus*, was hence derived, since it has no independent meaning in Greek; and Herodotus and Diodorus expressly assert that the chief gods of Greece

and their mysteries, especially the Dionysiac or Bacchic revels, in which the *phallus* was carried in procession, were derived from the east. Compare also the Latin *pales*, English *pale, pole*, = May*pole*. A similar word, with a corresponding meaning, exists in the Sanscrit. Thus, then, according to the Hebrew scriptures, there were two chief symbols used in the worship of Baal, one male, the other female.

We can now look upon the very symbols themselves, which were so used—perhaps the most remarkable in existence. It is well known that the Chaldeans, from whom all other nations derived their religion, astronomy, and science, gave the name of Bel or Baal to their chief god. In the most ancient inscription yet deciphered, written in the Babylonian and Arcadian languages, a king rules by "the favour of Bel." Another name for Baal is Assur, or Asher, from whom Assyria is named. In the cuneiform inscriptions of Sennacherib, the great king of Assyria, Nineveh is called "the city of Bel," and "the city beloved by Ishtar." In another inscription he says of the king of Egypt:—"the terror of Ashur and Ishtar overcame him and he fled." Assurbanipal thus commences his annals "The great warrior, the delight of Assur and Ishtar, the royal offspring am I." In a cuneiform inscription of Nebobelzitri, we read:—"Nineveh the city, the delight of Ishtar, wife of Bel." Again, "Beltis, the consort of Bel." "Assur and Beltis, the gods of Assyria." Thus we see that Baal and Bel were identical with Assur, and Ashur. Doubtless, then, "*Asherah*" is the last name with the feminine termination (as Ish = man, Ishah=woman), and is identical with Ishtar, Ashteroth, Astarte and Beltis. The Septuagint has rendered "Asherah" by "Astarte," in 2 Chron. xv. 16, and the Vulgate by "Astaroth," in Judges iii. 7. Herodotus described (b.c. 450) the great temple of Belus at Babylon, and its seven stages dedicated to the sun, moon, and planets, on the top of which was the shrine. This contained no statue, but there was a golden couch, upon which a chosen female lay, and was nightly visited by the god. Now, therefore, that the palaces of the Assyrian kings, and their "chambers of imagery," have been by great good fortune laid open to us, we might expect to discover the long-lost symbolism of Baal-worship. And so we have.

To commence with the simplest. The אשרים (Asherim) is seen as the mystic palm-tree, the tree of life, Fig. 99; the phallic pillar putting forth branches like flames, Fig. 65; and the tree with seven phalloid branches, so common on Assyrian and Babylonian seals, Plate xvii., Fig. 4. See also the remarkable Syrian medals, Plate xvii., Fig. 2, on which is represented Baal as the sun-god, holding the bow, and surrounded by phalli.

Or, least conventional of all, the simple phallus, of which there are two remarkable specimens in the British Museum. Each of these is about two and a half feet high, and once guarded the bounds of an estate. Among the Greeks and Romans, boundaries were also marked by a phallic statue of Hermes, the god of fertility. These Assyrian emblems have doubtless often been honoured with rural sacrifice. Themselves the most expressive symbol of life, they are also covered with its conventional emblems. A back view of one is given, Fig-

117

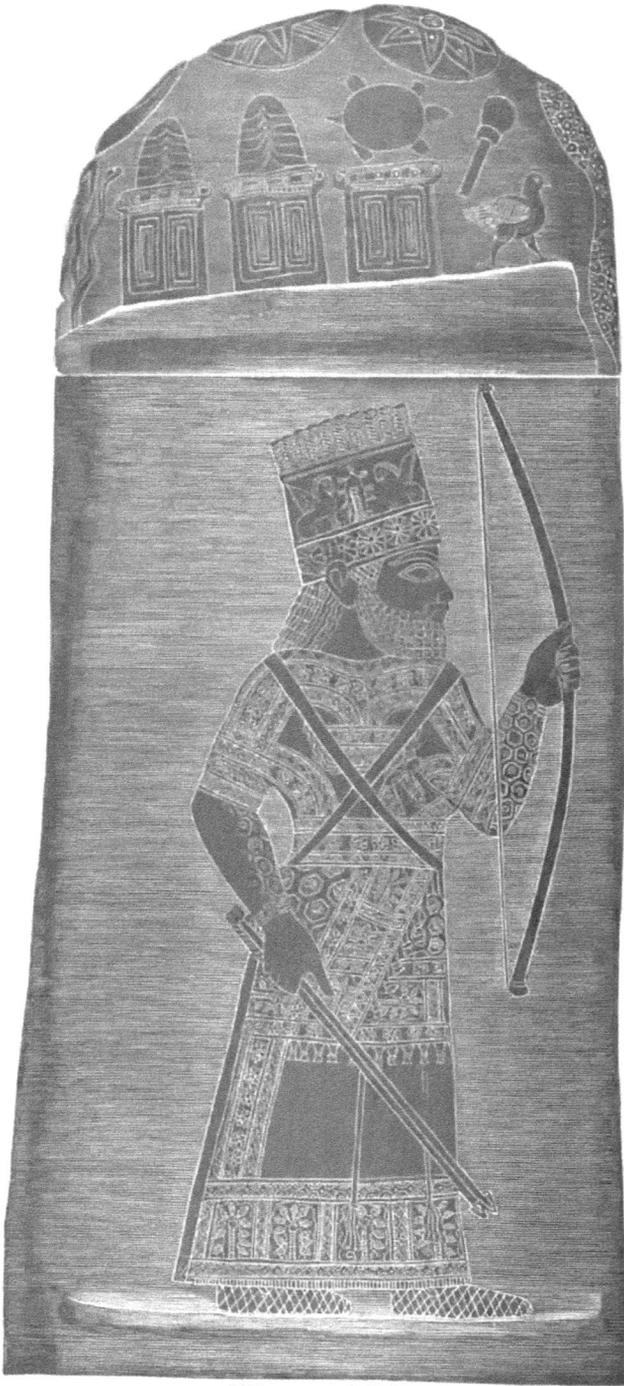

Figure 174.

ure 174. The body is mainly occupied with a full length portrait of the great king. For as the Assyrians represented the Deity, the source of all life, by the phallus, so the monarch was the god of this lower world, the incarnation of God on earth. He was the source of life to the empire, and as such was addressed—"O king, live for ever" (Dan. v. 10). He, like the gods, never dies. "*Le Roi est mort; Vive le Roi*" The ensigns of royalty were also those of the creator-god. Accordingly, his garments and crown are embroidered with that sacred emblem, the Asherah. He bears the strung-bow and arrows, emblems of virile power, borne afterwards by the sun-god Apollo, and the western son of Venus. An erect serpent occupies the other side, and ends with forky tongue near the orifice. The *glans* is covered with symbols. On the summit is a triad of sun emblems; beneath are three altars, over two of which are the glans-shaped caps, covered with bulls' horns, always worn by the Assyrian guardian angels, and intense emblems of the male potency. For in ancient symbolism, *a part of a symbol stands for the whole*; as here, the horns represent the bull, and the glans the phallus. Above the third altar is a tortoise, whose protruded head and neck reminded the initiated of the phallus; and the altars are covered with a pattern drawn from the tortoise scales. We have, besides, a vase with a rod inserted, emblem of sexual union, and a cock, with wings and plumage ruffled, running after a hen in amorous heat. The glans only of the other is copied.

Fig. 175. At the top are the sun-symbols, as before. Beneath is the horse-shoe-like head-dress of Isis, and there are two altars marked with the tortoise-emblem in front. Over both rises the erect serpent, and upon one lies the head of an arrow or a dart, both male symbols. The *miphlet-*

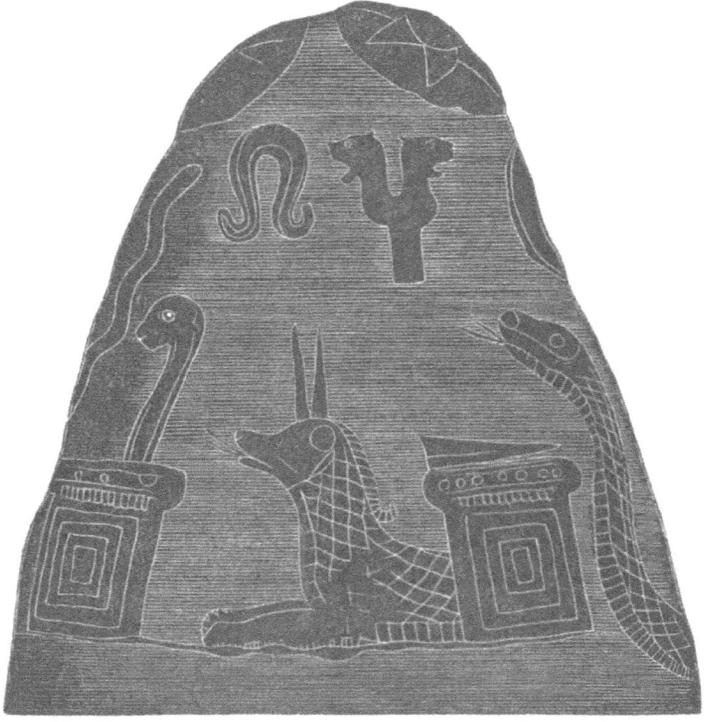

Figure 175.

119

zeth which Queen Maachah placed in or near the Asherah, probably resembled these Assyrian phalli, or the Asherim.

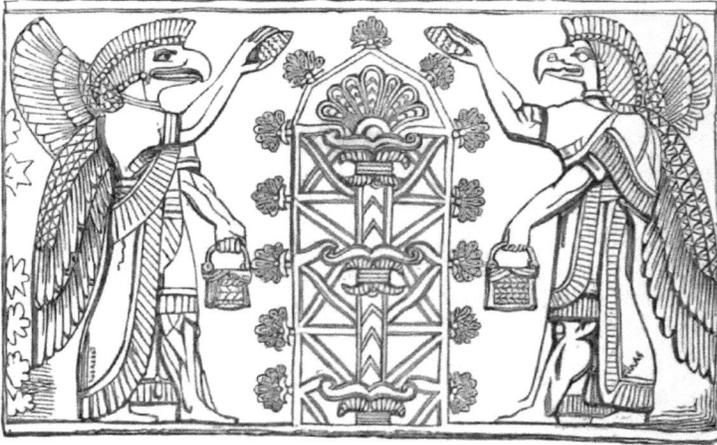

Figure 176.

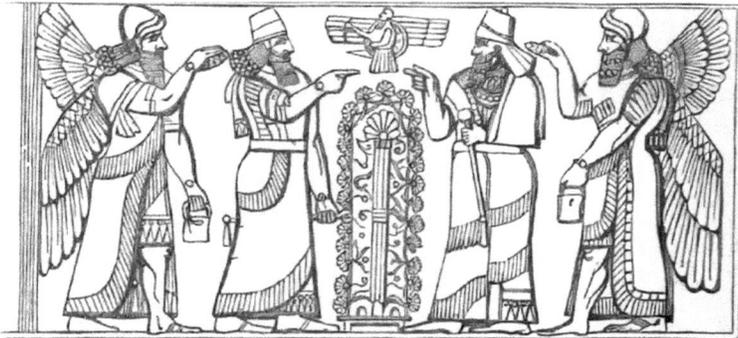

Figure 177.

And now we come to the Asherah, a much more complex and difficult symbol than any other which we have named. This object has long puzzled antiquarians, and though it is continually recurring in the sculptures from Nineveh, it has not yet been fully explained. In Fig. 176 we see it worshipped by human figures, with eagles' heads and wings, who present to it the pine-cone, = the testis, and the basket, = the scrotum (?), intense emblems of the male creator. In Fig. 177 it is adored by the king and his son or successor, with their attendant genii. The kings present towards it a well-known symbol of life and good fortune, the fist with the forefinger extended, or "the phallic hand." Here, then, we have evidently the Asherah, or Ashtaroth-symbol, the female Baal, the life-producer, "the door" whence life issues to the world. As such the goddess is here symbolised as an arched door-way. In the Phonician alphabet, the fourth letter, *daleth* דֶּלֶת = a door, has the shape of a tent-door,

120

as on the Moabite stone, A, and also in the Greek Δέλτα But another form, perhaps as ancient, is **D**, which, when placed in its proper position, would be ◖, the very form of the Asherah. [8] In the plural, this word stands for the *labia pudendi*, כִּי לֹא סָגַר דַּלְתֵי בִטְנִי, "because it shut not up the *doors* of the womb," Job iii. 10. [9] We infer from Numbers xxv. 6-8, that in the rites of Baal-peor, the *Kadeshoth*, or women devoted to the god, offered themselves to his worshippers each in a peculiar bower or small arched tent, called a *qubbah,* קֻבָּה. The part also through which Phinehas drove his spear (see Num. xxv. 8), the woman's vulva, is also called *qobbah,* קֹבָה, the one word being derived from the other, according to Onkelos, Aquila, and others. *Qubbah* means, according to Fürst, Heb. Lex., "something hollow and arched, an arched tent, like the Arabic El. *Kubba,* whence the Spanish *Al-cova,* and our *Alcove.*" In the Latin also, the word *fornix,* a vault, an arch, meant a brothel, and from it was derived *fornicatio. Qubbah* is translated by the LXX., χάμινος, *kaminos,* "an oven or arched furnace" (Liddell and Scott); but it meant also the female parts. See Herodotus v. 92 (7). Thus, then, the Alcove was itself a symbol of woman, as though a place of entrance and emergence, and whence new life issues to the world. And when the male worshipper of Baal entered to the *kadeshah*, the living embodiment of the goddess, the analogy to the Asherah became complete, as we shall now show.

The central object in the Assyrian "grove" is a male date-palm, which was well known as an emblem of Baal, the sun, the phallus, and life. This remarkable tree, תָּמָר, *Tamar* in Phoenician and Hebrew, the *phoenix* (ὁ φοίνιξ) in Greek, was formerly abundant in Palestine and the neighbouring regions. The word *Phoenicia* (Acts xi. 19, xv. 8) is derived from θοίνιξ, *phoinix,* as the country of palms; like the "*Idumeo palmo*" of Virgil. Palmyra, the city of the sun, was called in the Hebrew *Tamar* (1 Kings ix. 18). In Vespasian's famous coin, "*Judea capta,*" Judoa is represented as a female sitting under a palm-tree. The tree can at once be identified by its tall, straight, branchless stem, of equal thickness throughout, crowned at the top with a cluster of long, curved, feather-like branches, and by its singularly wrinkled bark. All these characteristics are readily recognised in the highly conventional forms of the religious emblem, even in the ornament on the king's robe, fig. 174. The date-palm is dioecious, the female trees, which are sometimes used as emblems, being always distinguished by the clusters of date fruit. "Thy stature is like to a palm-tree, thy breasts to clusters" (Cant. vii. 7). "The righteous shall flourish like the palm-tree" (Ps. xcii. 12), fruitful and ever green. "They are upright as the palm-tree, but speak not" (Jer. x. 8-5). The prophet is evidently describing the making of an Asherah. There was a Canaanite city called Baal-Tamar, = Baal, the palm-tree, designated so, it is probable, from the worship of Baal there "under the form of a priapus-column," says Fürst, Heb. Lex. The

PLATE XVII.

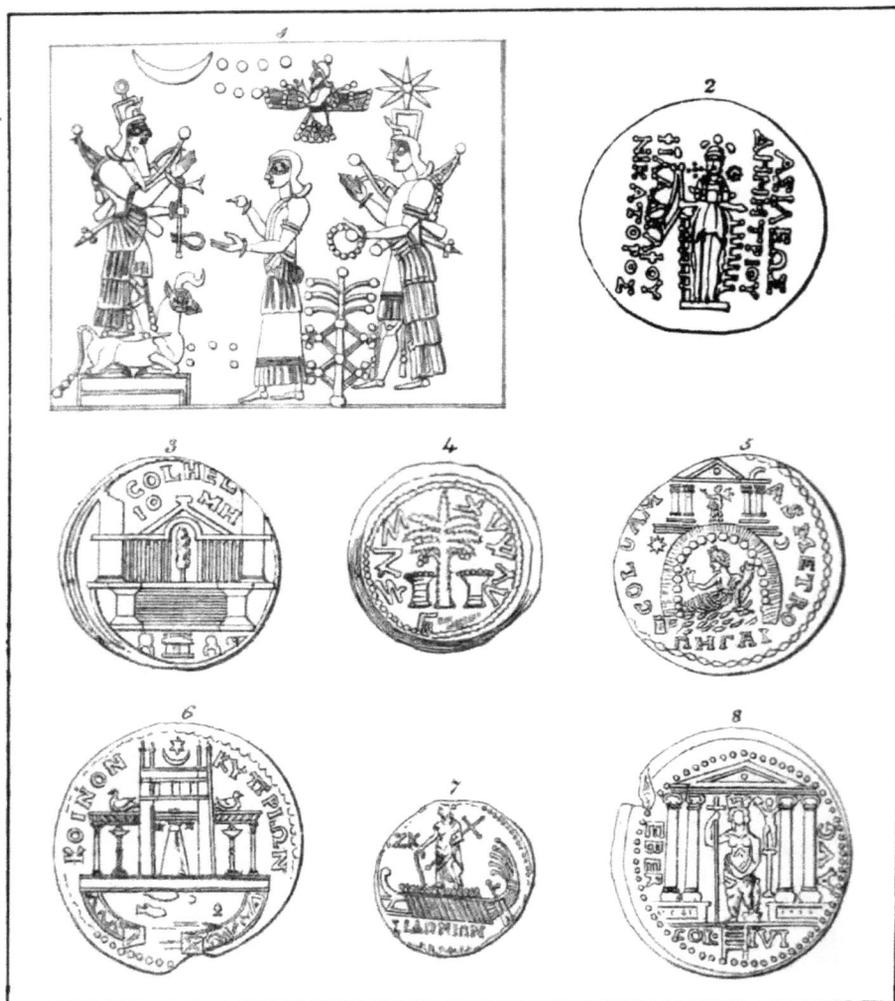

real form was doubtless an "Asherim," a modified palm-tree, as we have already shown. Palm-branches have been used in all ages as emblems of life, peace, and victory. They were strewn before Christ. Palm-Sunday, the feast of palms, is still kept. Even within the present century, on this festival, in many towns of France, women and children carried in procession at the end of their palm-branches a phallus made of bread, which they called, undisguisedly, "la pine," whence the festival was called "La Fête des Pinnes." The "pine" having been blest by the priest, the women carefully preserved it during the following year as an amulet. (Dulaure, *Hist, des differens Cultes.*)

Again, the Greek name for the palm-tree, *phoenix*, was also the name of that mythical Egyptian bird, sacred to Osiris, and a symbol of the resurrection.

With some early Christian writers, Christ was "the Phoenix." The date-palm is figured as a tree of life on an Egyptian sepulchral tablet, older than the Exodus, now preserved in the museum at Berlin. Two arms issue from the top of the tree; one of which presents a tray of dates to the deceased, whilst the other gives him water, "the water of life." The tree of life is represented by a date-palm on some of the earliest Christian mosaics at Rome. Something very like the Assyrian Asherah, or sacred emblem, was sculptured on the great doors of Solomon's temple, by Hiram, the Tyrian (1 Kings vii. 18-21). We read "he carved upon them carvings of cherubims and palm-trees and open flowers, and spread gold upon the cherubims and palm-trees" (1 Kings vi. 82-35). He also erected two phallic pillars in front of the Temple, Jachin and Boaz, = It stands—In strength. No wonder Solomon fell to worship Astarte, Chemosh, and Milcom.

Although to our modern ideas the mystical tree, symbol of life and immortality, seems out of place in Judaism, yet no sooner did the Jews possess a national coinage under the Maccabees than the palm-tree reappears, *always with seven branches* (like the golden candlestick, Ex. xxv.), as on the shekel represented Plate xvii., Fig. 4. The Assyrian tree has *always* the same number, and the tufts of foliage (symbolising the entire female tree) which deck the margins of the mystic D—apt emblems of fertility—have also invariably seven branches. This may remind us of the seven visible spheres that move around our earth "in mystic dance," and of Balak's offering, upon seven altars, seven bulls and seven rams (Num. xxiii. 1; Rev. ii. 1) The mystic door is also barred, like the Egyptian sistrum carried by the priestesses of Isis, to represent the inviolable purity and eternal perfection which were associated with the idea of divinity. When Mary, the mother of Jesus, took the place in Christendom of "the great goddess," the dogmas which propounded her immaculate conception and perpetual virginity followed as a matter of course.

Thus, then, we explain the greatest symbol in Eastern worship,—it is the "Tree of Life in the midst of the Garden," which has remained so long a mystery. To Dr. Inman belongs the distinguished merit of having first broken ground in the right direction. In his *Ancient Faiths*, vol. 1, 1868, he identified the Assyrian "Asherah" with the female "door of life," and pointed out its analogy to the barred sistrum. We have seen that it is really much more complex, being precisely analogous in meaning to the famous *crux ansata* (Fig. 170), the central mystery of Egyptian worship; to the lingam or lingyoni of India (Fig. 109), the great emblem of Siva-worship; and to the caduceus of Greece and Rome. As represented on the Assyrian sculptures, it is always substantially the same. Probably this stereotyped form was the result of a gradual refinement upon some rude primitive type, perhaps as coarse as that seen by Captain Burton in the African idol-temple.

To exhibit all the strange developments and modifications which this idea has assumed in the religious symbolism of Eastern and Western nations would require a large volume. But the subject is so rich in varied interest that we cannot conclude without taking a glance at it. First, the simple ◖, barred,

PLATE XVIII.

is reproduced with a contraction towards the base, as in the Indian "yoni," and the Egyptian sistrum, used in the worship of Isis. Second, within the ⌂ was represented the goddess herself, as revealed within her own symbol. This is illustrated in Plate xvii., Fig. 5, where Demeter or Ceres is thus depicted, with her cornucopia, from a bronze coin of Damascus. Thirdly, but much more commonly, the goddess holds in her hands emblems of the male potency in creation, and thus completes the symbol. As in the coin figured Plate xvii., Fig. 8, the goddess, standing within the ⌂, the portico of her temple, holds in her right hand the cross, that most ancient emblem of the male and of life. In the beautiful Greek coin of Sidon next figured, the goddess— evidently Astarte, the moon-goddess, the Queen of Heaven—stands on a ship, the mystic *Argha* or *Ark,* holding in one hand a crozier, in the other the cross. (Plate xvii., Fig. 7.)

Under Christianity, the Virgin Mary, who, as Queen of Heaven, stands on the crescent moon, is pictured beneath the mystic doorway, with (the God as) a male child in her arms. See Plate xviii., copied from the woodcut title to the *Psalter of the Blessed Virgin,* printed at Czenna, in old Prussia, 1492. Like Isis, she is the mother and yet the spouse of God, "clothed with the sun, and having the moon under her feet" (Rev. xii. 1). The upper half of the picture is very like the Assyrian scenes. On either side is a king, Frederick III. and his son the Emperor Maximilian, at their devotions. The alcove is of roses, an emblem of virginity. The famous Mediæval "Romaunt de la Rose" turns upon this. Among the many titles given to "the Virgin" in Mediæval times, we find *Santa Maria della Rosa,* that flower being consecrated to her. Hence it is often represented in her hand. Dante writes

> "Here is the Rose,
> Wherein the Word Divine was made incarnate."

In Plate xviii., the Virgin goddess is seated with the God-child in a bower, exactly the shape of the Assyrian, composed of fruits highly significant of sex, as has already been explained. In some Hindoo pictures, the child is naked, having the member erect, and also making the phallic hand, with the right forefinger erected. (Plate xiv., Fig. 14.)

In other conventional forms we have male symbols only within the female ⌂. This is a very numerous class. In the Fig. 3, Plate xvii., we see the fir-tree or pine take the place of the palm-tree, and in Fig. 6, Plate xvii., the cone. On this remarkable medal of Cyprus is a representation of the temple of Venus at Paphos, famous even in the days of Homer. (*Odyss.* viii. 862.) The worship of that divinity is said to have been imported into Cyprus from the East. The goddess united both sexes in her own person, and was served by castrated priests. We see here, within the innermost sanctum of the temple, a cone as emblem of the male; and the meaning is further pointed by the sun-emblem above, inserted within the crescent moon.

Let us next examine how the cone came to be used as a masculine emblem. If we turn to Figs. 174 and 175, it will be seen that the "glans" was particularly honoured as the head of the phallus; it was also the part dedicated to God by effusion of blood in the rite of circumcision. This "acorn" is conical or dome-shaped, and thus—a part being taken for the whole—the cone or pyramid was used as a conventional symbol of the male creator. Placed on a stem it is frequently represented as worshipped on Assyrian bas reliefs. See Fig. 177. It was also a symbol of fire, the sun, and life; as such it formed a fitting monument for the Egyptian kings. Our word pyramid is from the Greek πυραμίς, *puramis*, itself derived from πυρ, *pur, fire*, and πυρος, *puros, wheat*, because pyramid-shaped cakes of wheat and honey were used in the Bacchic Fig. 177. rites. It played an important part in sun-worship. The emperor Heliogabalus (who, as his name implies, had been a priest of Baal, the sun-god, in Syria,) established the Syrian worship at Rome. He himself drove the golden chariot of the sun, drawn by six white horses, through the streets of Rome to a splendid new temple on the Palatine mount, the god being represented by a conical black stone, said to have fallen from heaven; and which the emperor removed from a temple of the sun, at Emesa, in Syria. At a subsequent period, an image of

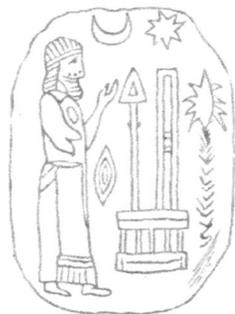

Fig. 177.

the moon-goddess, or Astarte, was brought by his orders from a celebrated fane at Carthage to Rome, and there solemnly married with licentious rites to the sun-god, amidst general rejoicing. [10]

A curious parallel to these mystic nuptials of the Assyrian god and goddess may be found in some of the religious ceremonies of the modern Hindoos. Fergusson tells us that "the most extraordinary buildings connected with Hindu temples are the vast pillared colonnades or *choultries.* By far their most important application is when used as nuptial halls, in which the mystic union of a male and female divinity is celebrated once a year."

Again, in Indian mythology, the pyramid plays an important part. It belongs to Siva, = the sun, = fire, = the phallus, = life. By one complex symbol, very common on ancient Hindoo monuments in China and Thibet, the universe was thus represented. Notice the upward gradation. Earth + water = this globe. The

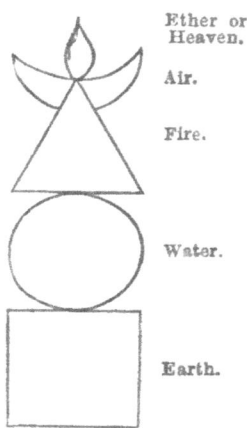

Ether or Heaven.

Air.

Fire.

Water.

Earth.

Fig. 178.

creator-god, whose emblem, flame, mounts upwards, is the author and representative of all life upon it; he is the connecting link, united by the crescent moon with heaven. The arrow- or spear- head inserted within the crescent is an earth emblem of Siva; like the lingam it typified the divine source of life, and also the doctrine that perfect wisdom was to be found only in the combi-

126

nation of the male and female principles in nature. It decorates the roofs of the Buddhist monasteries in Thibet, and like the sacred lotus flower and the linga, both of which became emblems of Buddha, was derived from older faiths. Other interpretations may suggest themselves. This will enable us to understand the remarkable sculptures of the second or third century, from the Amravati Tope, Plate xix., which present so many points in common with the religious symbols of the Chaldeans. In Fig. 2 we see a congregation of males and females, the sexes being separated, worshipping a linga, or stone conical pillar, on the front of which is sculptured the sacred tree, with branches like flames; three symbols of life in one. It rises from a throne, on the seat of which are placed the two emblems of earth and water. In the other figure, the sacred tree takes the place of the linga, rising above the throne, as if from the *trisul* or *trident,* male emblems of Siva. Winged figures, *Garudas,* attend it above, floating over the heads of the worshippers. An intrusion of the newer faith is also to be recognised, as the feet of Buddha are sculptured before the throne.

In the mysteries of Mithra, the symbols in Fig. 178 were also employed. They represented the elements to which the soul ought to be successively united in passing through the new birth.

We will add but two more emblems, culled from medieval heraldry, Figs. 179 and 180, in both of which the Asherah, the "grove" of Baal-worship, will be at once recognised; the arrow and the cross, symbols of the male creator, taking the place of the mystic palm-tree.

Fig. 180.

Fig. 179.

In all these, from the rudest to the most complex, we are thus able to trace a common idea, viz., a feeling after God, as the Life and Light of the Universe, and an attempt to express a common hope in visible forms.

[1] St. Paul points out (Eph. vi. 2) that to only one of the ten commandments is a promise added. And what is the promise? "That thy days may be long." (Exod. xx. 12.) See also Psalm cxxxiii. 3, "the blessing, even life for evermore."
[2] Apuleius, who had been initiated into the mysteries of Isis, informs us that long life was the reward promised to her votaries. (*Metam.* cap. xi.)
[3] We may point out that, according to all the Gospels, Christ expired towards sunset, and the sun became eclipsed as he was dying. He rose again exactly at daybreak.
[4] The consort, or life-giving energy of Vishnu.
[5] As in French, the name for the male organ and for life is the same in sound, though not in spelling or gender.

[6] The lupanars at Pompeii were distinguished by a sign over the street door, representing the erect phallus, painted or carved, and having the words underneath, "Hic habitat félicitas."

[7] See Figs. 15, 16.

[8] The first letter, Aleph, = an ox, is, even on the Moabite stone, written thus, ∢, and has become the modern A. In the earlier hieroglyph it must have been thus Ɐ. The Egyptian hieroglyph for ten is ∩. Compare the Greek Δέκα and Latin *Decem.*

[9] The first of the Orphic Hymns is addressed to the goddess Artemisias Προθυραία (Prothnraia) or the Door-keeper, who presided over childbirths, like the Roman Diana Lucina.

[10] In Astrology, the conjunction of Jupiter and Venus was considered the most fortunate of all; such as kings and princes should be born under.

PLATE XIX.

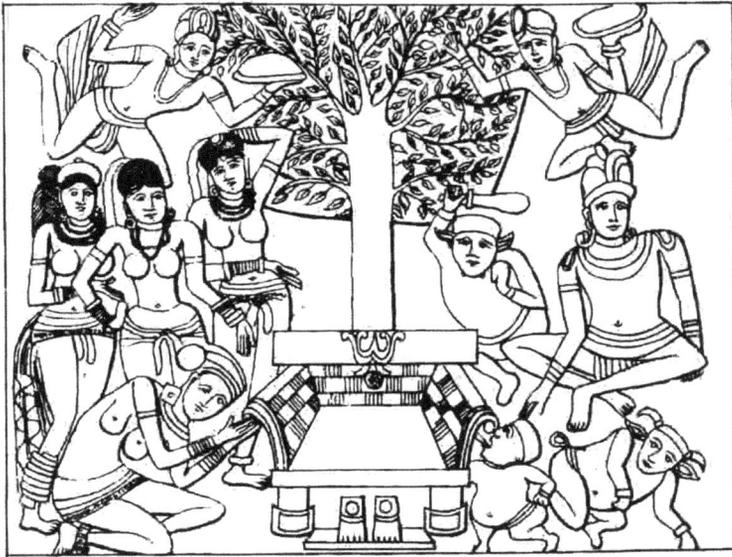

1

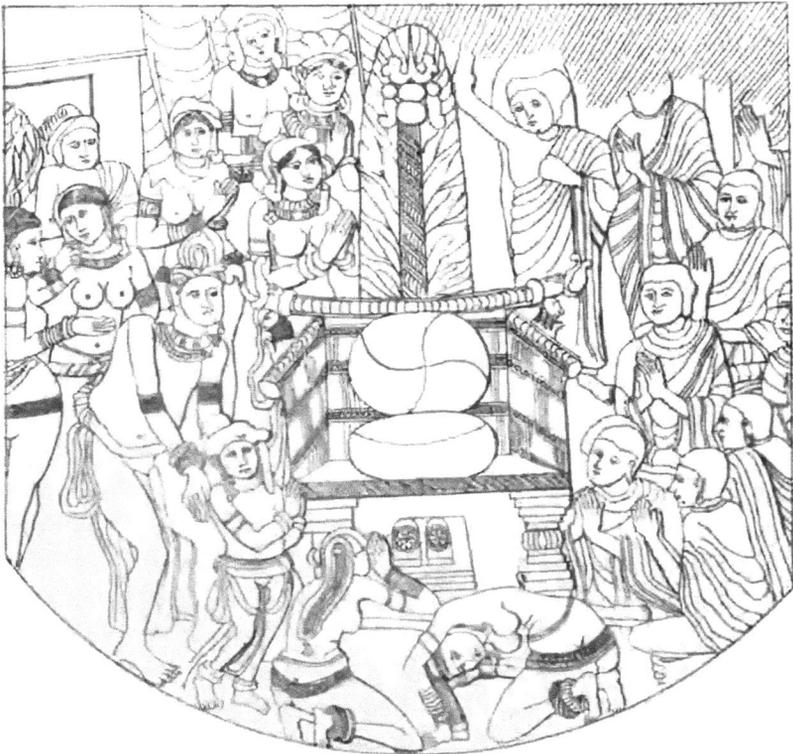

2

Milton Keynes UK
Ingram Content Group UK Ltd.
UKHW011834210624
444498UK00001B/105

9 781789 872712